LIZ

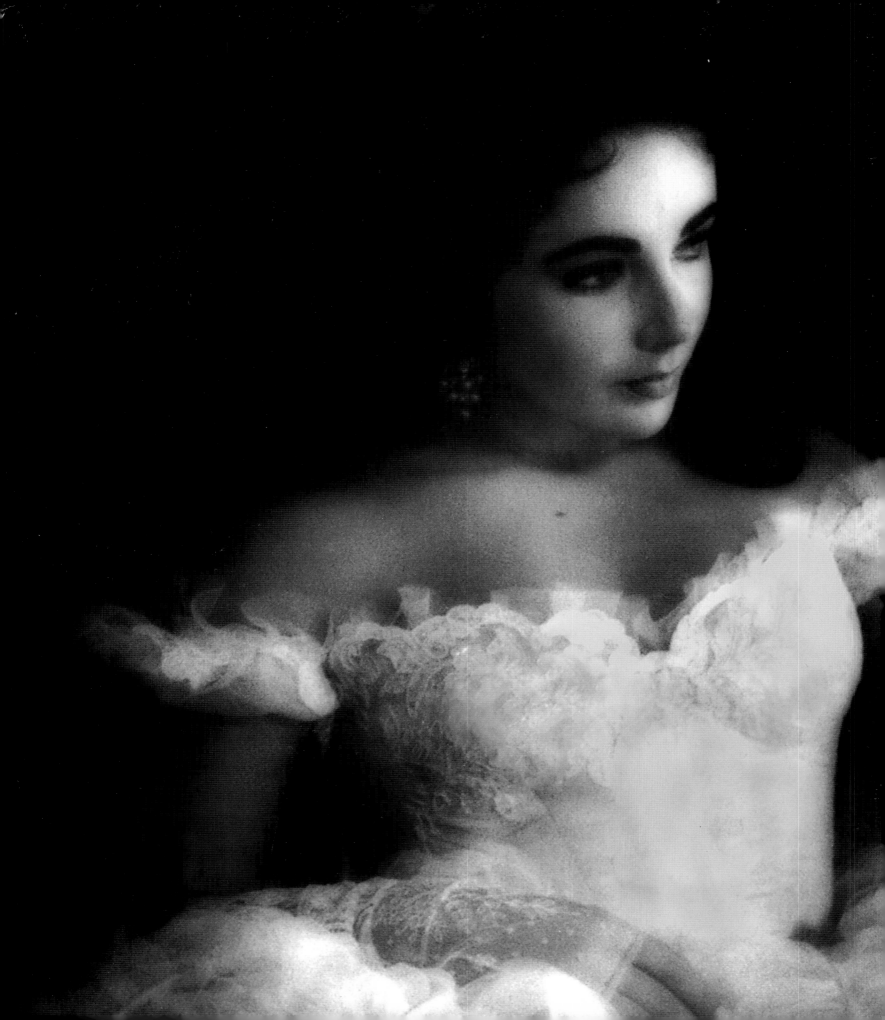

LIZ

An Intimate Collection:
Photographs of Elizabeth Taylor

Bob Willoughby

MERRELL

LONDON · NEW YORK

First published 2004
by Merrell Publishers Limited

Head office:
42 Southwark Street
London SE1 1UN

New York office:
49 West 24th Street
New York, NY 10010

www.merrellpublishers.com

Publisher Hugh Merrell
Editorial Director Julian Honer
US Director Joan Brookbank
Sales and Marketing Director Emilie Amos
Sales and Marketing Executive Emily Sanders
Managing Editor Anthea Snow
Editor Sam Wythe
Design Manager Nicola Bailey
Production Manager Michelle Draycott
Design and Production Assistant Matt Packer

British Library Cataloguing-in-Publication Data:
Willoughby, Bob
Liz – an intimate collection : photographs of Elizabeth Taylor
1.Taylor, Elizabeth, 1932– – Portraits 2.Portrait photography – United
States 3.Motion picture actors and actresses – United States – Portraits
I.Title
779.2'092

ISBN 1 85894 270 5

Produced by Merrell Publishers Limited
Designed by John Grain
Edited by Kirsty Seymour-Ure
Managed by Iona Baird

Printed and bound in China

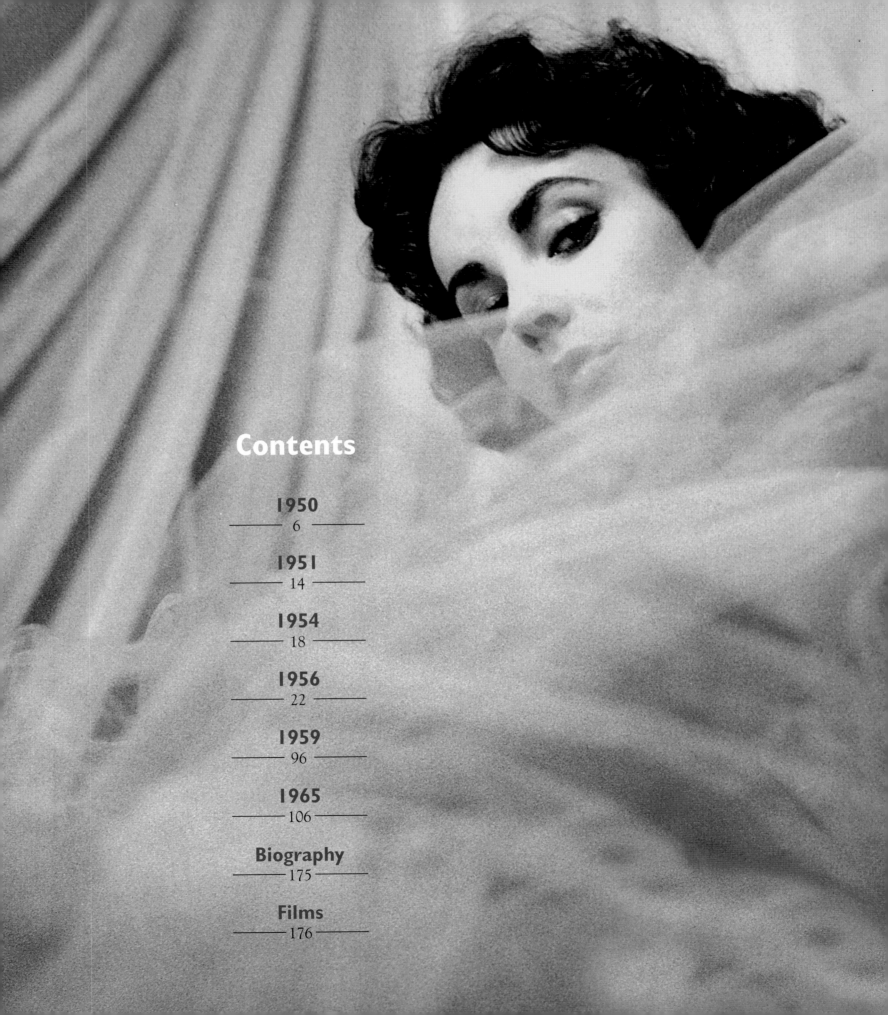

Contents

1950

It was 1950 when my old Los Angeles high school pals Barbara and Beverly Bustetter told me that they were invited to Marilyn Hilton's baby shower. They were especially excited because Elizabeth Taylor (married then to Nicky Hilton, Marilyn's brother-in-law) and Barbara Thompson, wife of the actor Marshall Thompson, were hosting it.

"God!" I told them. "I would love to have the chance of photographing Elizabeth!" The girls reminded me that Marilyn and I had met, before she was married. "We'll just ask her and see if it would be okay."

Elizabeth was just about every young man's dream girl, and some of her MGM films had brought me under her spell. To this day I still remember her dazzling beauty in *Ivanhoe*, when she quietly looks out from the shadows, admiring Robert Taylor, who had come to see her father – but that's getting ahead of myself.

I was over the moon when they told me that Marilyn had cleared my visit with Elizabeth. I set out on the day with all my gear and with great excitement. When I arrived at the house in Brentwood, Elizabeth was on the phone (*right*). *Wow!* There she was, dressed in a lovely white fluted top and a flared skirt with layers of petticoats. And that profile!

I started photographing right away. I felt like I was flying!

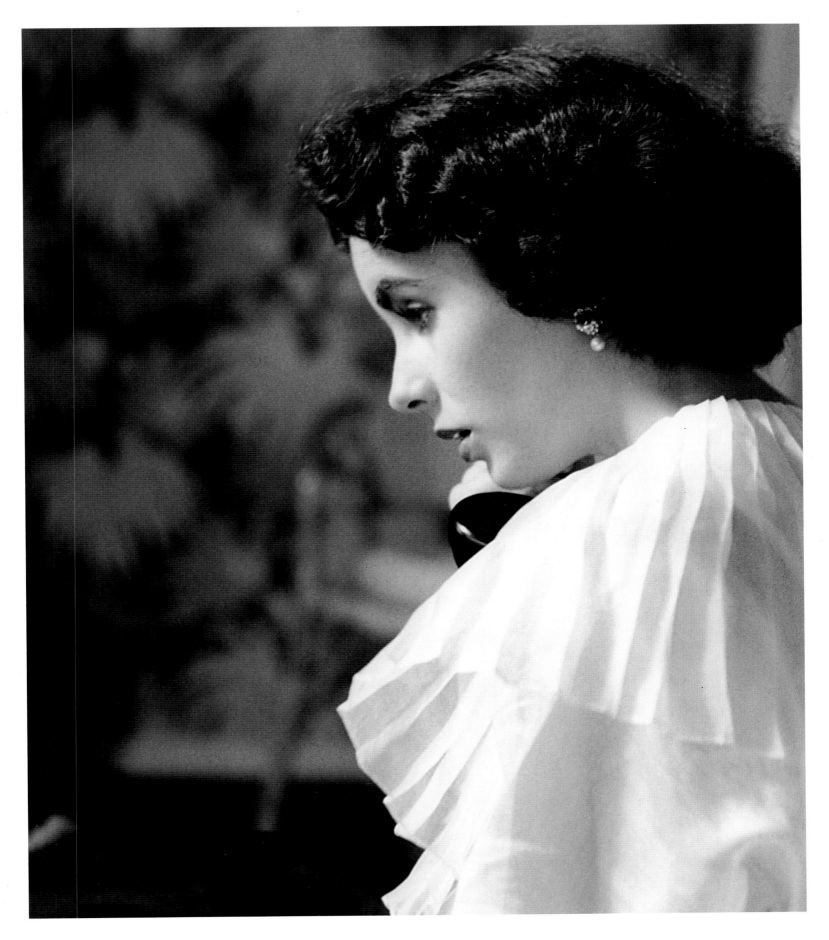

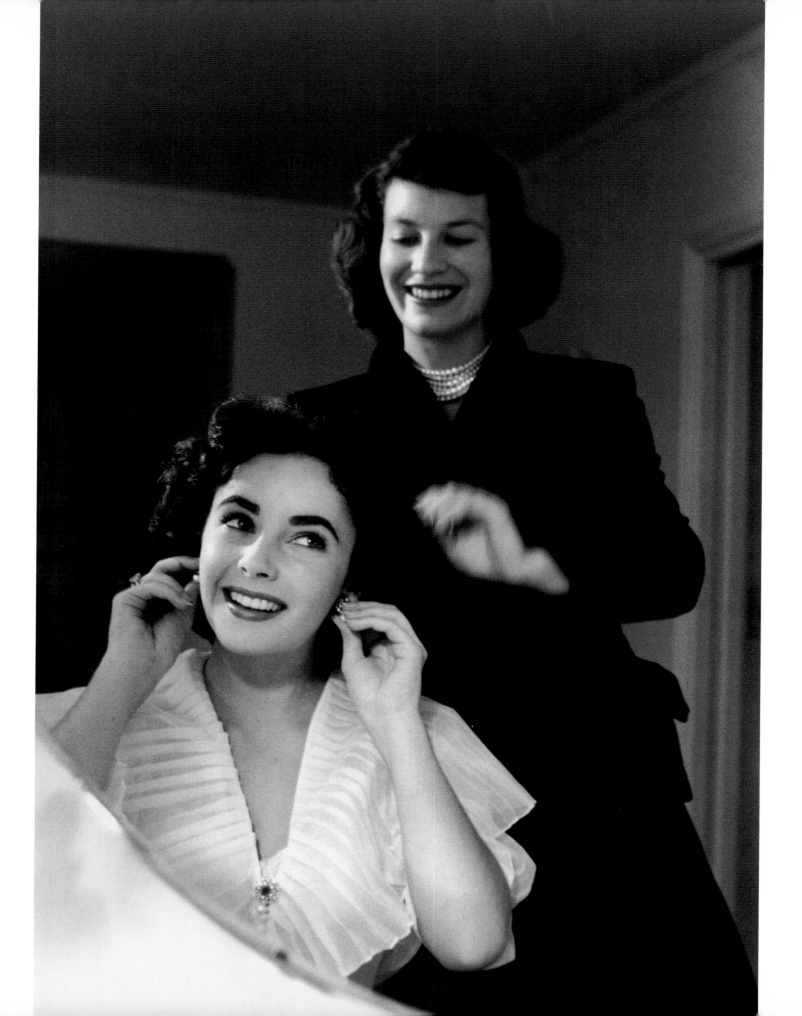

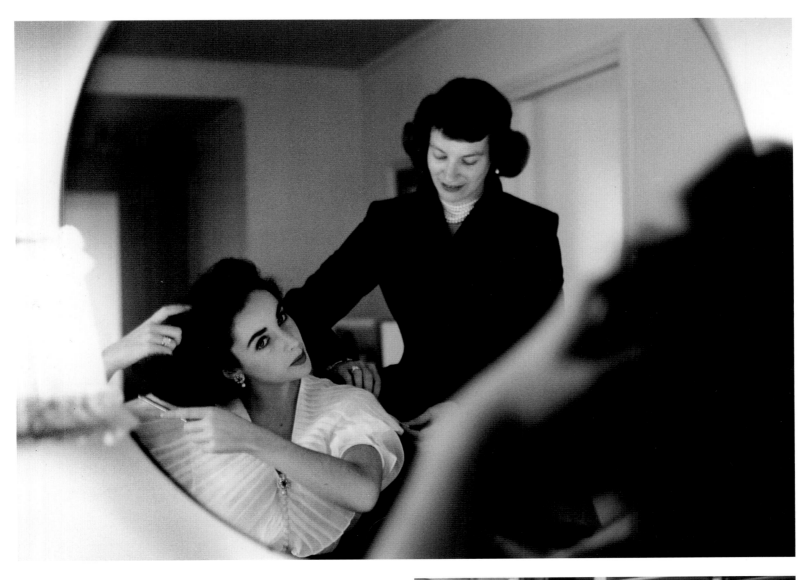

Elizabeth and Barbara Thompson were getting ready for their guests, Elizabeth was tasting some of the food, and I thought it was all terrific.

At the time, of course, I had no way of knowing that Elizabeth's and my paths would cross so often again in the future, and at important times in her life.

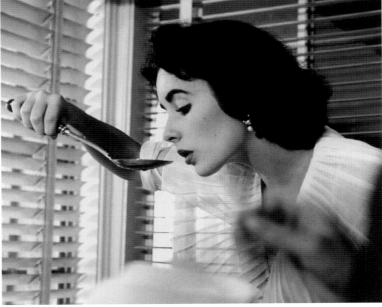

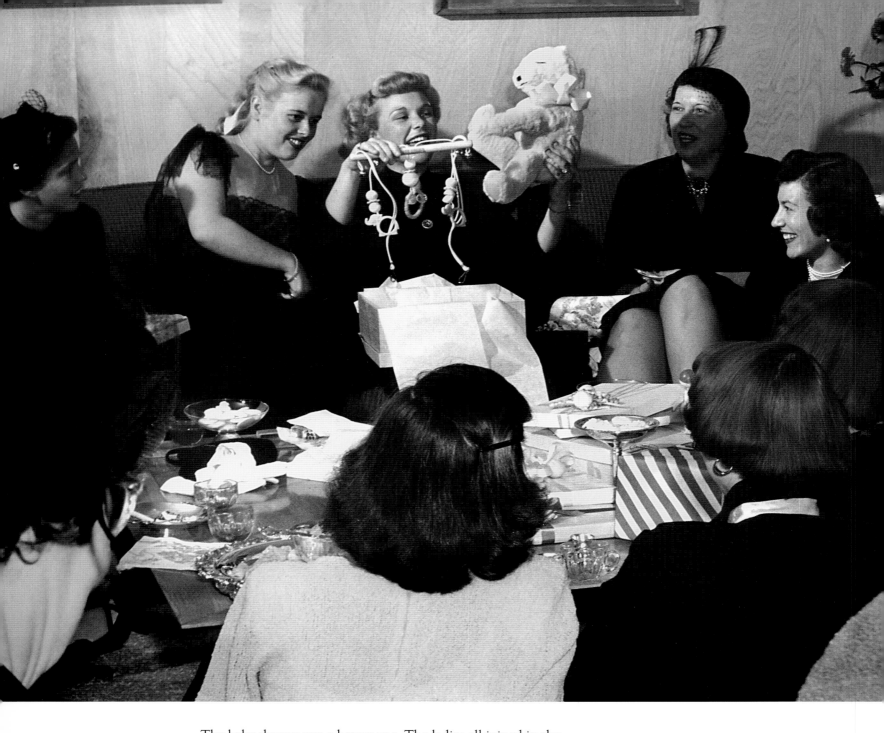

The baby shower was a happy one. The ladies all joined in the fun and clucked appreciatively when Marilyn held up the baby presents. The Bustetter twins, who opened the Aladdin's cave for this photographer, can be seen in the picture above, with matching hairdos (*bottom right, backs to camera*). One memorable moment occurred when Elizabeth got up to answer the door, and her flared skirt spun around and cleared all the glasses off the coffee table.

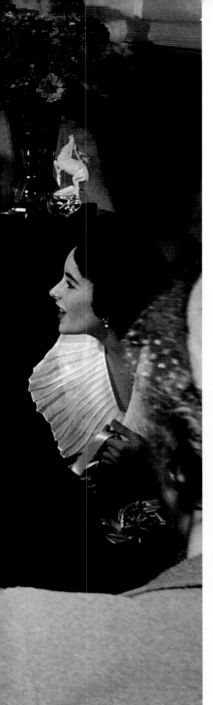

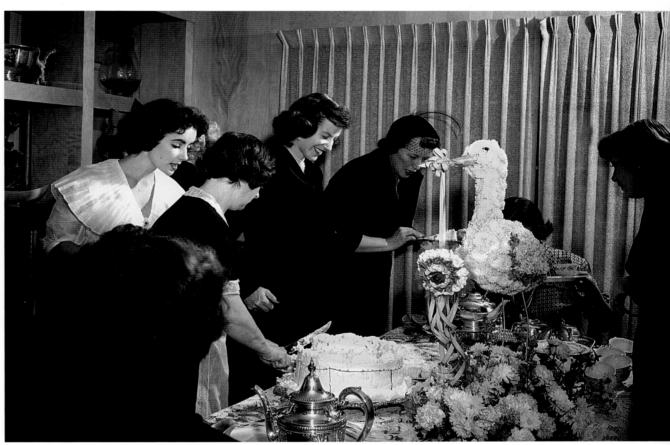

ABOVE Elizabeth and Barbara supervise the cutting of the cake. Jane Powell, another of MGM's bright stars, can be seen at far right.

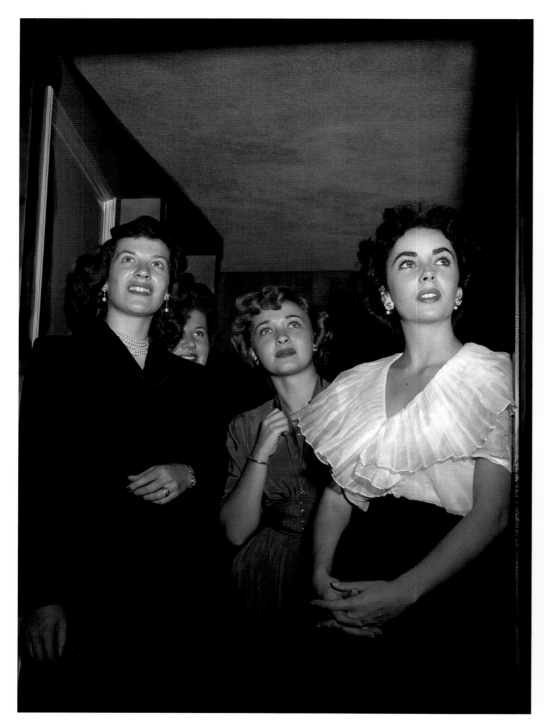

ABOVE Barbara, Jane Powell, and Elizabeth saying their goodbyes.

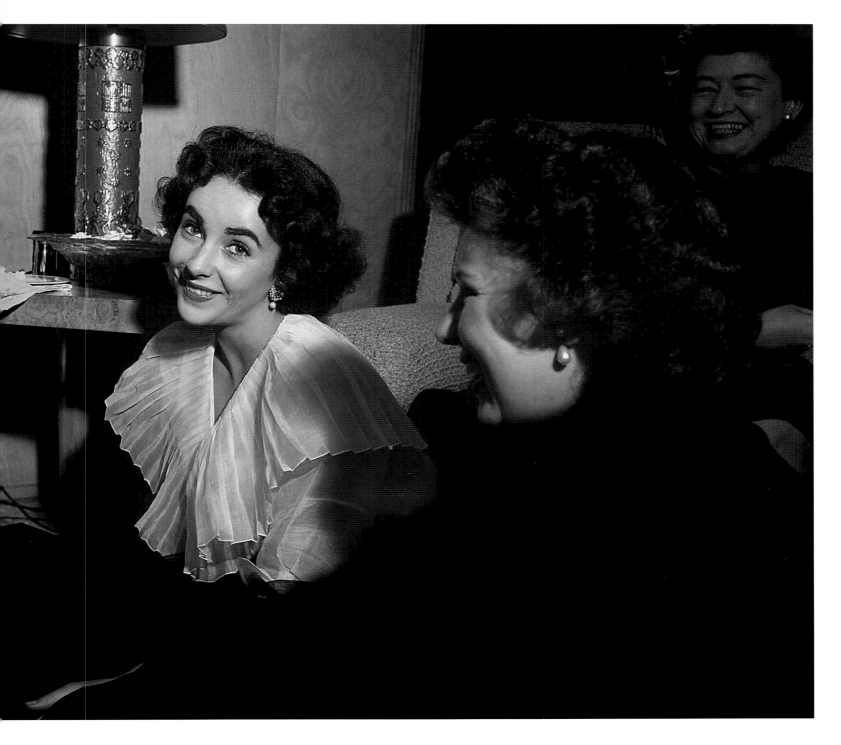

Most of the guests had gone, and those few that were left sat down on the floor to do a postmortem. I guess I would have stayed on and on, but Elizabeth's expression (*above*) gave the signal that this was departure time for Bob.

I remember packing up my gear and rushing home to start processing the film. I just loved taking pictures, especially of beautiful young women, and that enthusiasm has never dissipated over all of these years. From this day onward, Elizabeth became my benchmark.

1951

At this point in my photographic career I was working as a photo assistant to several of the commercial photographers in town. One of them recommended me to visiting English photographer Anthony Beauchamp. He had been assigned by *Pageant* magazine to photograph Elizabeth and hired me to assist and to photograph him as he was working (not only that, but he rented my portable lights as well, so it was a nice windfall for a struggling photographer).

We drove to the hotel in Palm Springs where Elizabeth was staying, and I started to set up. When Elizabeth appeared, she had obviously been sunning herself at the pool and was in her bathing suit. Beauchamp swathed her in voile, *à la* Cecil Beaton, and proceeded with the shoot. What he missed, and I didn't, was her bare legs peeking out from under that cloud of voile. *Pageant* didn't miss it either, and ran my photo instead of his.

Happily, there I was again pointing my camera at this most delicious of young ladies, for the second time in the space of a few months. It was 1951.

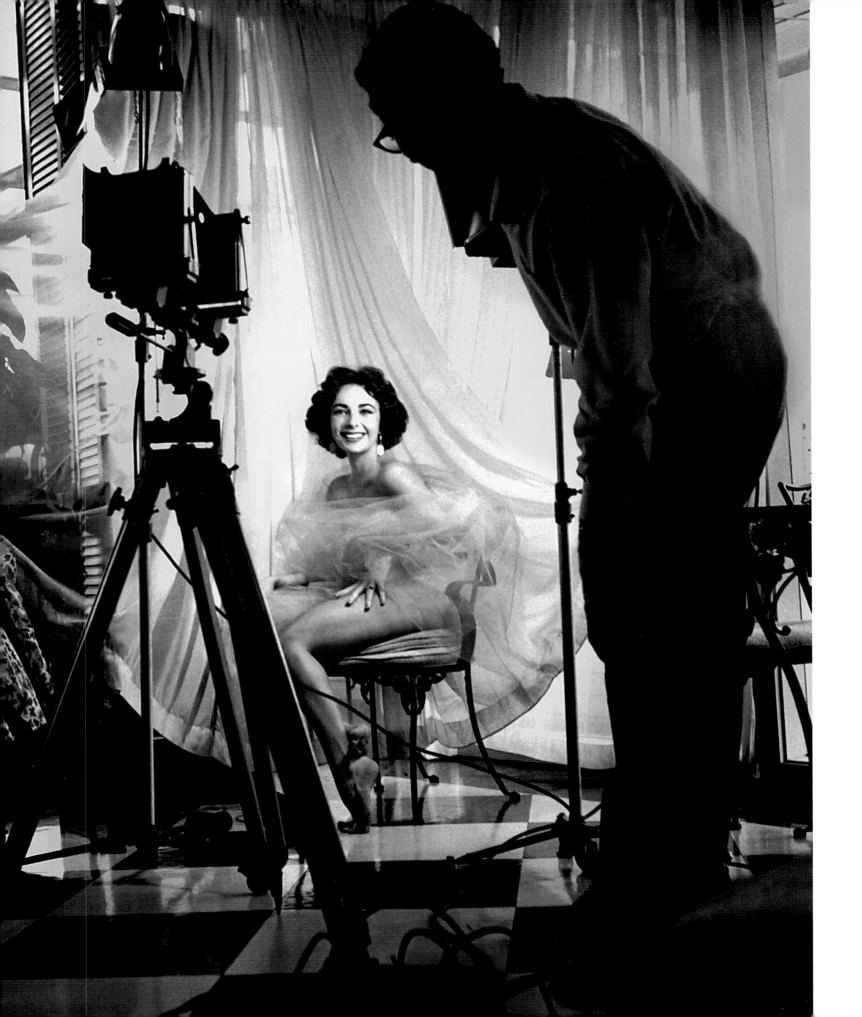

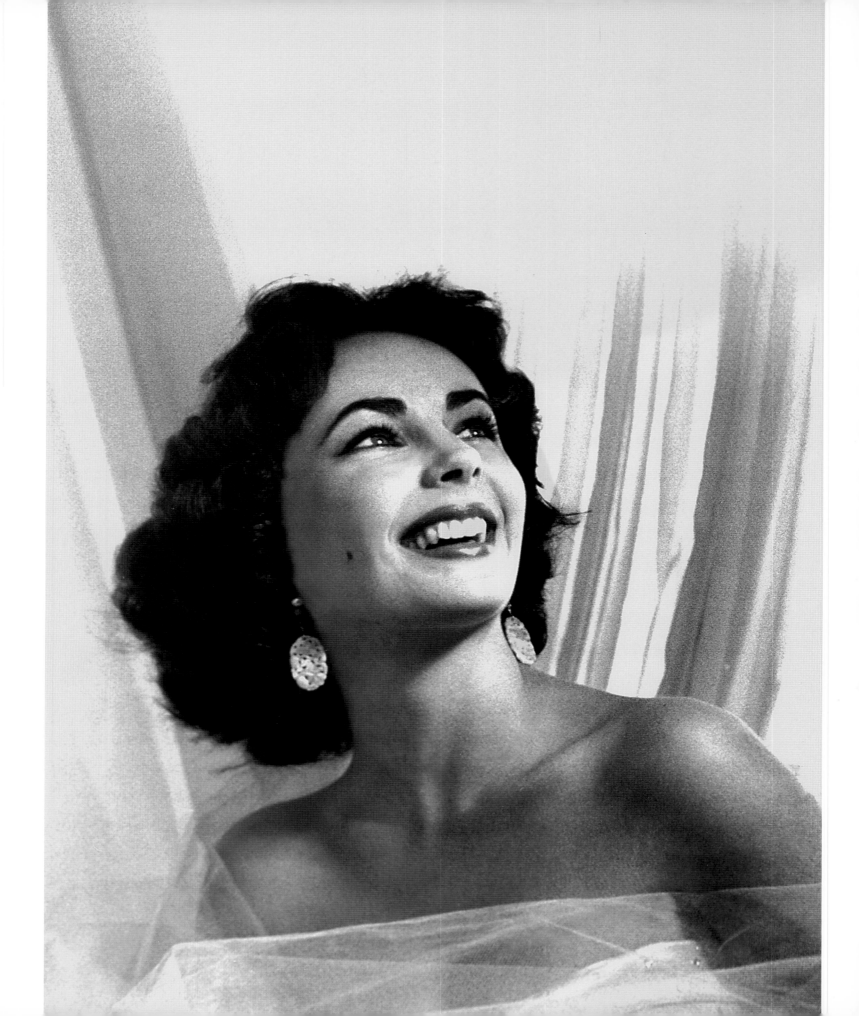

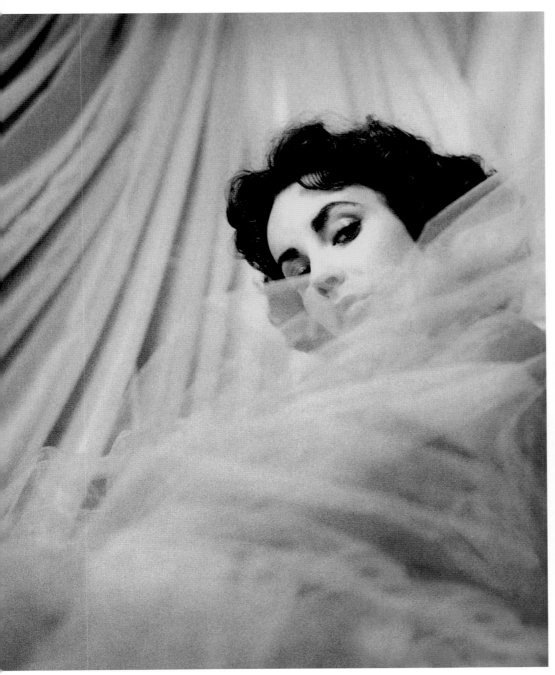

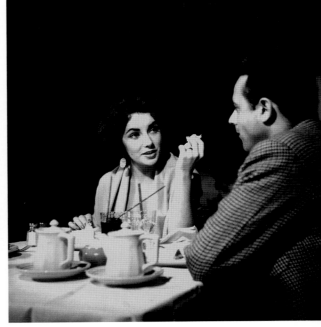

ABOVE Looking down from Mount Olympus, Elizabeth casts her eye on this mortal cameraman.

As I finished packing up the lights and was carrying out the equipment, I noticed that Elizabeth was having lunch with director Stanley Donen (*above right*). It was my guess that this was the reason she was in Palm Springs. Her marriage to Nicky Hilton had lasted only a few months and there could be no doubt about it, there would be a long line of admirers forming for Elizabeth's attention.

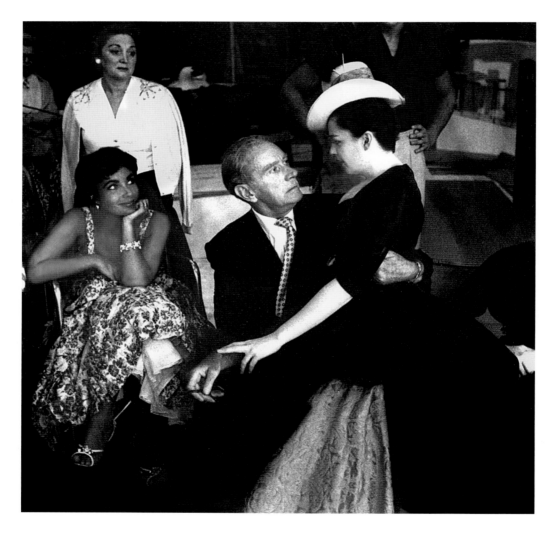

I saw Elizabeth briefly in 1954 on the final night (so they thought at the time) of filming on Warner Brothers' *A Star Is Born*. She was with a group of friends who were all there to cheer on Judy Garland, in this most important film in Judy's career. There was a great feeling of camaraderie that night, and I would observe that this support was something Judy seemed desperately to need.

ABOVE & OPPOSITE The actor Clifton Webb with Elizabeth and (*above*) Judy on his lap.

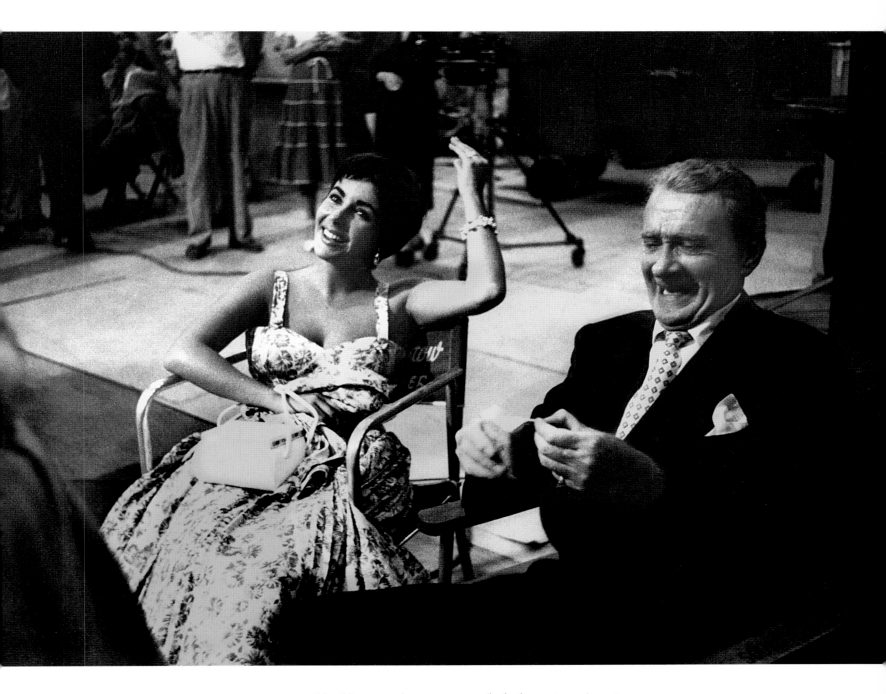

I had been working quite regularly for various American
magazines by this time, and began this film with seven different
magazine assignments. But while I was just really getting the wind
in my sails, Elizabeth had already made about two dozen films,
and was a major star.

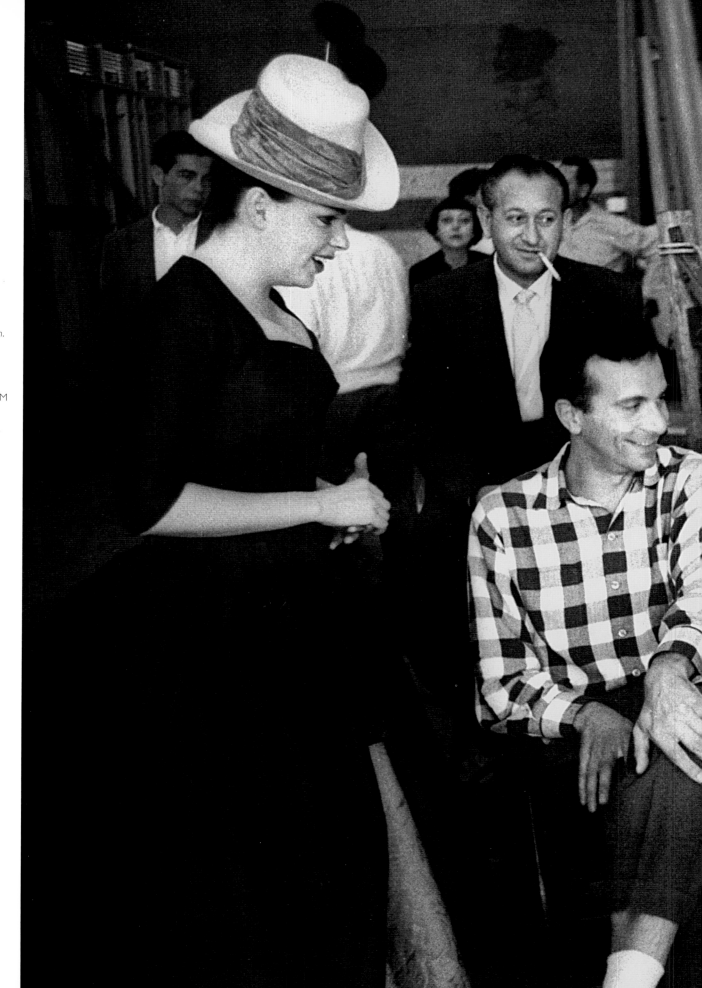

RIGHT Judy Garland welcomes her visitors on the set of *A Star Is Born*. Seated, left to right: choreographer Roland Petit, Elizabeth Taylor, and Leslie Caron. Judy, Leslie, and Elizabeth were all MGM alumni and old friends.

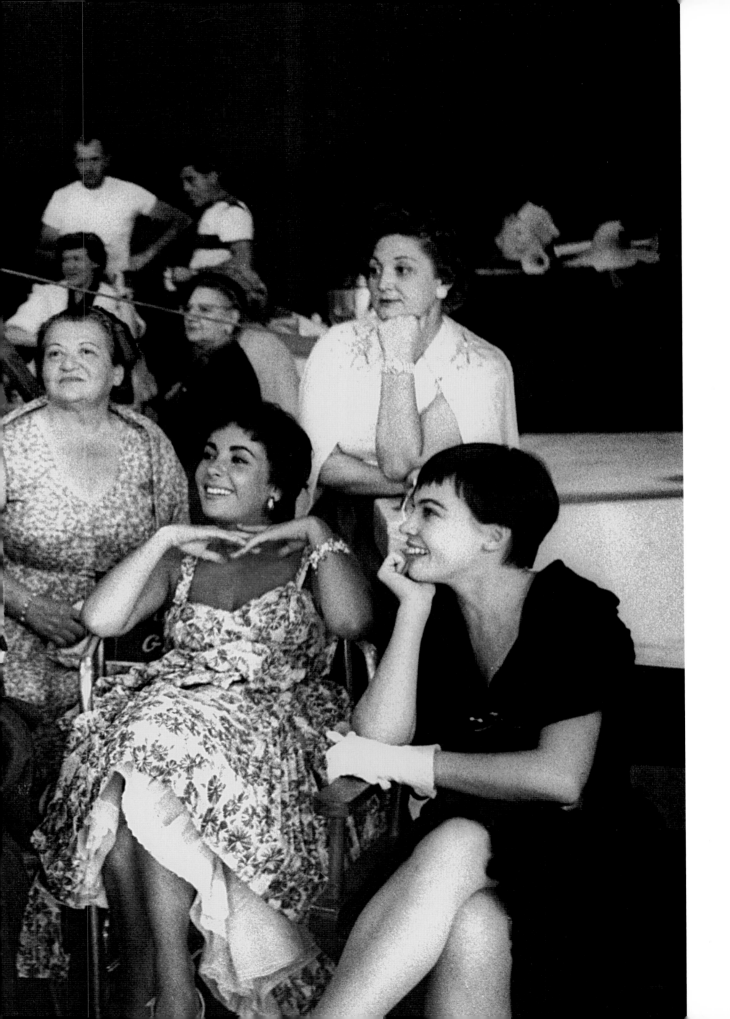

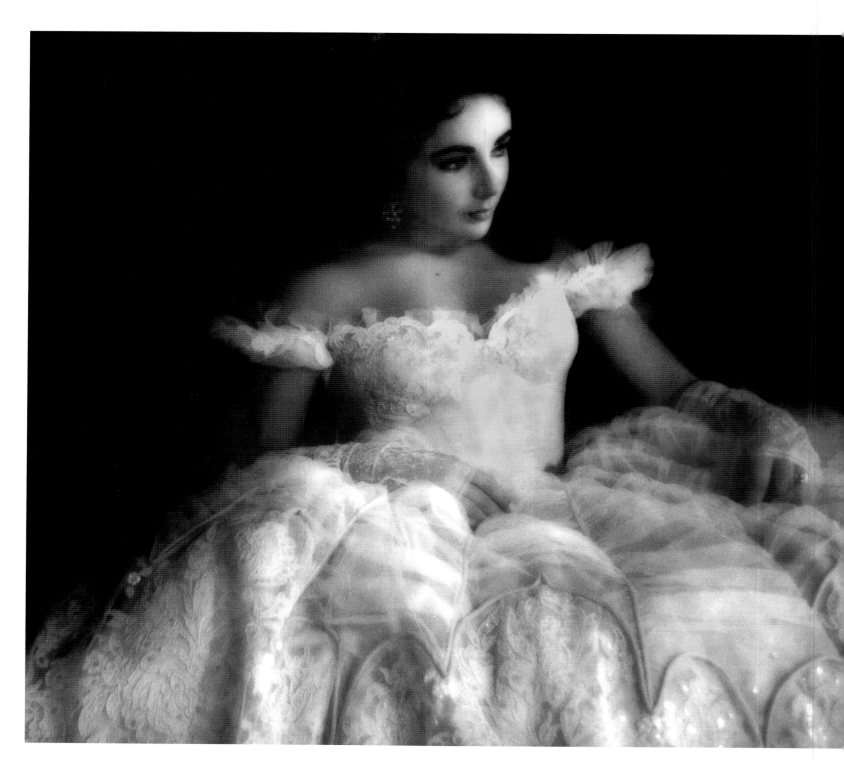

About two years had passed since the film with Judy Garland, and I was working in my office when the telephone rang. It was George Nichols from the MGM publicity department, asking me if I would like to work on their new film starring Elizabeth Taylor. It was to be a big epic; I think he compared it at the time to *Gone With the Wind*. The film was called *Raintree County*, and Nichols wanted me to cover the entire production.

I seem to remember golden beams shooting down from heaven at that moment, lighting up the room. For a freelance photographer this was a gift from the gods! It was 1956.

My name went on the permanent roster at MGM, enabling me to drive on the lot (a rare privilege), and my first weeks were spent either on the sound stage or on the back lot, where some of the action was filmed before we went on location to Natchez, Mississippi, and Danville, Kentucky.

When I arrived on the set for the first time, I saw Elizabeth quietly sitting in the shadows, wearing a heart-stopping whipped-cream confection of lace (*left*). Walter Plunkett had outdone himself in creating the setting for this almost edible young lady. *Don't move*, I thought, and scrambled to get my cameras out; *will she hold it for just a minute more?*

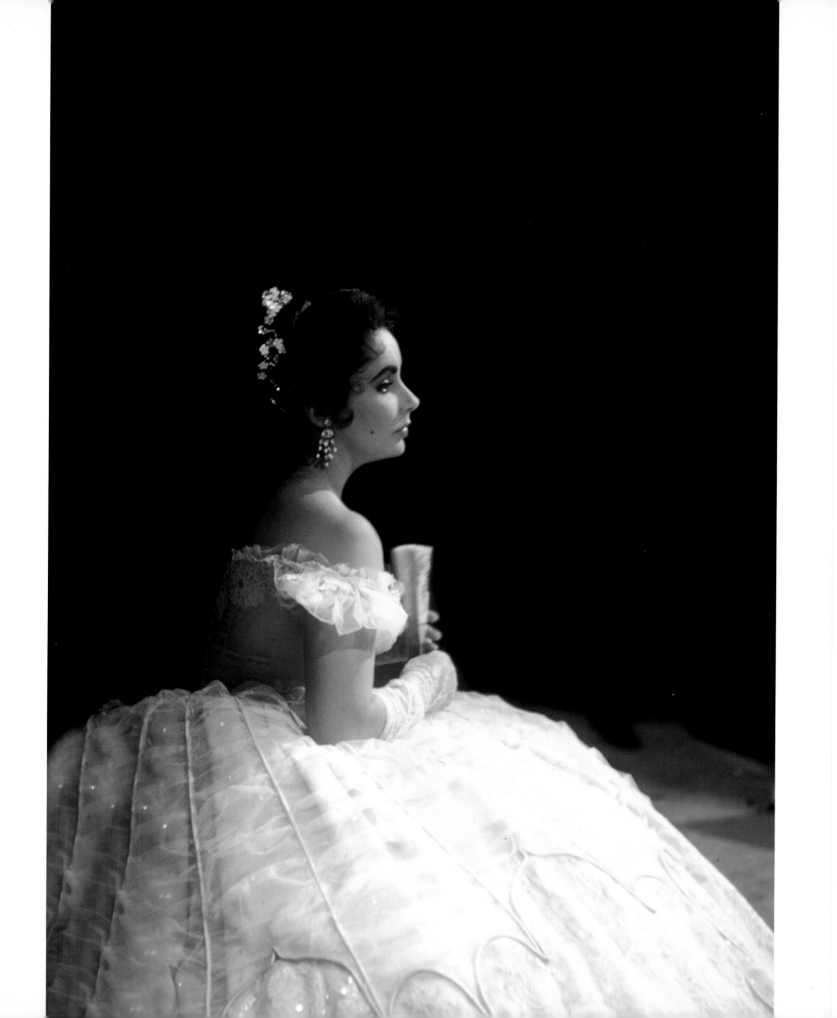

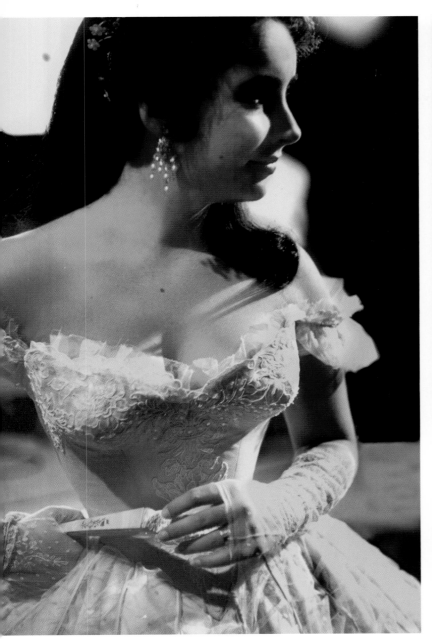
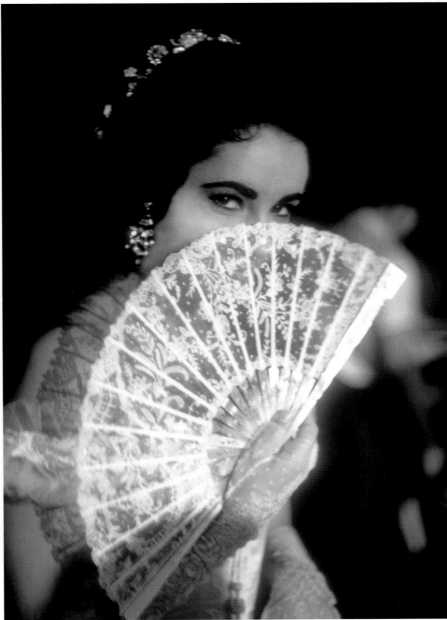

Yes, she did hold it! Could she have known I was going to photograph her, and waited? She stood up (and oh that tiny waist!), looked over towards me, posed with her fan, winked, and headed to the set, leaving me rooted to the spot. She knew … she knew I was there!

Later when I introduced myself and told her I had been assigned to the film, she seemed genuinely pleased, saying with a giggle that she remembered me.

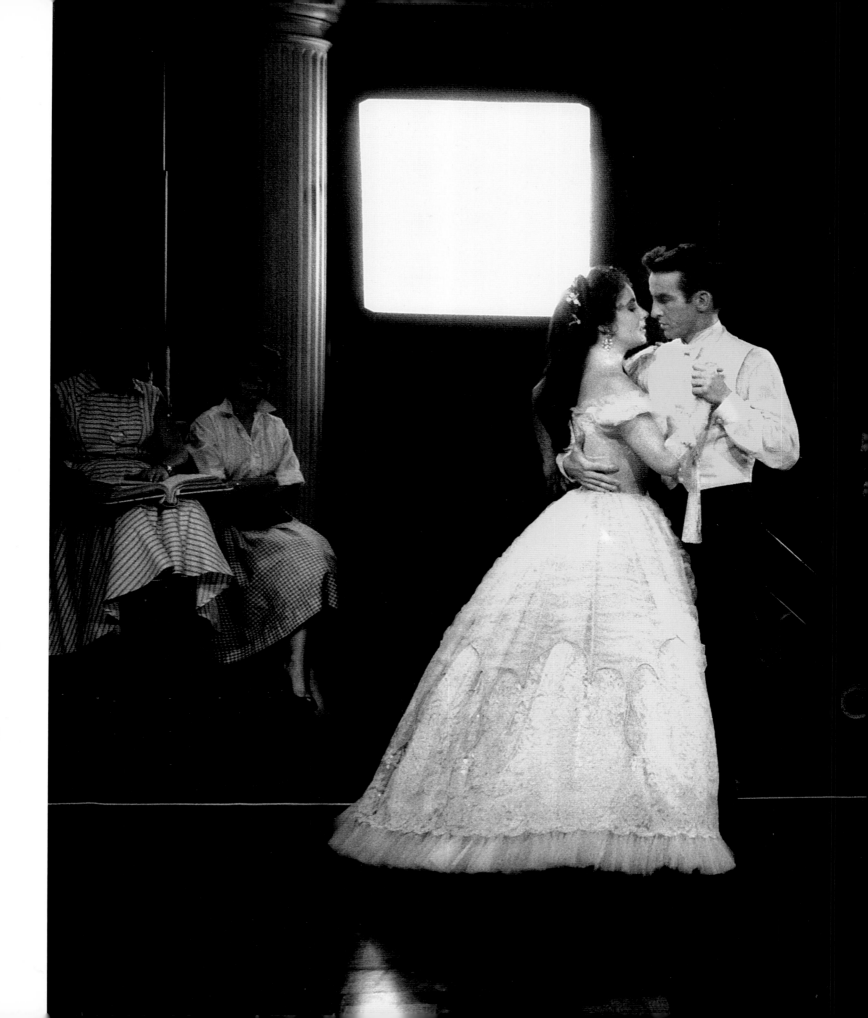

LEFT Looking at this photograph, one could believe that the two dancers moved as one, but Montgomery Clift had never waltzed before, and Elizabeth moved him slowly around the camera marks while he loudly counted "One, two, three."

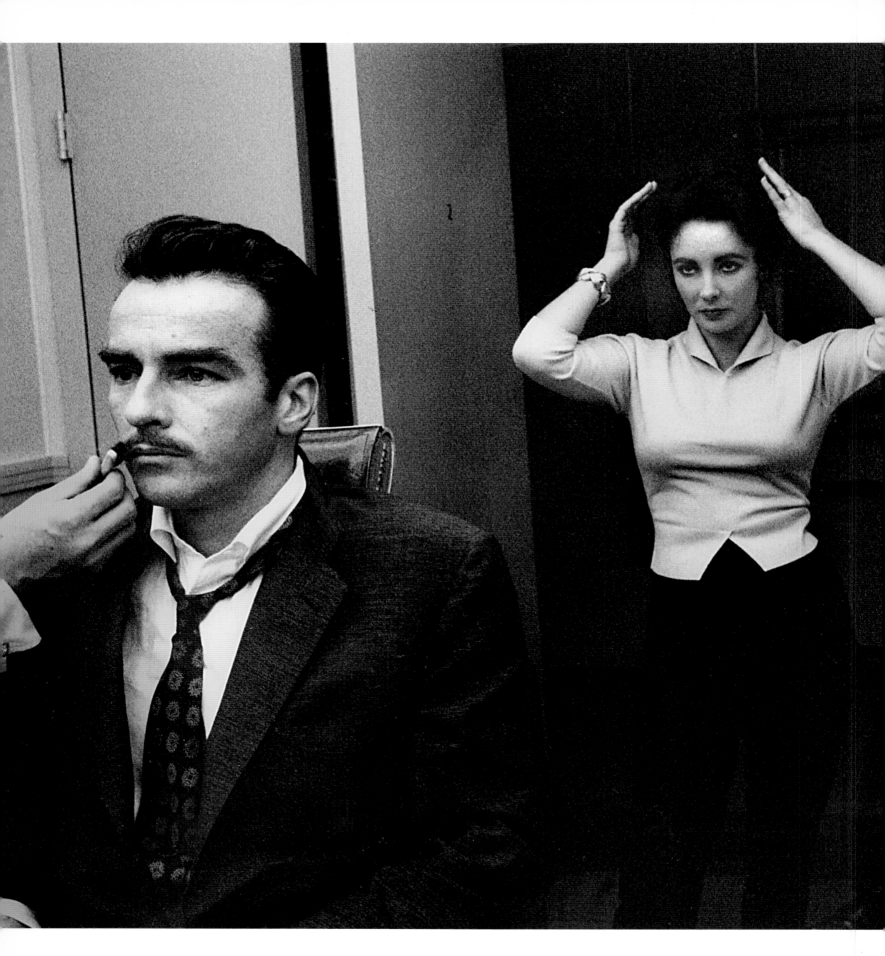

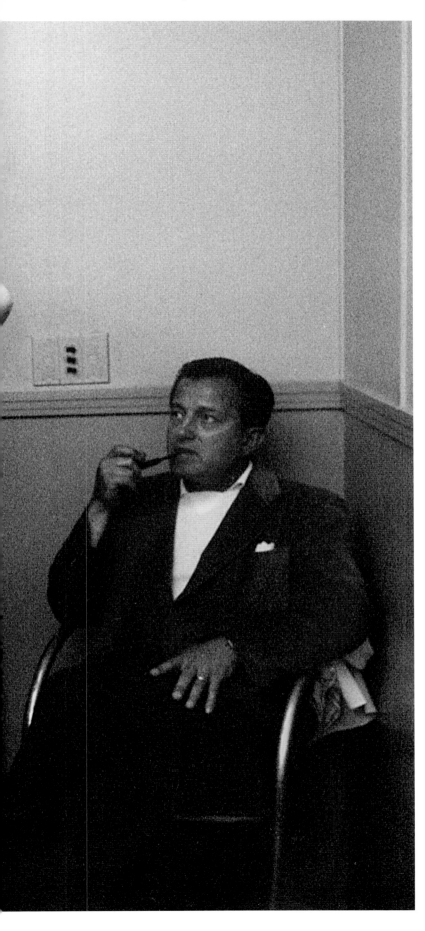

Clift was a dedicated actor, and when he was working drove everyone a bit crazy with his compulsion to do everything perfectly. Off-stage was another matter. When he was with Elizabeth, they played together like two kids. You would hear a scream across the stage and know the two of them were up to something.

Bill Tuttle, head of the MGM makeup department, needed to make some tests with various styles of mustache, which Clift would need to wear in later scenes in the film. Elizabeth accompanied him to the makeup department, where she had practically grown up and felt right at home.

LEFT As Bill tries a test mustache on Clift, Elizabeth fusses with her hair. That's director Edward Dmytryk seated at the right.

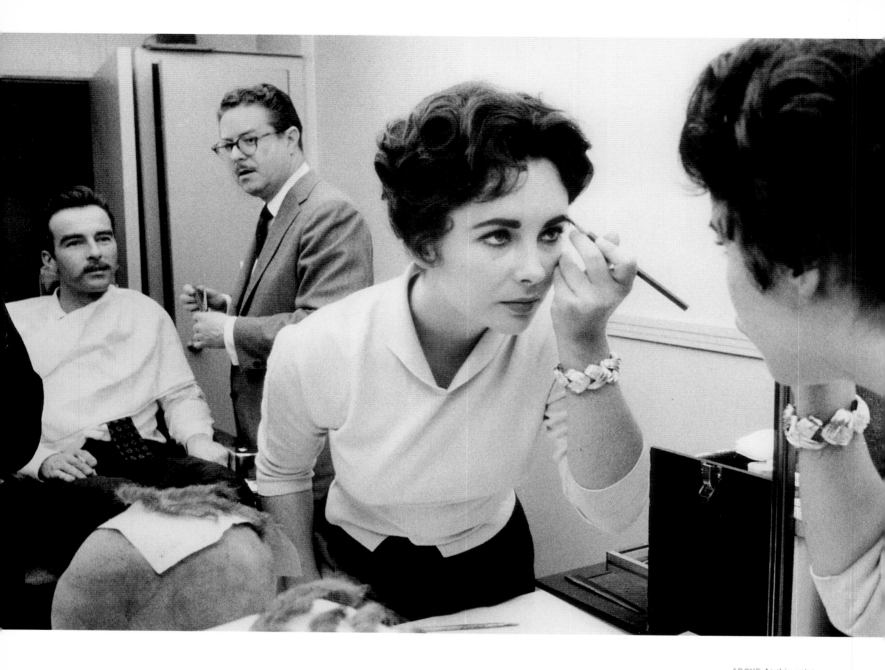

ABOVE At this point Elizabeth decides to do her makeup and takes over the mirror, so Bill Tuttle can't see how Clift looks. They all just stop their work until she finishes.

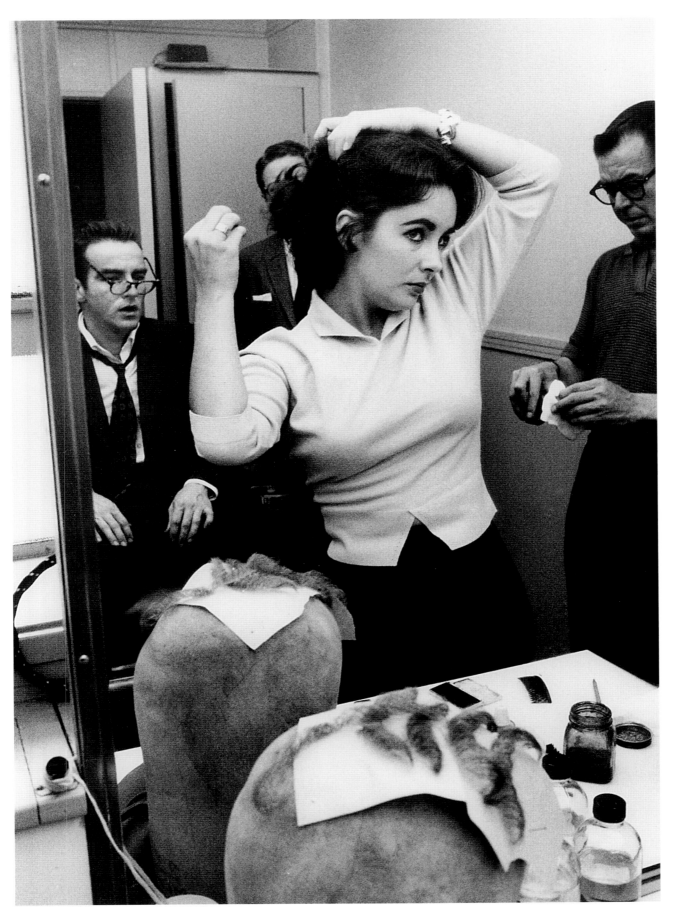

LEFT Bill has laid out
various mustaches for
Monty to try. Note Clift's
glasses askew as he gives
up, forced to wait until they
can continue.

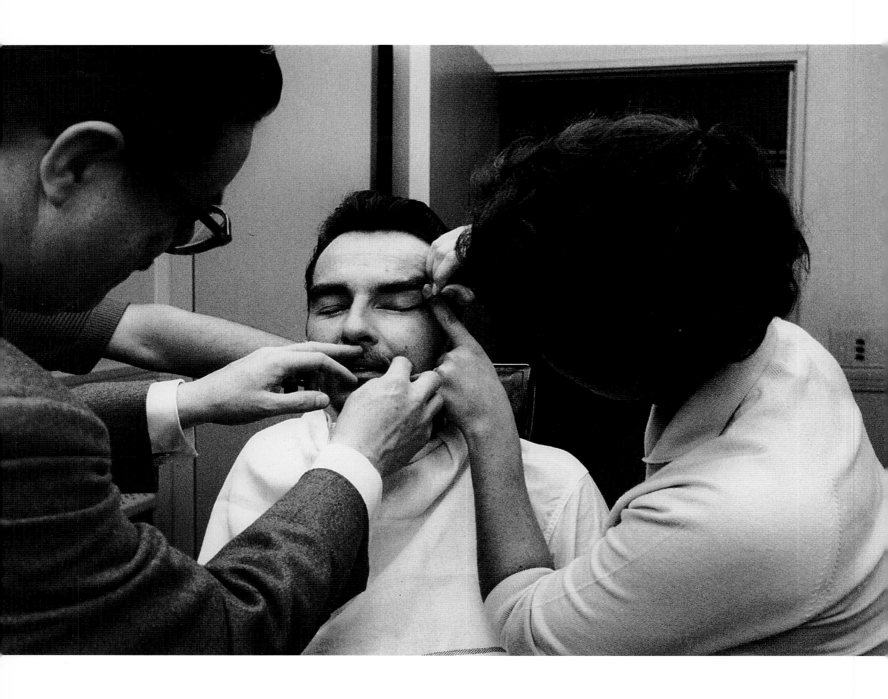

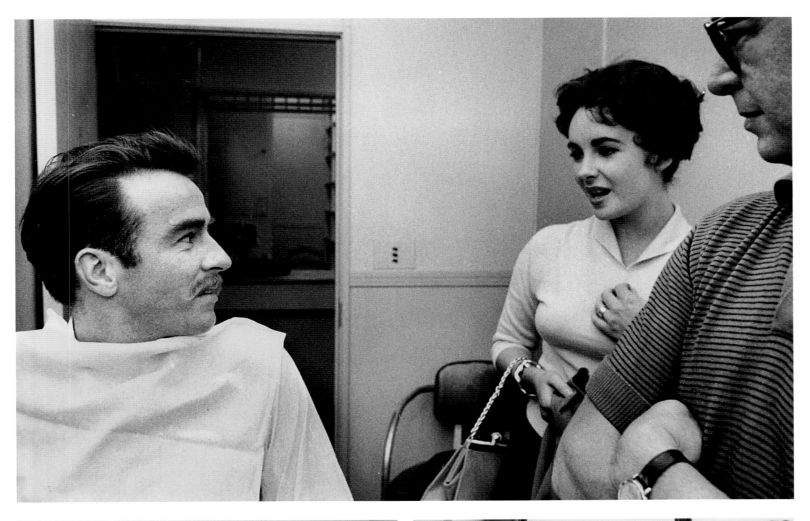

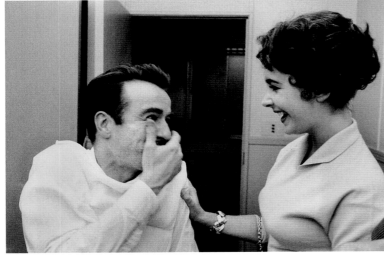

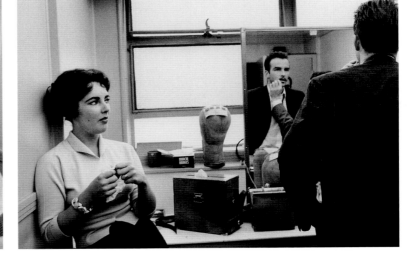

OPPOSITE Now Elizabeth decides that Monty needs eye-liner, and proceeds to apply it with enthusiasm, as poor Bill Tuttle tries to work around her.

TOP Bill has the mustache in place, and Elizabeth finally turns her attention to the business at hand: does she or does she not like Clift in a mustache?

ABOVE LEFT "Well, I like the eye-liner best of all," she advises. Clift had forgotten it was there.

ABOVE RIGHT Bill tries another mustache, which Elizabeth completely disapproves of. I think Bill finally scheduled Clift another day to decide what to use, when the two of them would be alone.

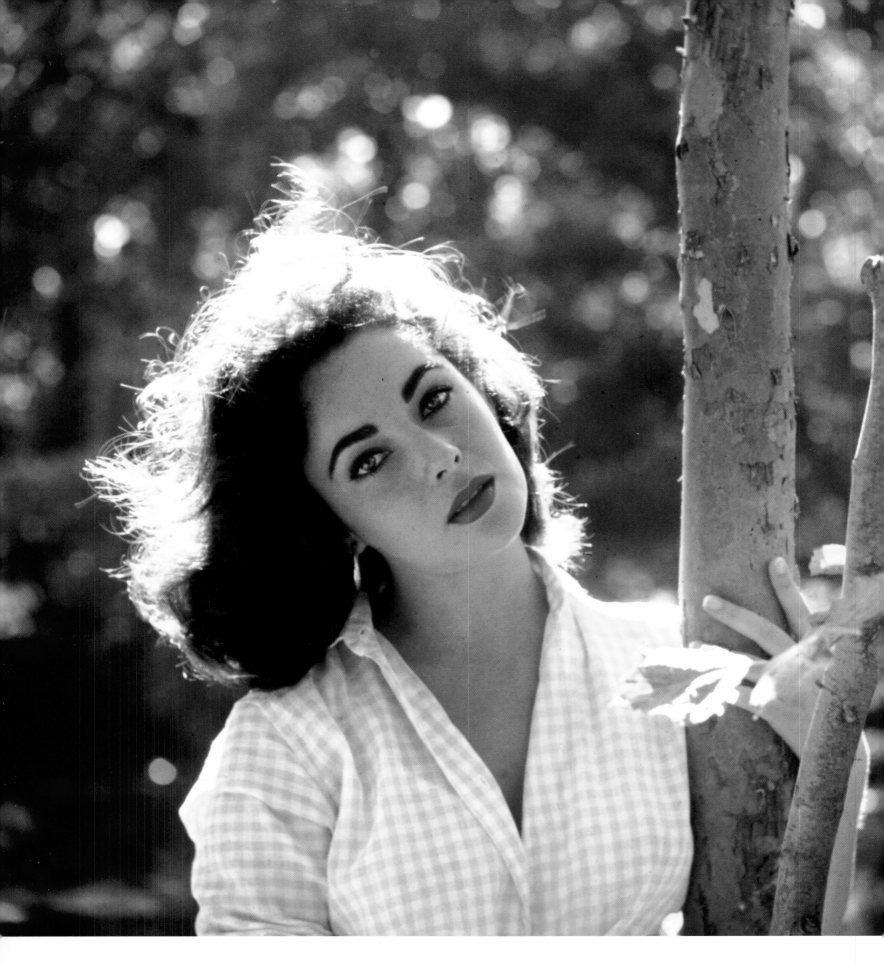

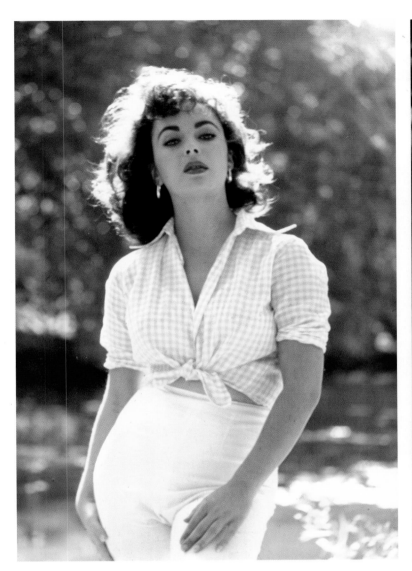
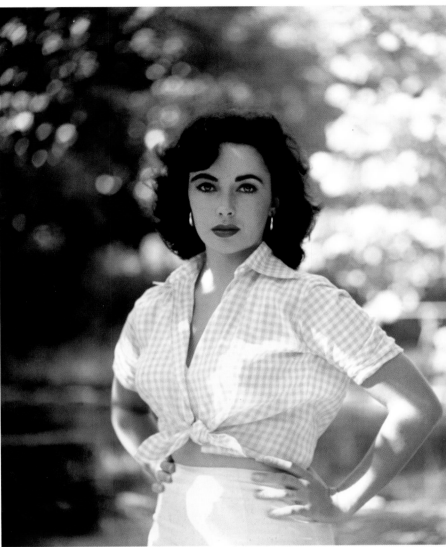

I knew that the magazines I was working for would need cover photos of Elizabeth other than those of her in costume. So we took a moment out of her schedule on the back lot, and shot these. In the end I found it difficult to select my favorite. Each shot has something different: it was amazing the magic she could work in front of a camera.

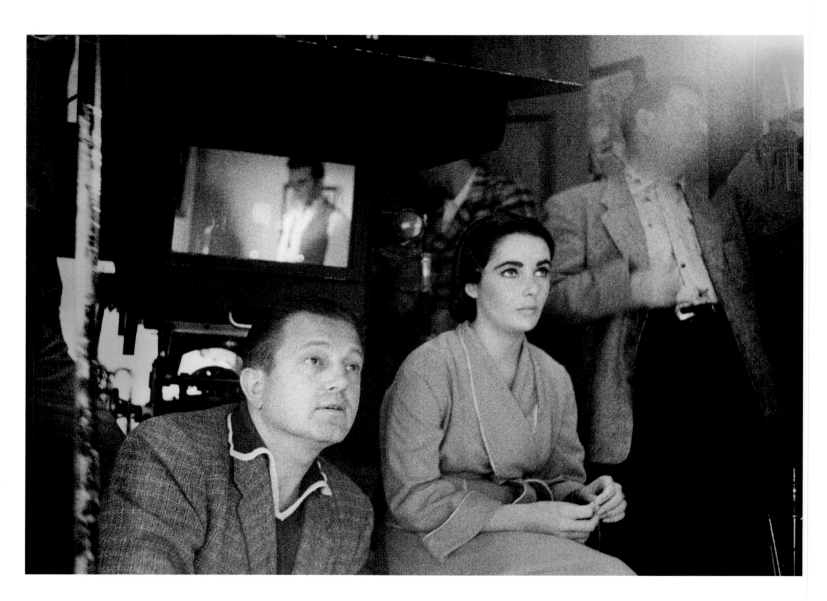

A fine and sensitive actor, Clift came to this film having already been nominated for three Academy Awards, for *The Search*, *A Place in the Sun* (in which Elizabeth also starred), and *From Here to Eternity*. He would go on to be nominated for a fourth Oscar for his role in *Judgment at Nuremberg*: an achievement most actors could only dream about. So his hard work paid off, and everyone would just wait until he felt a scene was working for him.

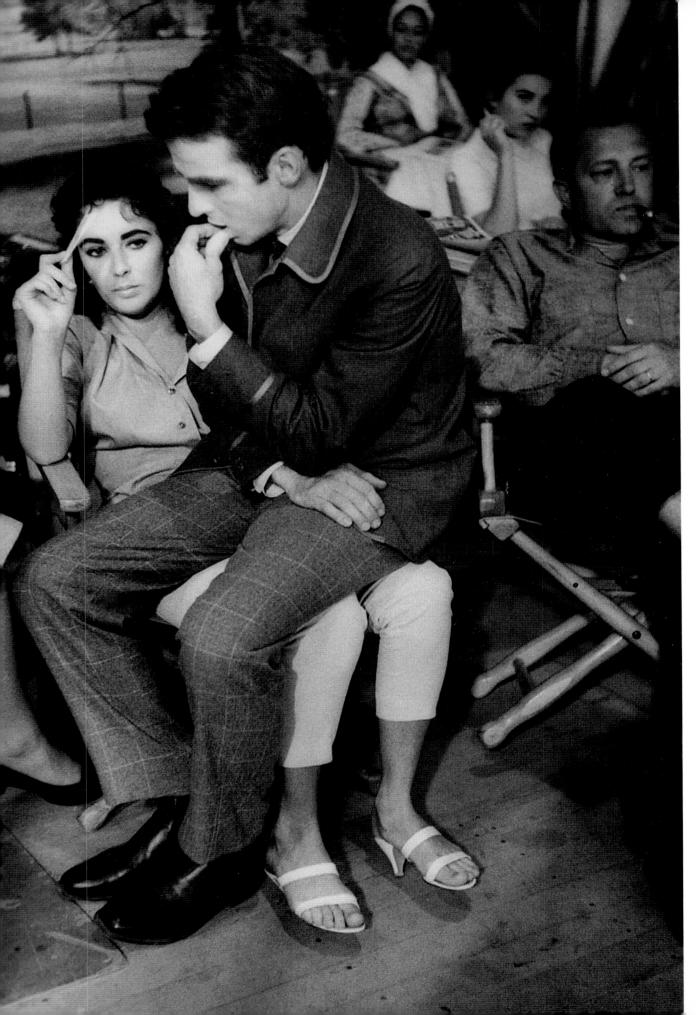

LEFT Clift continues to worry over every little detail. Elizabeth was always there for him, reading off-stage lines, fussing and reassuring him.

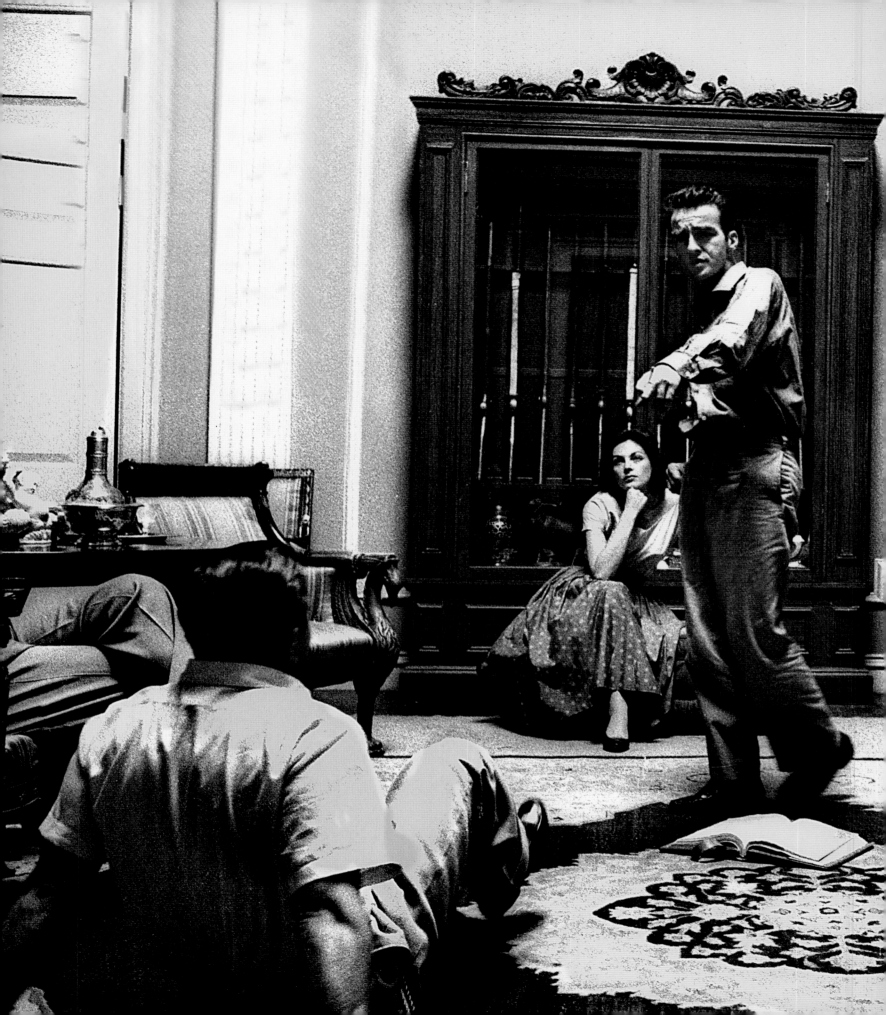

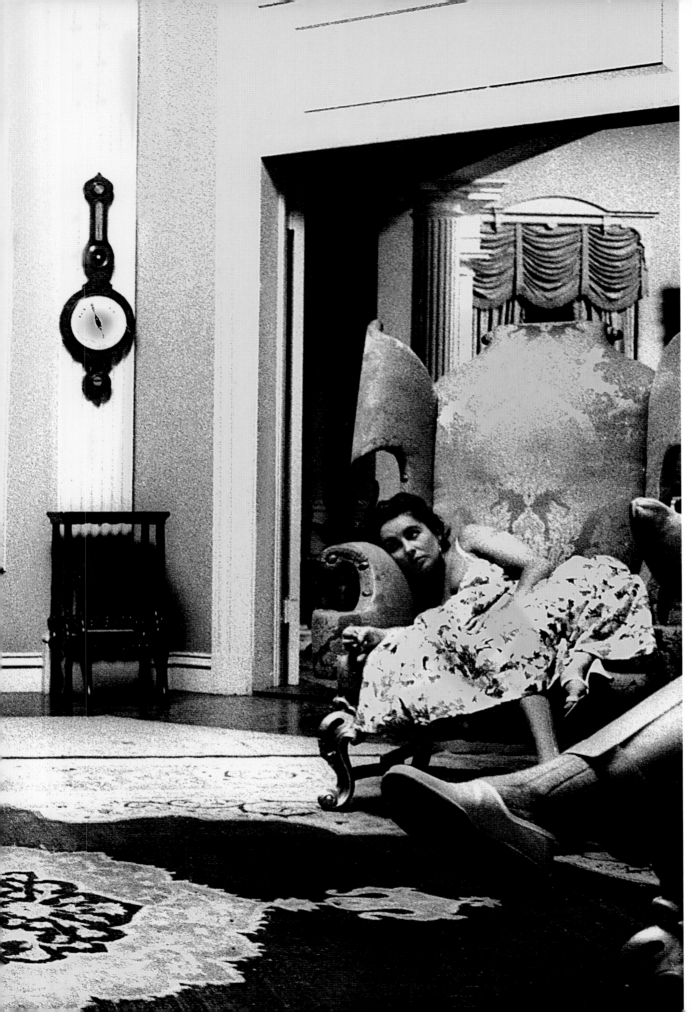

LEFT Clift explores every detail of the scene they're rehearsing, exhausting everyone. Director Dmytryk finally sits down on the floor (left foreground). Elizabeth curls up for the long haul in a chair at the right, while the other actors fall where they can.

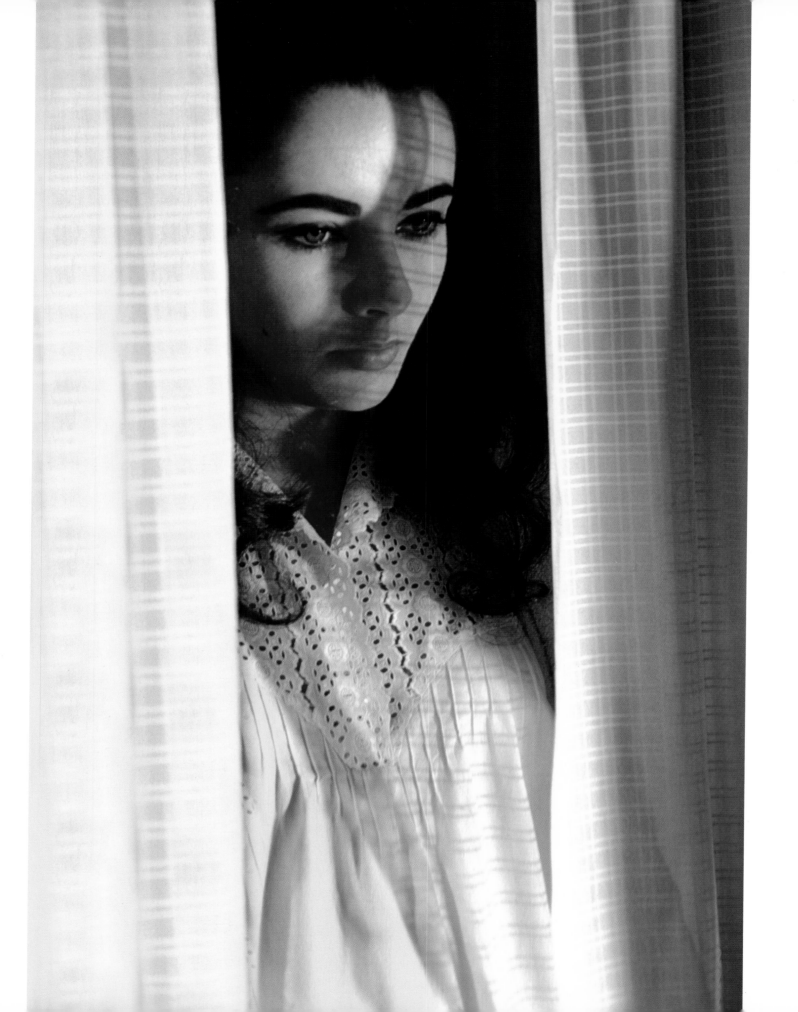

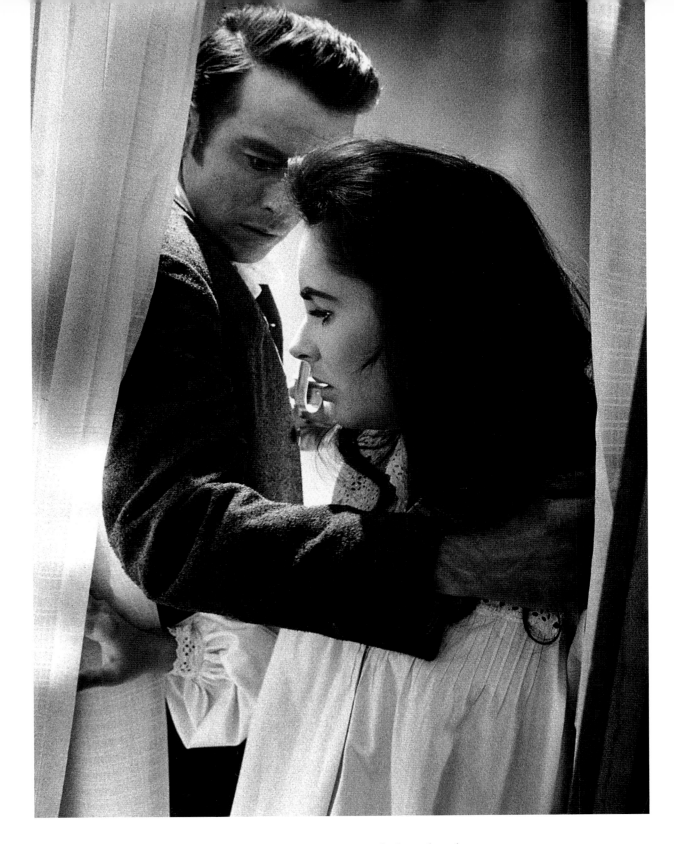

The subplot of this film at times was very dark, and in this sequence the character Elizabeth played is haunted by clouded childhood memories. The effect on her psyche leads her close to madness, and she disappears, taking their child back to the South, in the middle of the Civil War.

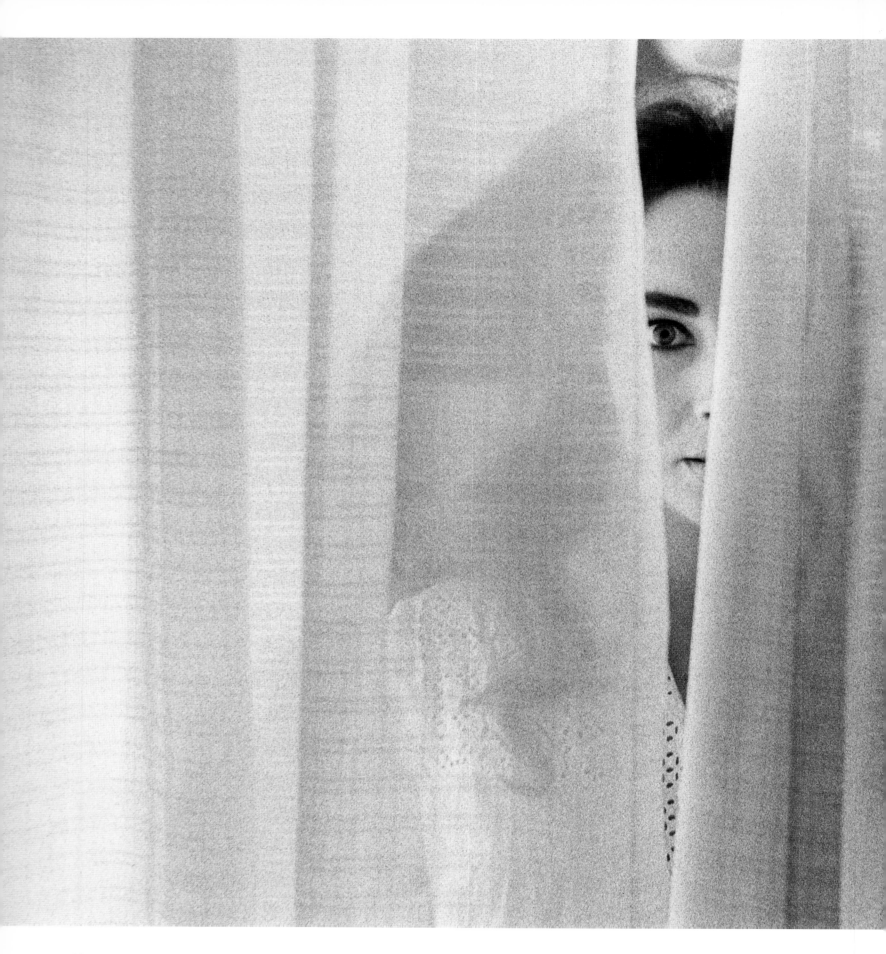

What amazed me about Elizabeth's acting was that one moment she would be relaxed, talking to Clift, and the minute the director called "action," she would slip into another mode, another mood (*left*). Clift on the other hand would be walking up and down wringing his hands, and was always anxious before a take. The difference between them was notable.

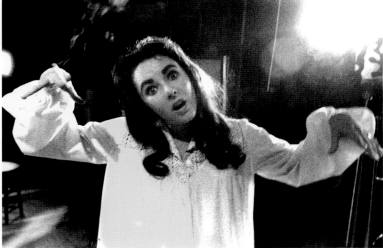

ABOVE I think I got a little too close photographing Elizabeth during this scene (*left and previous page*), and here she makes that point clearly. A lesson learned, which I never forgot then nor on any future film.

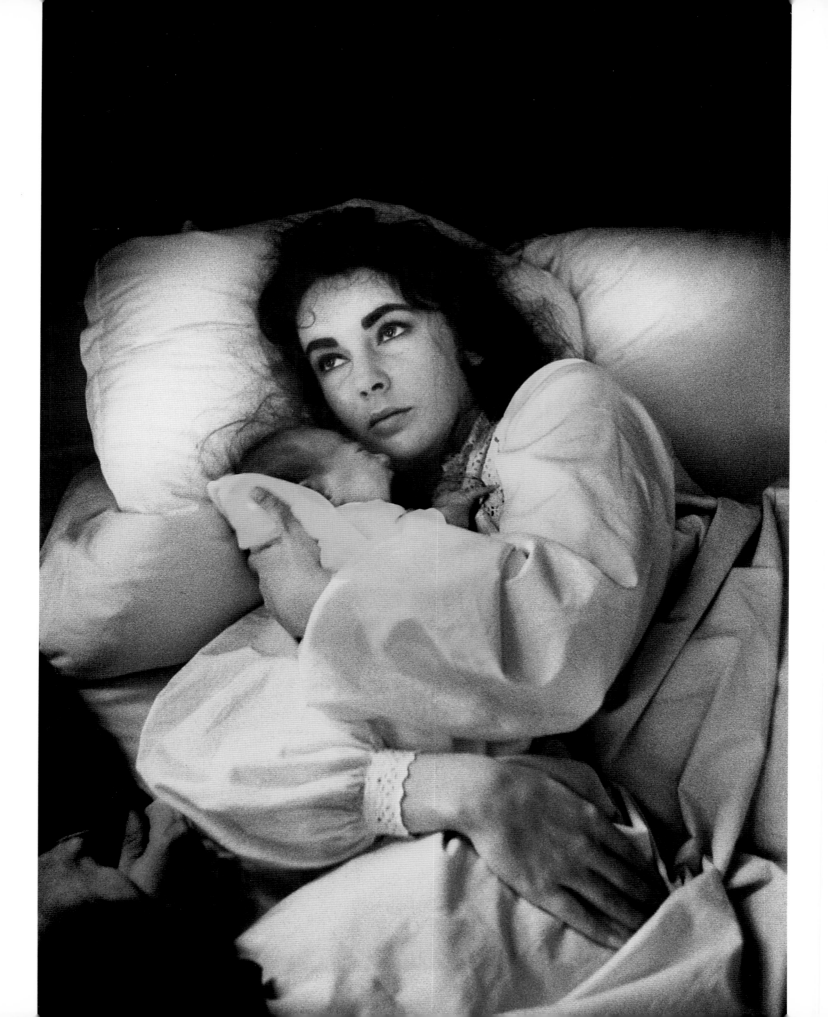

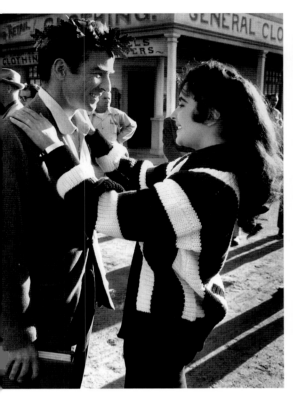

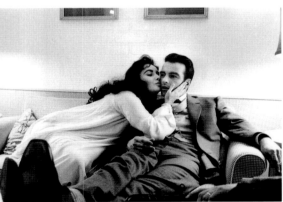

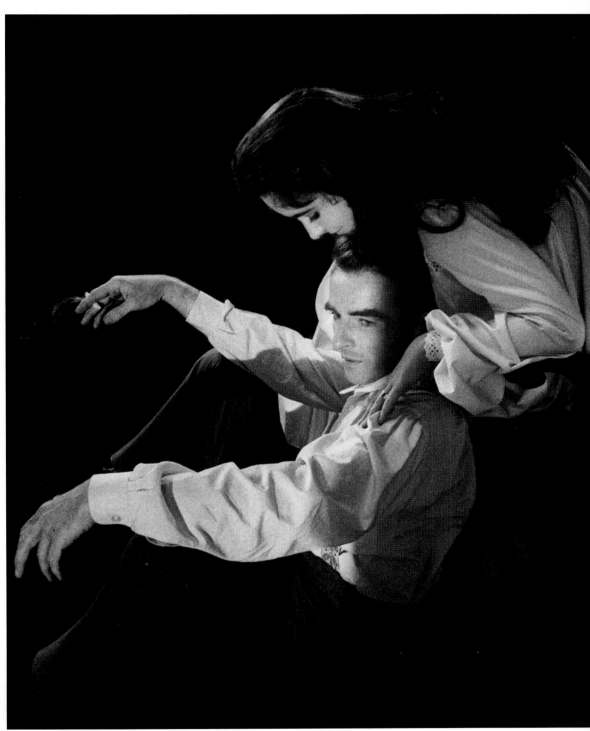

Elizabeth received an Academy Award nomination for her performance in *Raintree County* as a slightly deranged Southern wife and mother (*opposite*). This mothering role reasserted itself in real life, as she watched over Montgomery Clift.

RIGHT Then a tragic thing happened. Returning from a party at Elizabeth's, Montgomery Clift crashed his car, and his face was smashed up so badly that MGM closed the production down for several months, while hoping that the plastic surgeons would work miracles for them.

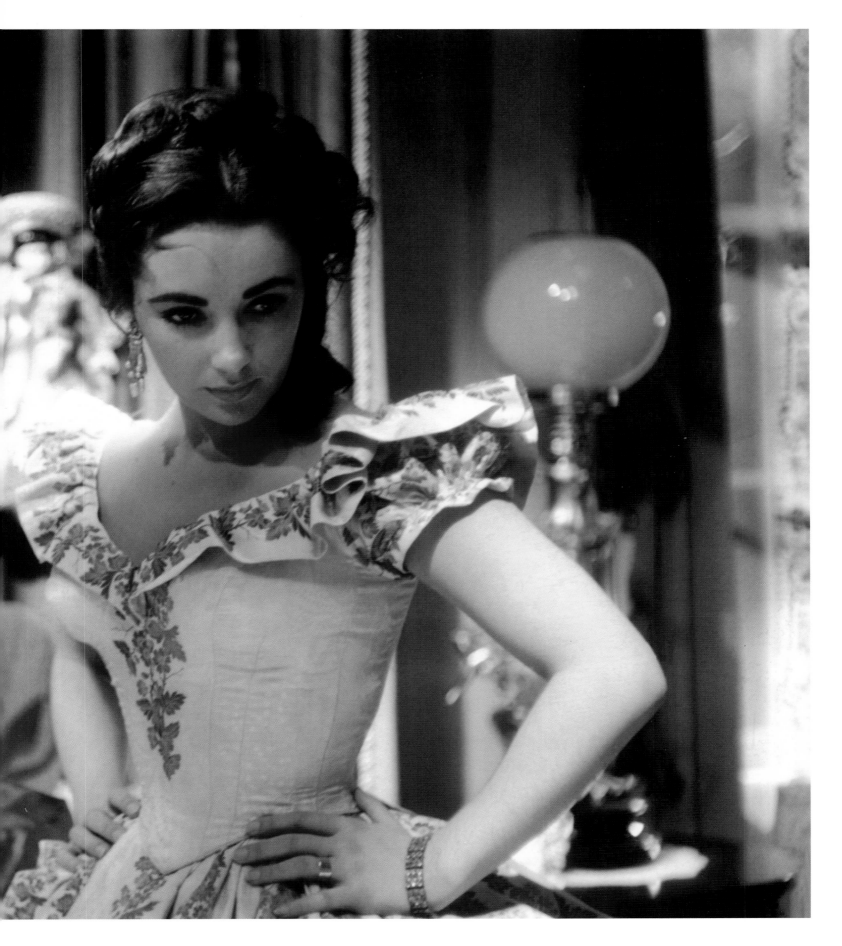

When Clift returned (*above*), he told me they wired his jaw shut for months. He never looked the same, and it affected him for the rest of his life (he died at forty-five). If he had been a little off the wall before, the pain medicine he took now made him even more eccentric. He tried his best to hold on through the rest of the film.

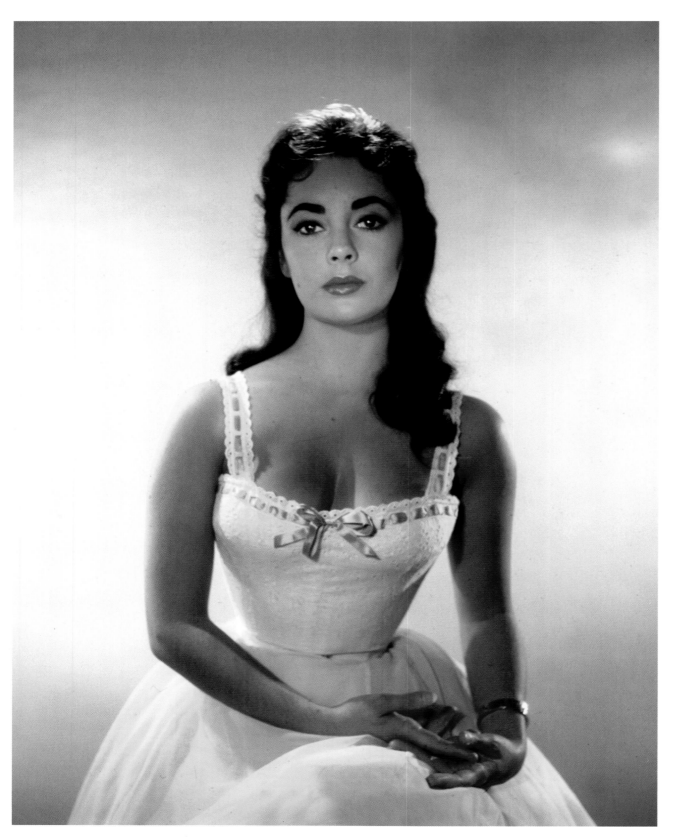

LEFT & RIGHT In the film there was a scene in which Elizabeth's character goes to the local portrait photographer, which gave me a marvelous opportunity, as these photographs show.

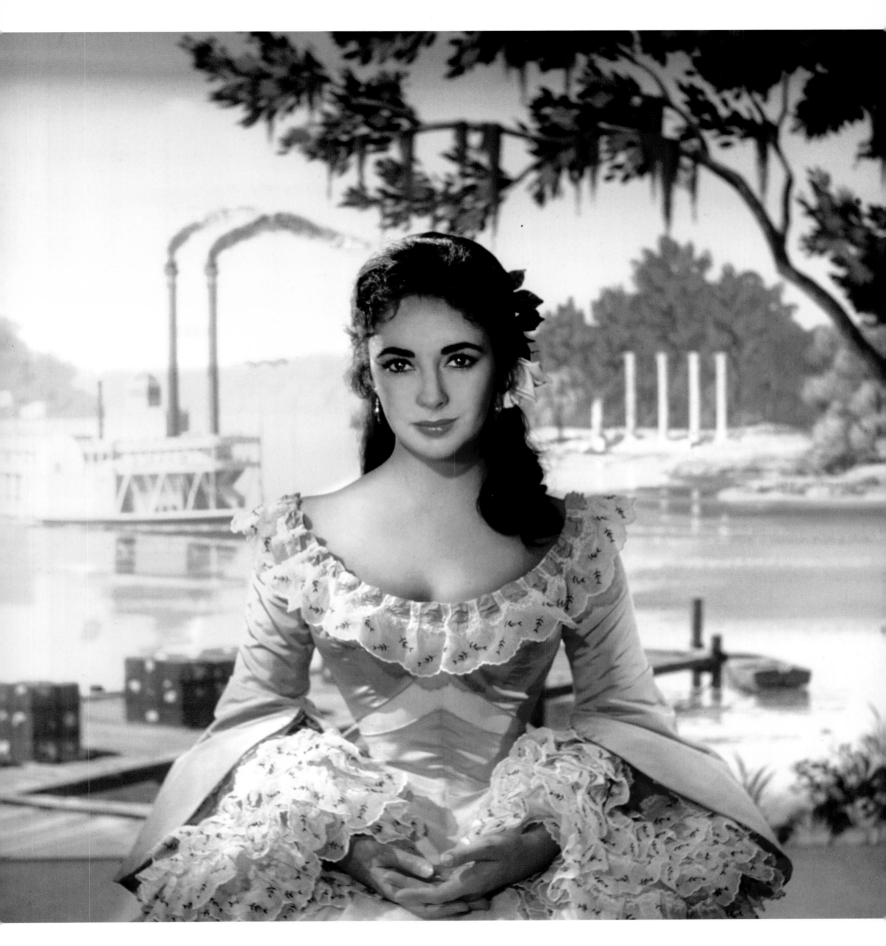

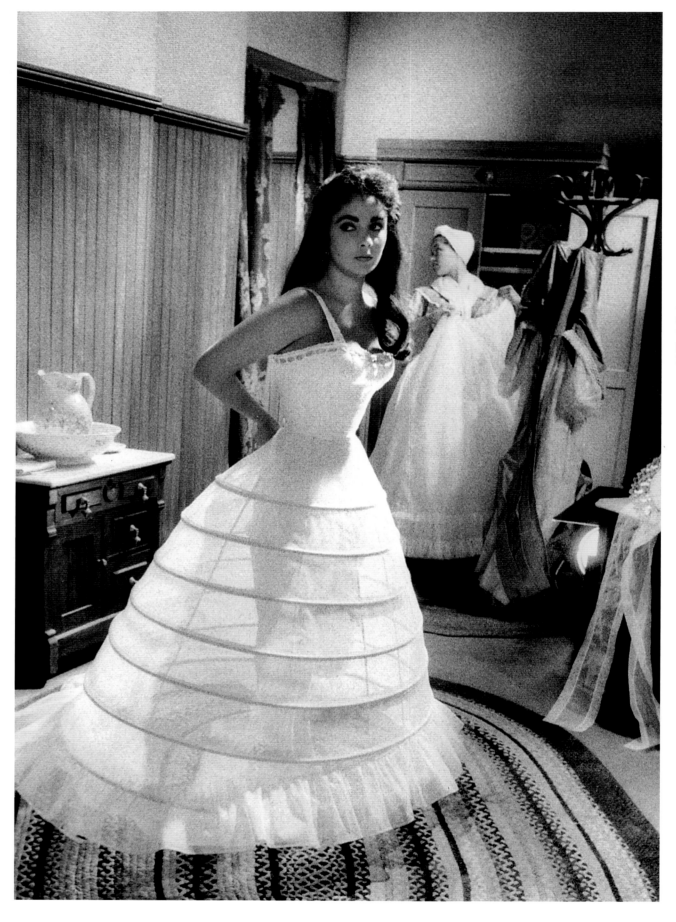

LEFT, RIGHT, & OVERLEAF Elizabeth dressed in her camisole and period hoop skirt was just too irresistible for me not to take as many photographs of her as possible.

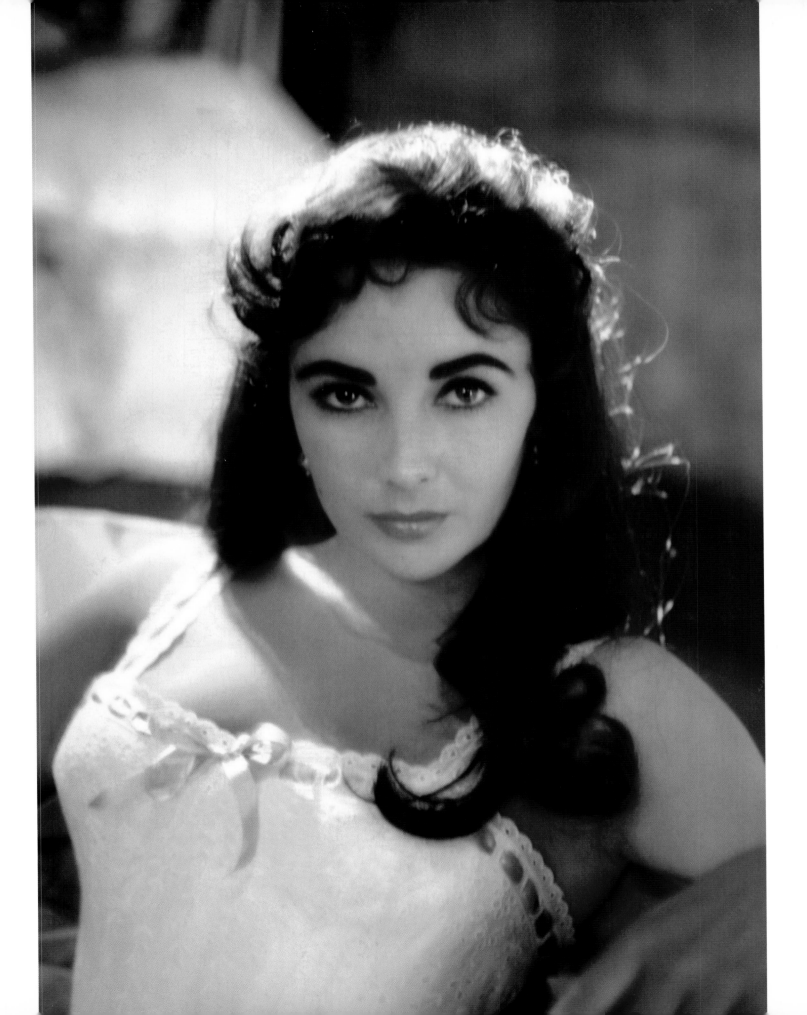

PLEASE
DO NOT
THROW TRASH
IN
TRACK PITS

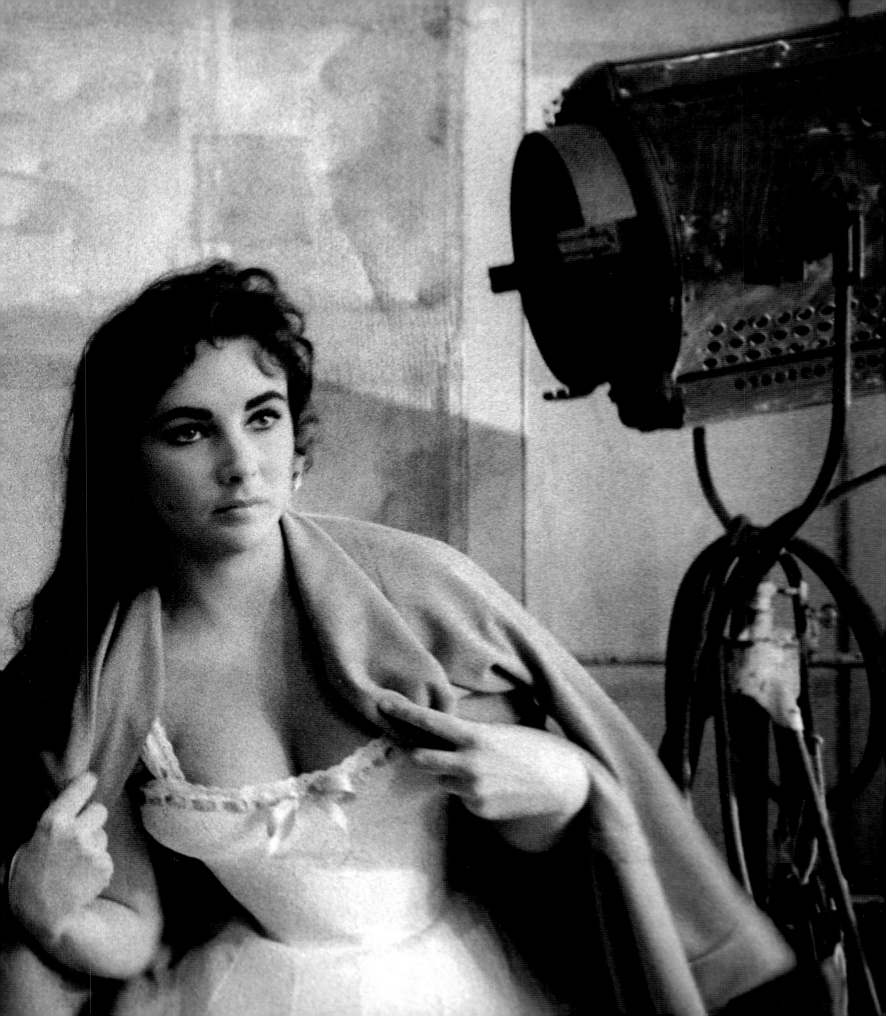

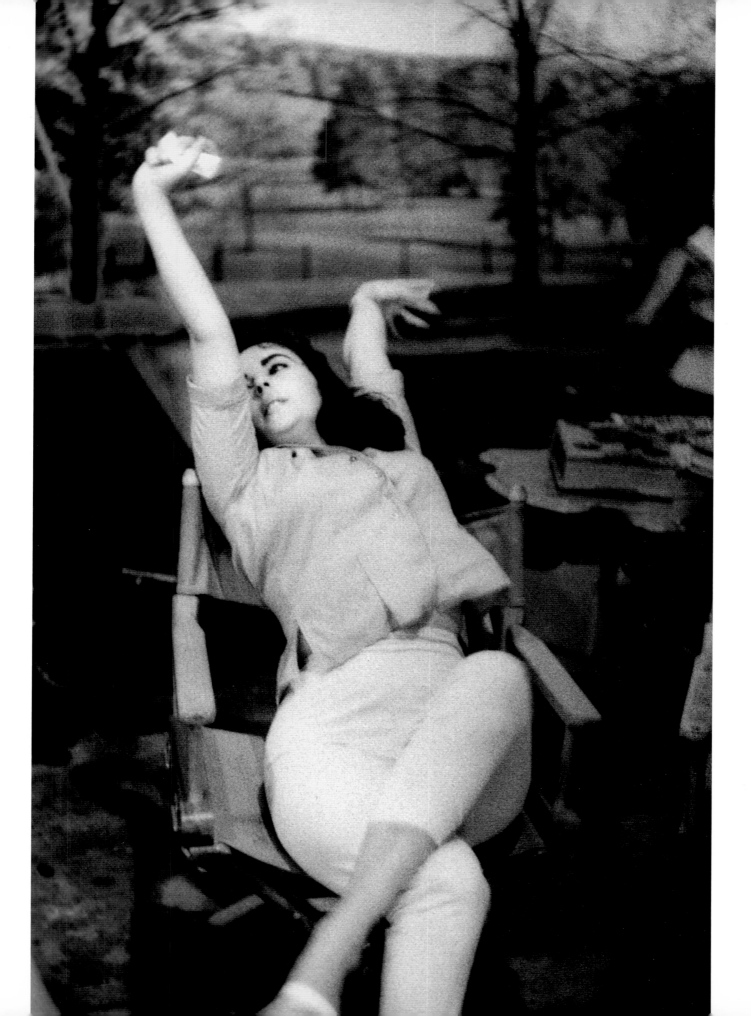

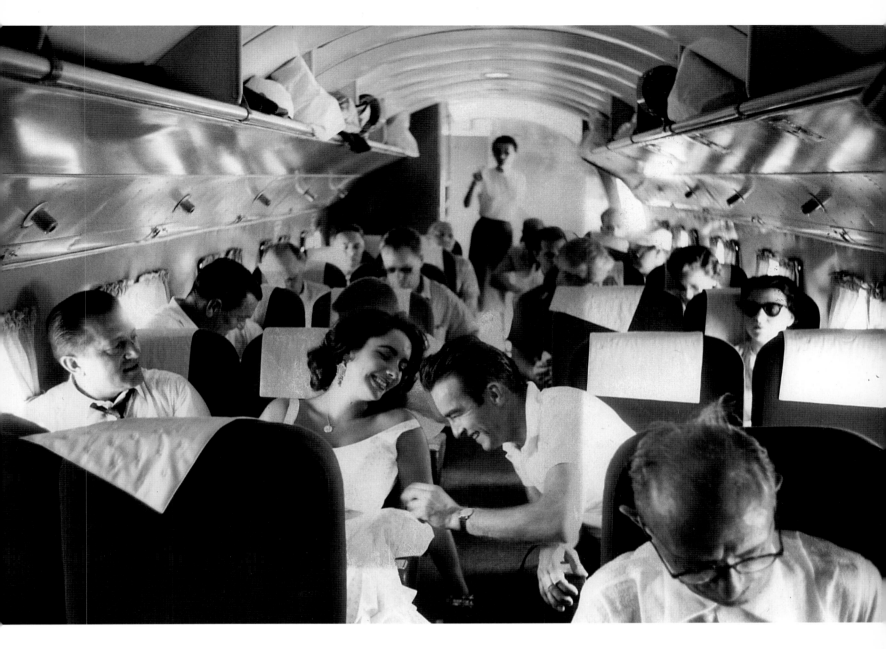

Then it was time to fly to Natchez, Mississippi, for the first film location (*above*). Elizabeth and Clift were in good spirits, I think just because they were doing something different and getting away from the MGM sound stages. Director Edward Dmytryk (seated next to Elizabeth) could never figure out what they were always laughing about. But Elizabeth was keeping Clift happy and on an even keel.

Getting off the plane in Natchez, the humidity was so high that it felt like walking into a wet sponge. Obviously no one had anticipated this, especially costume designer Walter Plunkett. The problem for Elizabeth and the other ladies was that the costumes were very heavy and they were laced tightly into them. At times it became hard for them to catch their breath.

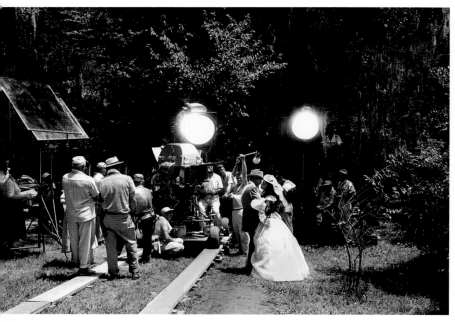

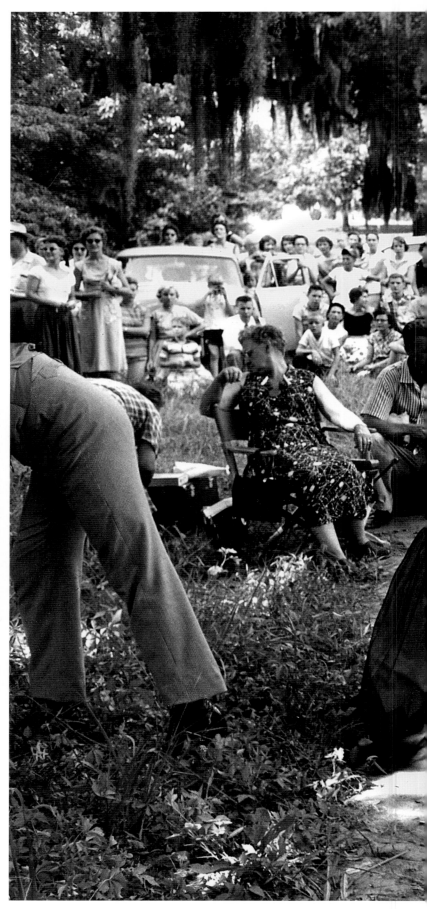

ABOVE The heat was intensified when they were actually filming. The studio lights and reflectors could raise the temperature an extra ten to fifteen degrees.

RIGHT The crew set up a fan for Elizabeth and Jarma Lewis but it was obvious they were suffering.

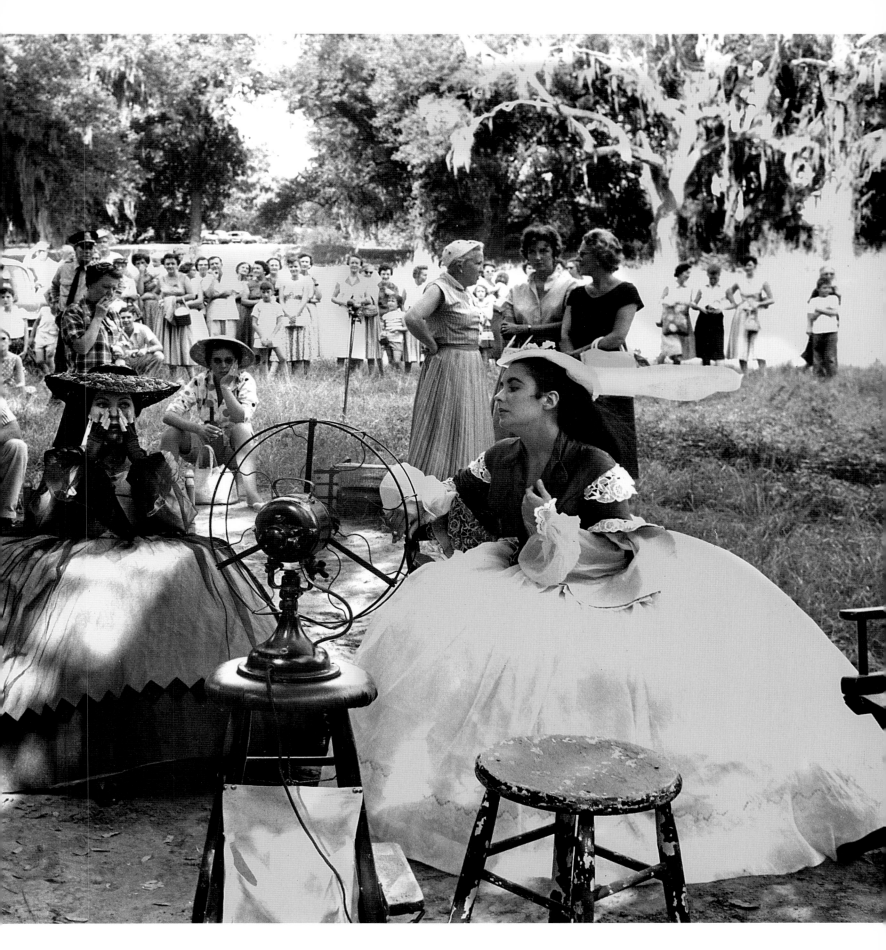

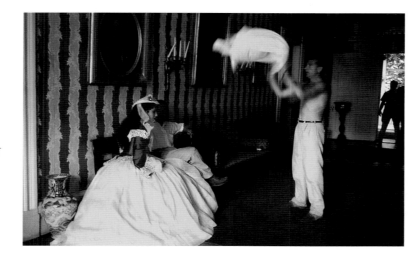

ABOVE Out of the heat of the sun and studio lights, Elizabeth sits quietly with Edward Dmytryk, trying to catch her breath, while screenwriter Millard Kaufman fans her with his shirt.

BELOW Elizabeth is put to bed, with Millard standing guard so no one would disturb her.

In fact Elizabeth did faint once from the heat, causing headaches at head office; and they briefly stopped filming all of the scenes that included her. For the rest of their time in Natchez, they watched over their star very closely.

RIGHT Elizabeth napped whenever there was a break in the production.

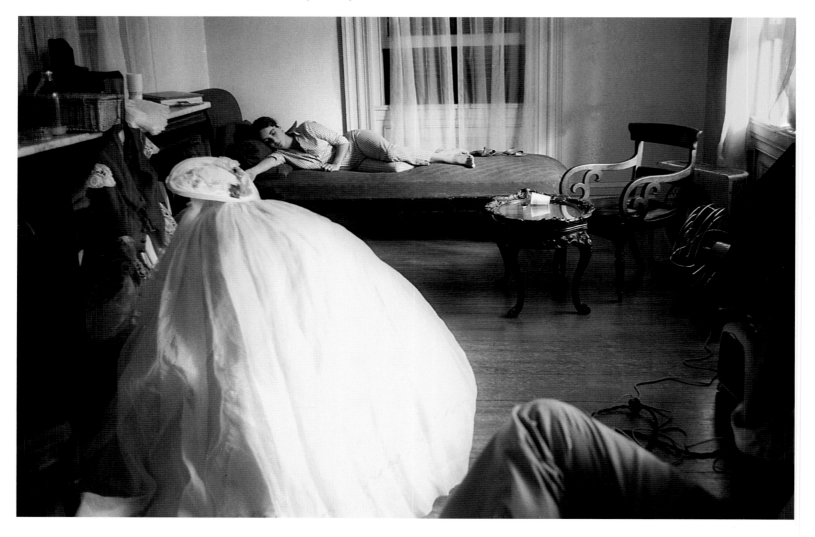

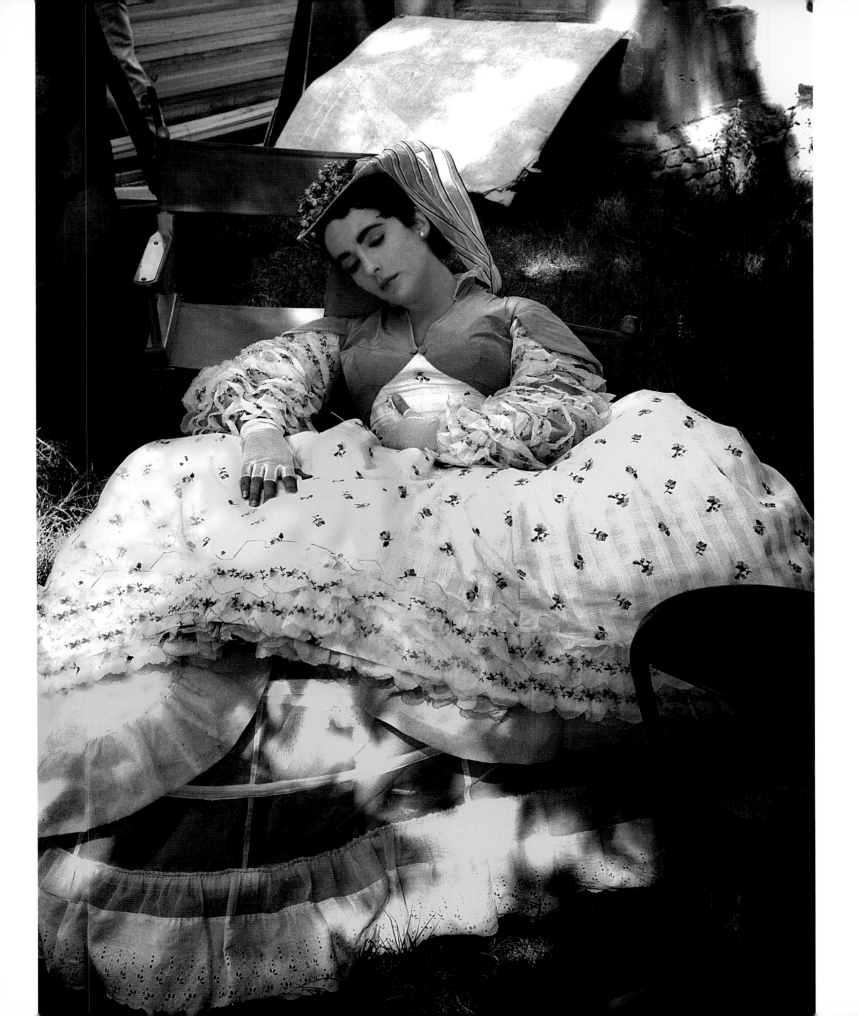

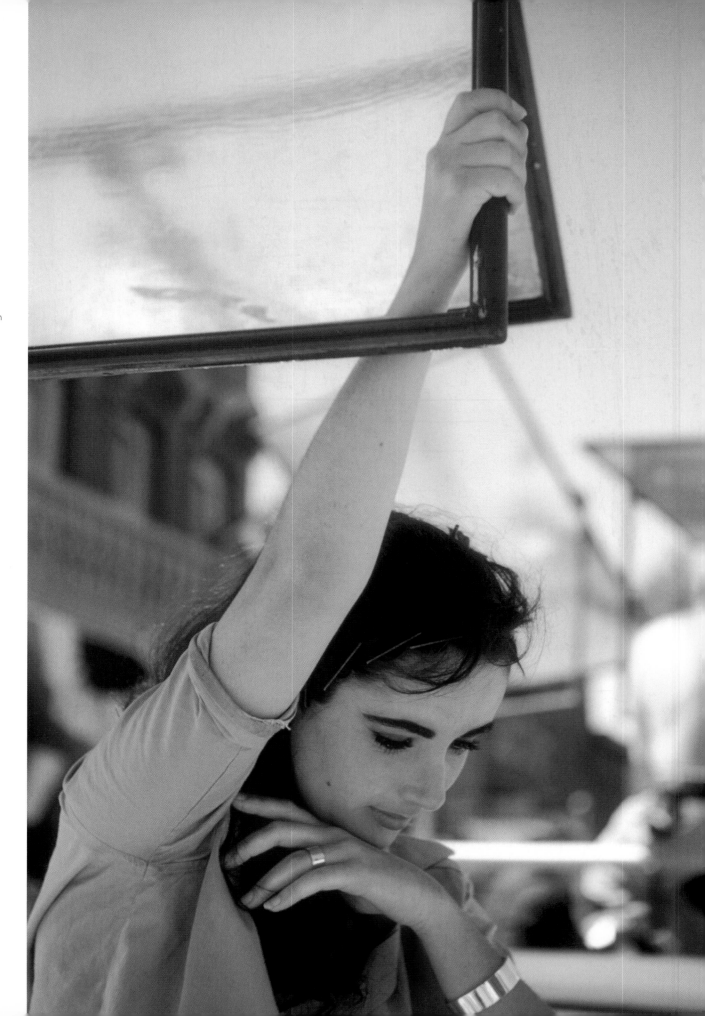

RIGHT Elizabeth stands in the shade of a studio reflector while she waits for rehearsals.

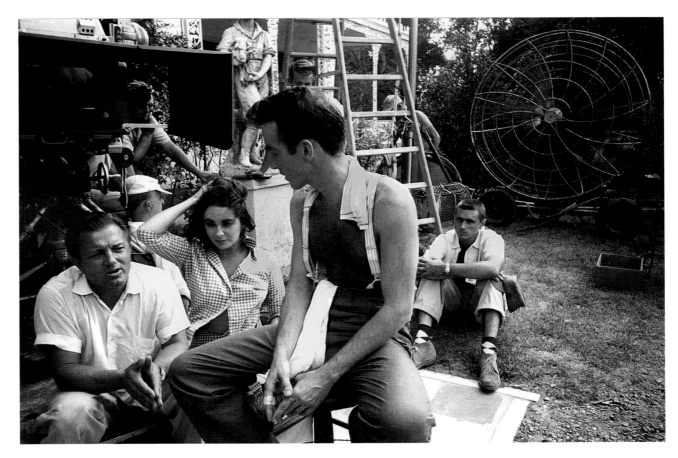

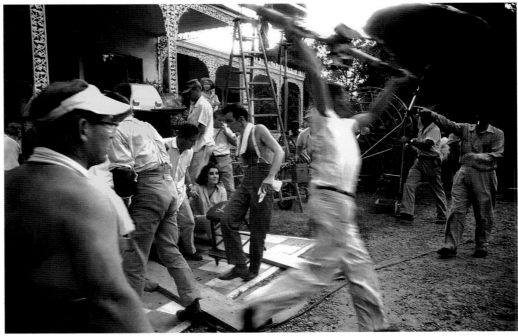

Heat wasn't the only trouble on this location: sudden summer storms were a problem too. One minute you could be sitting by a large fan to keep cool (*top*), and the next minute you and the crew were scrambling to get the camera and the other equipment under wraps (*above*).

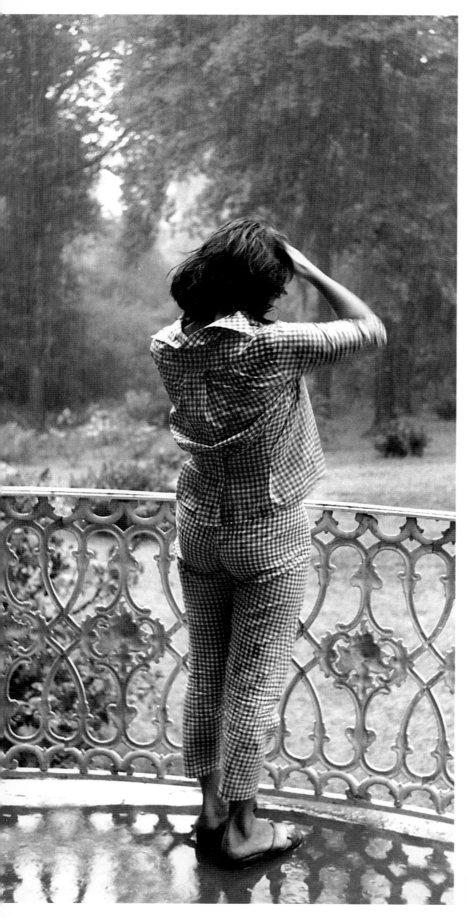

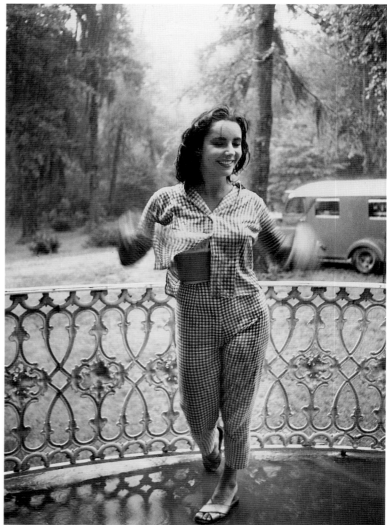

THESE PAGES With the cooling rain, Elizabeth couldn't resist jumping right in.

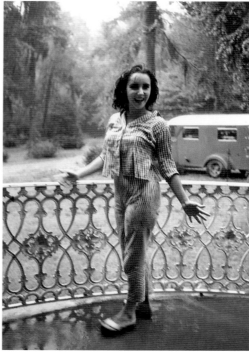

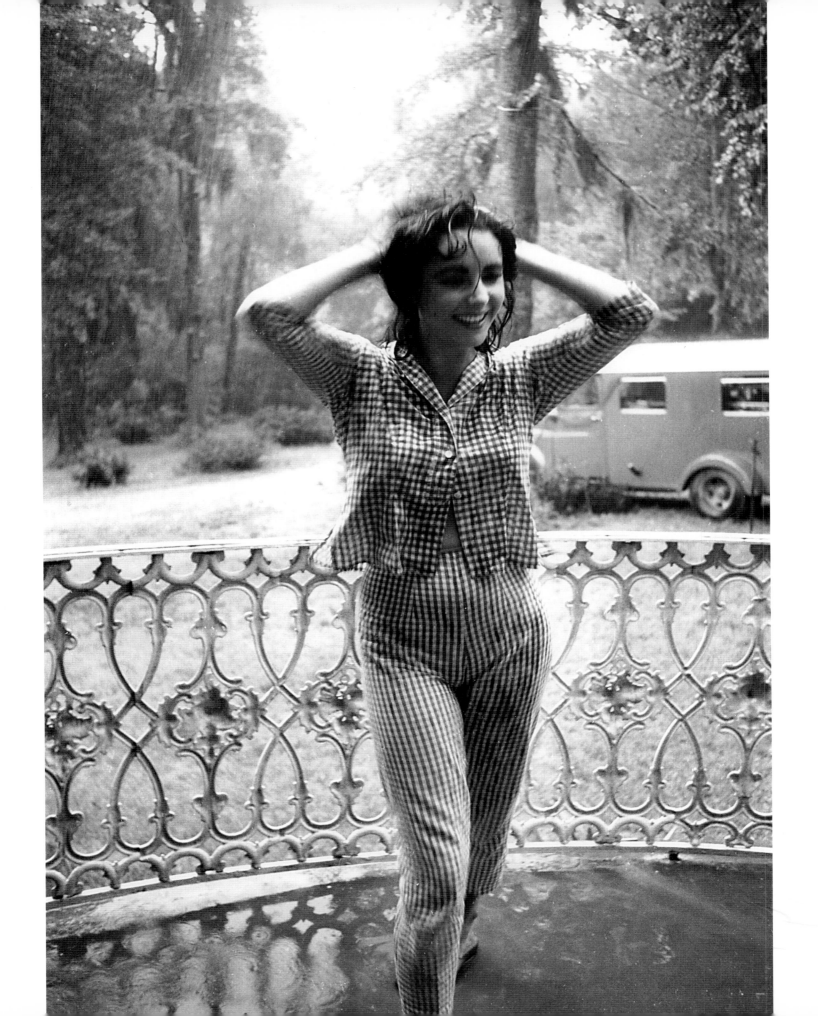

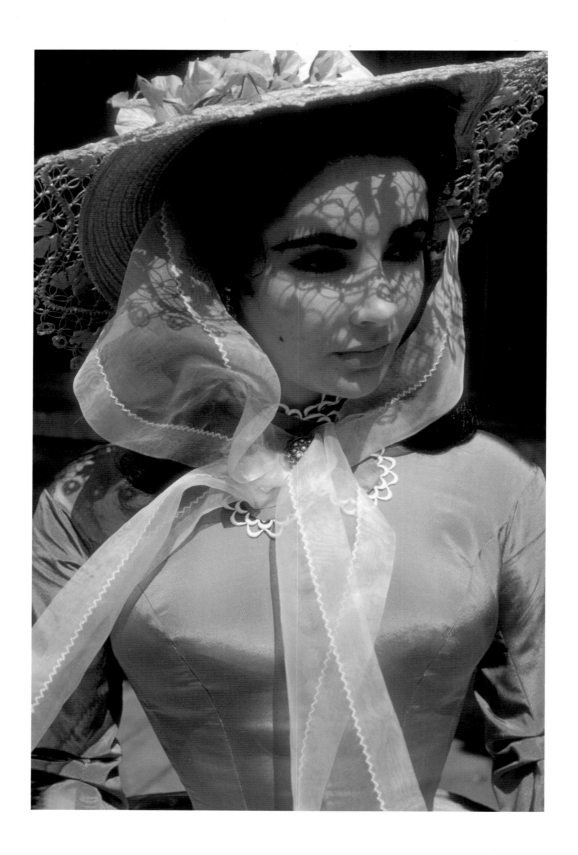

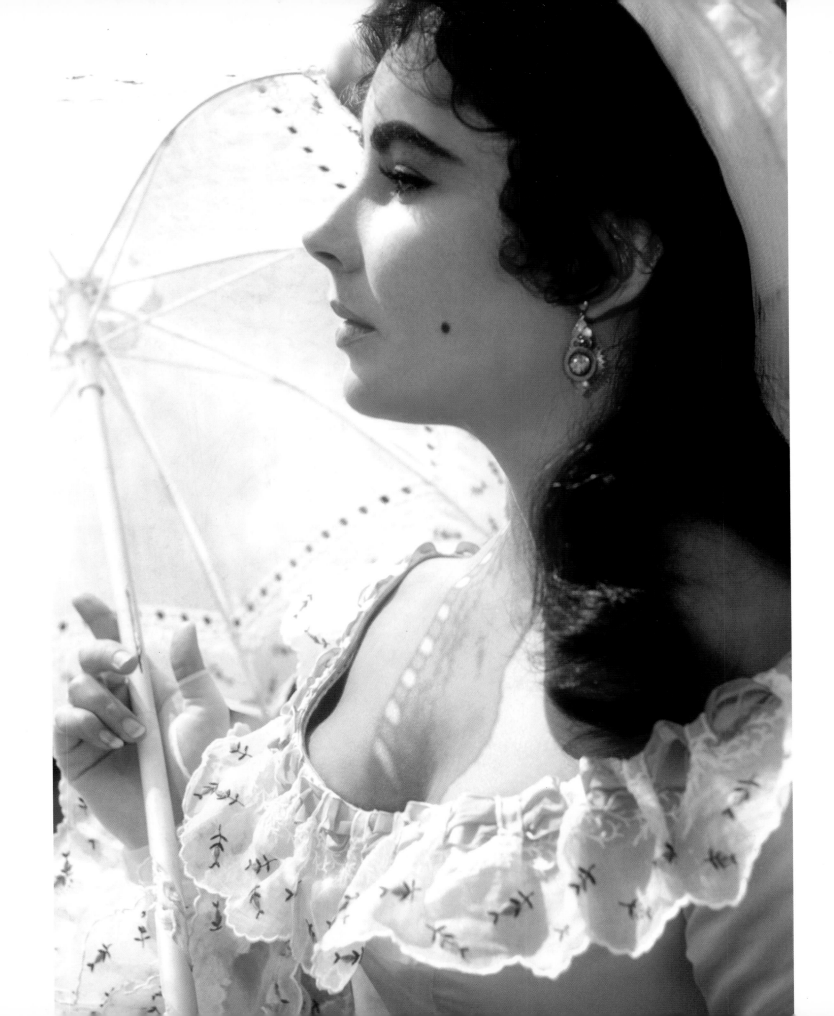

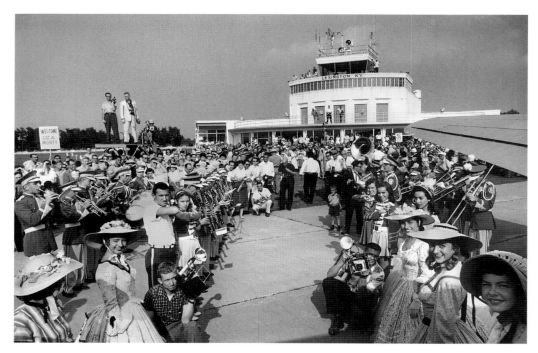

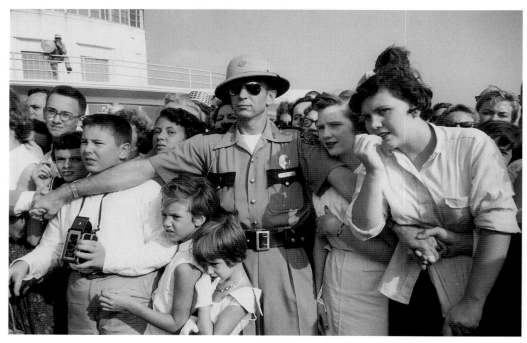

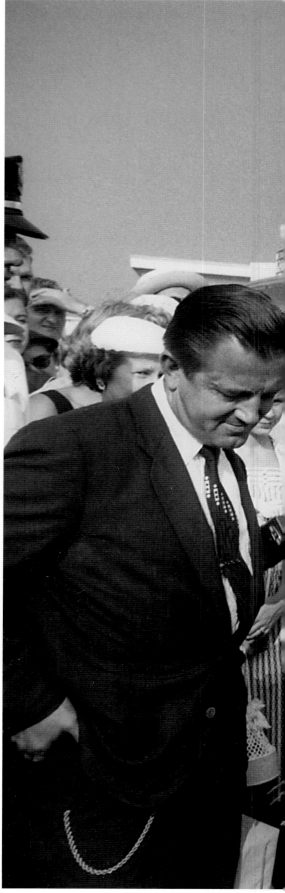

The film company had slipped into and out of Natchez comparatively quietly, but the MGM publicity department had other ideas when they moved location. Landing in Lexington, Kentucky, on their way to Danville, they had the Danville mayor W. Terry Griffin on hand to present a plaque – along with crowds of cheering fans, the press, colorful banners, and young ladies from Danville dressed in period costumes. The high school band played "My Old Kentucky Home." And finally there was a police escort all the way to Danville. It made one breathless.

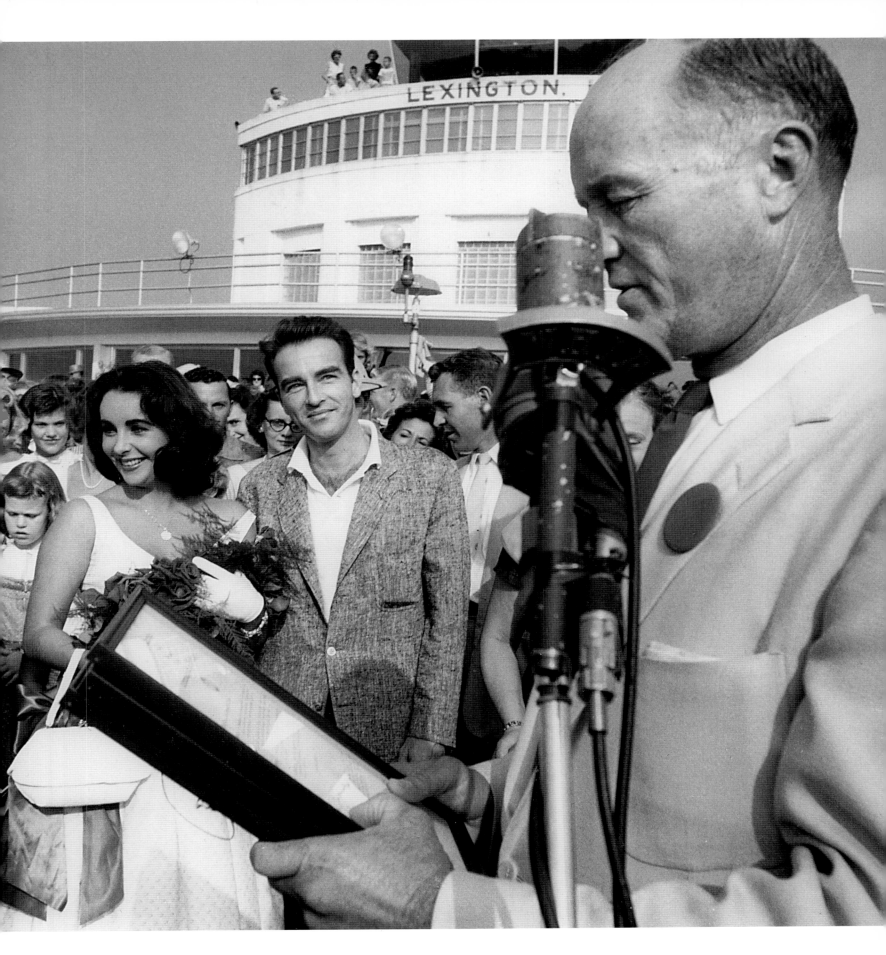

The crowds at the airport (*below*) were an omen of things to come. Wherever the company was filming in Danville, there would be literally hundreds of people watching (*right*). This could have been a nightmare for the sound department when they were recording dialogue, but the local people were without exception courteous and cooperative. There was, however, never any privacy for the actors.

Some of the town folk were used as extras in the film, which was a story that I photographed for *Collier's* magazine.

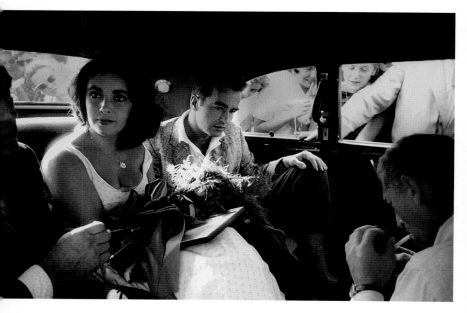

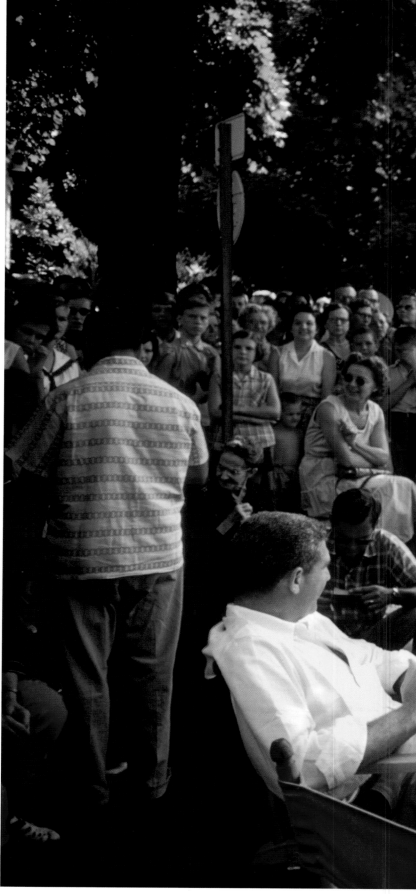

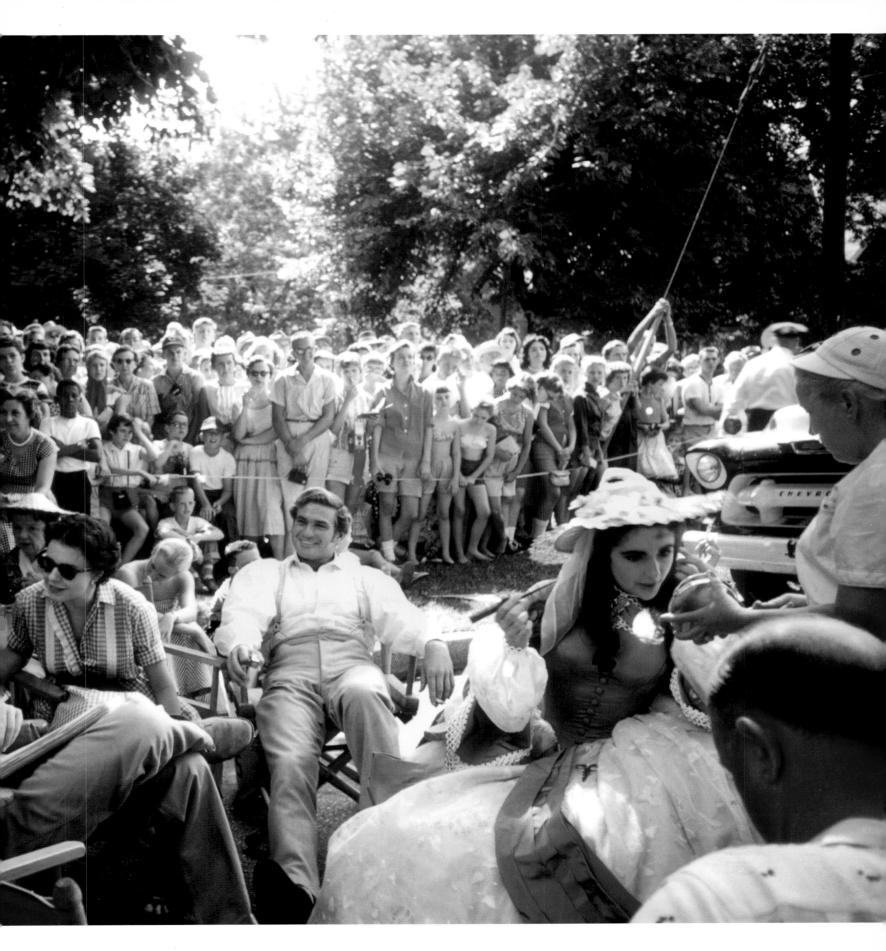

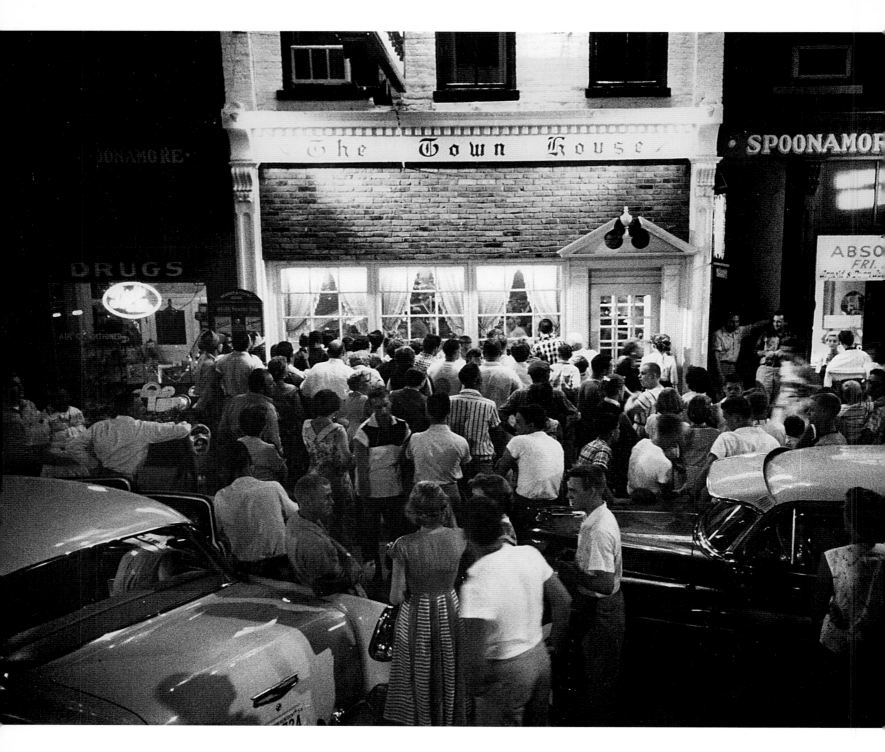

Not only did the crowds gather wherever the production was filming, but everywhere that Elizabeth went, the crowds followed her as well. Outside the house MGM had rented for her, people would notice when the light went on in her bathroom and point it out. How lucky I was to be able to move on this film and be anonymous: I'm sure Elizabeth would have liked that sometimes.

ABOVE Elizabeth having dinner at The Town House in Danville was a major attraction. It made me realize for the first time what a goldfish bowl she lived in. There was absolutely no privacy for her.

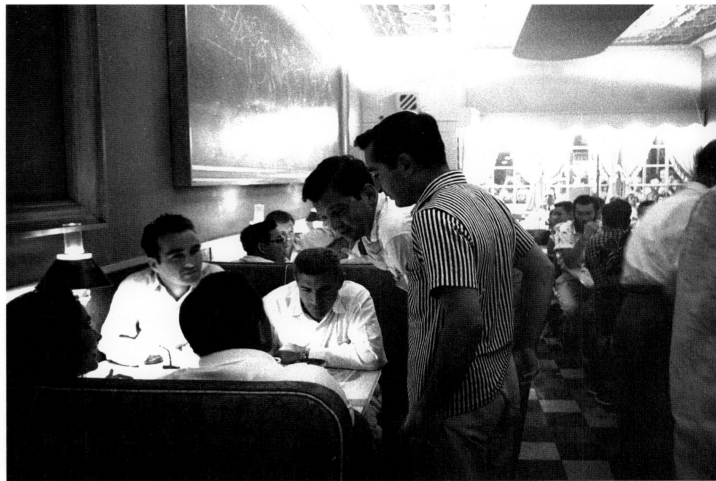

ABOVE A foursome for dinner. Eddy Dmytryk, Elizabeth, Clift, and Millard Kaufman – with the crowds peering through the windows. Their meal is also interrupted by the production team coming to get instructions for the following day's filming.

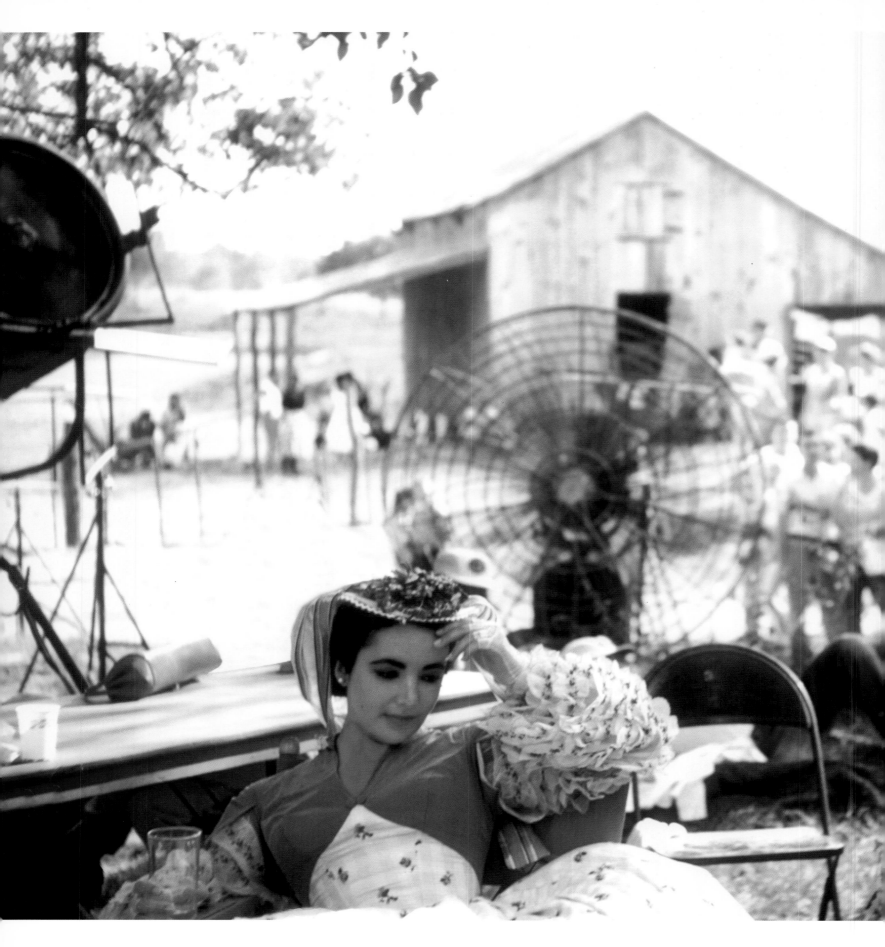

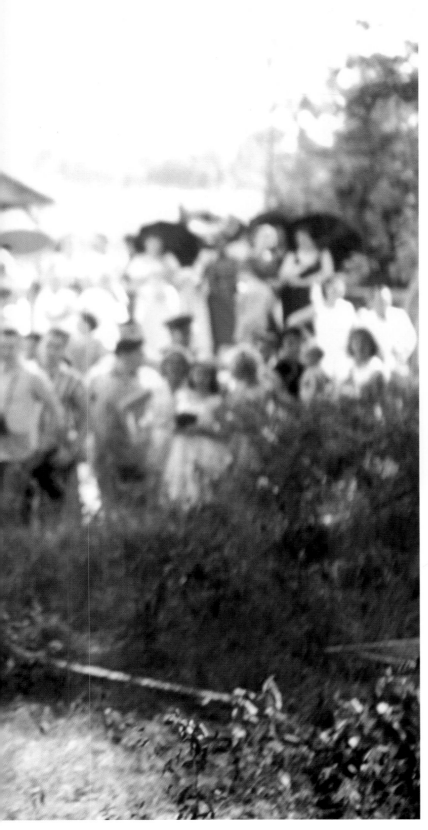

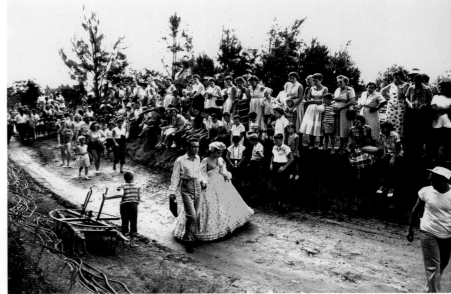

LEFT Elizabeth tries to keep cool in the shade, as the fan blows a little air her way – but the crowds in the background had to put up with the summer heat.

ABOVE Assistant director Hank Moonjean leads Elizabeth and Clift down the road to where they will be filming the next scene, running the gauntlet of Danville fans.

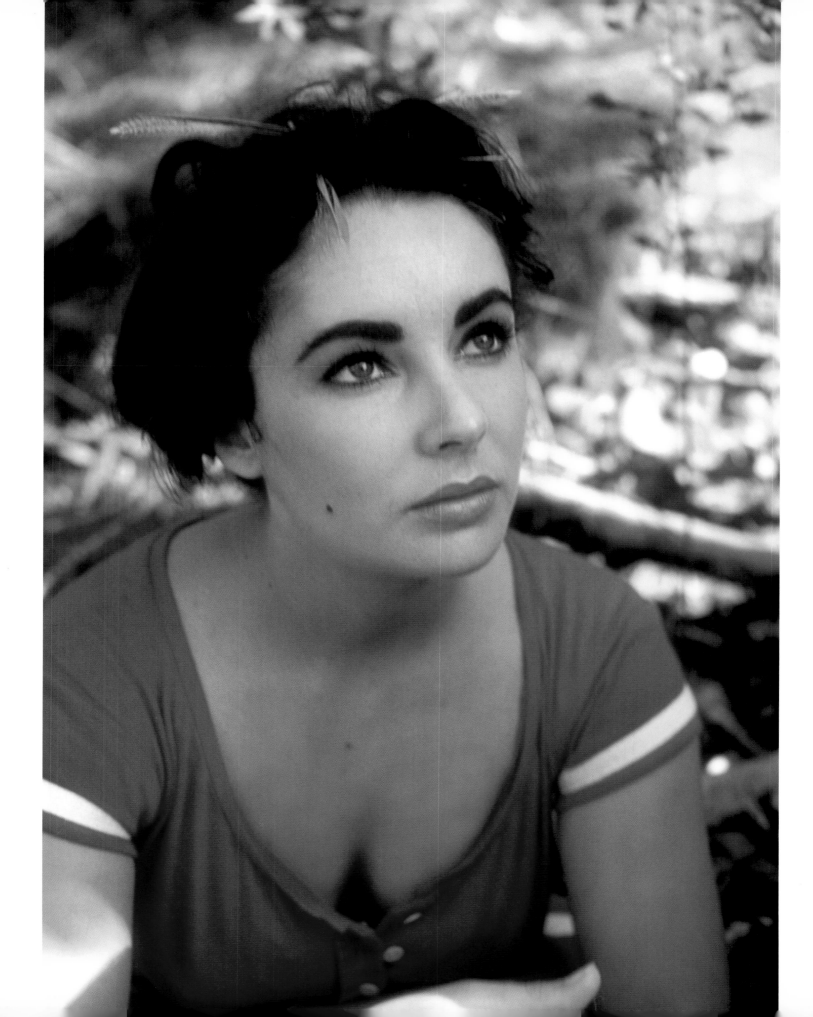

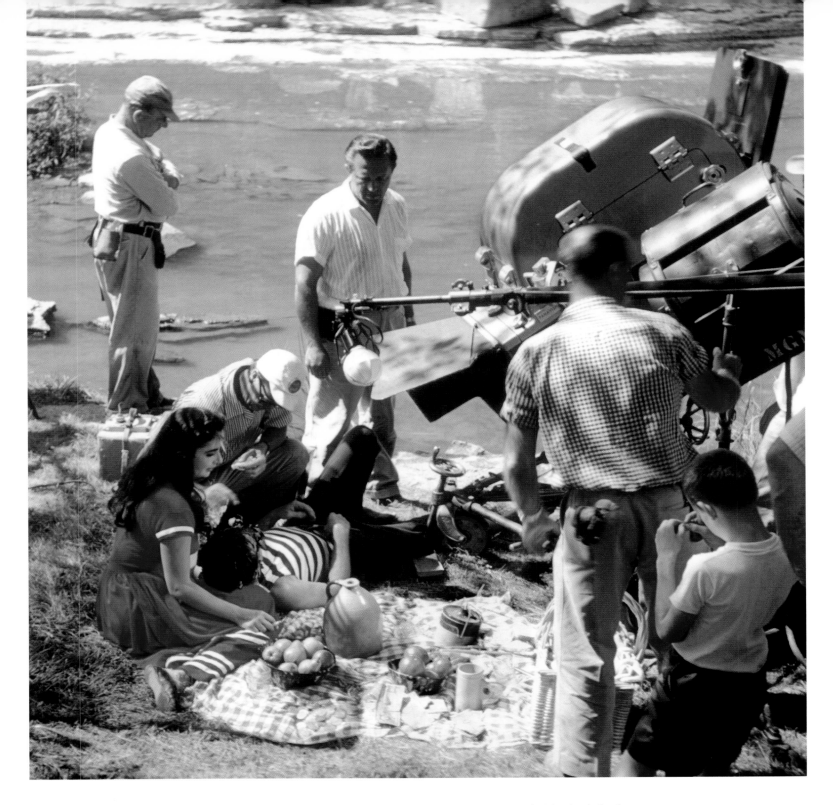

A charming scene filmed by the river with Elizabeth looking delicious in a period bathing suit. It was happy hunting for me, and *Look* magazine picked the set up immediately (*see also next page*).

ABOVE The massive MGM special 65 mm camera dwarfs Clift and Elizabeth. It was many times the weight of a conventional camera, and took almost all of the film grips to move it.

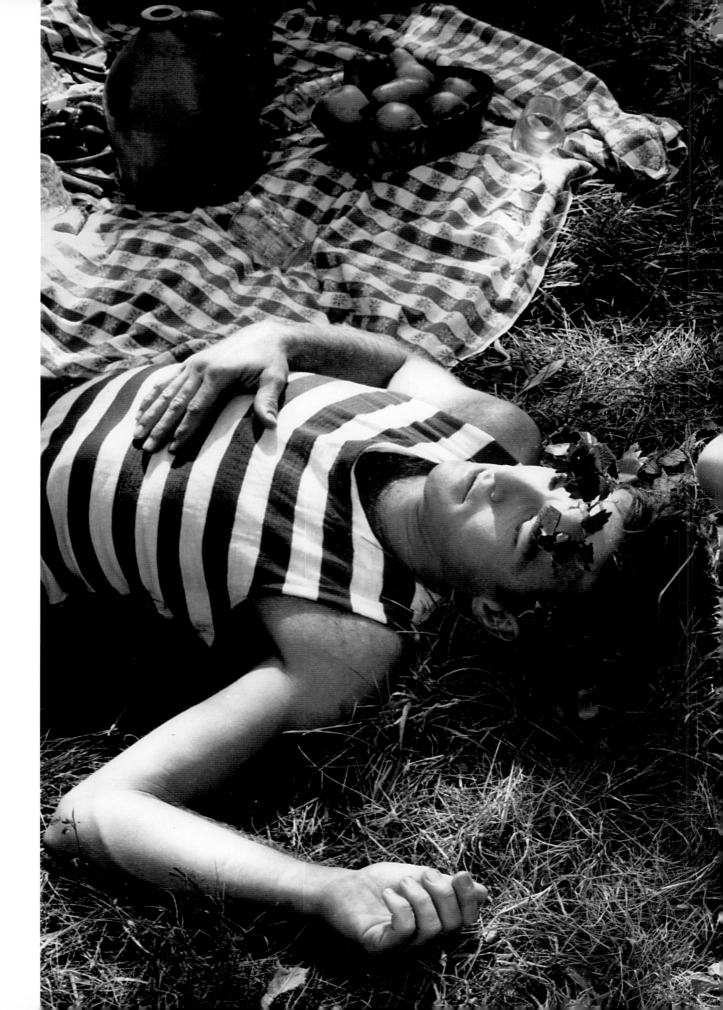

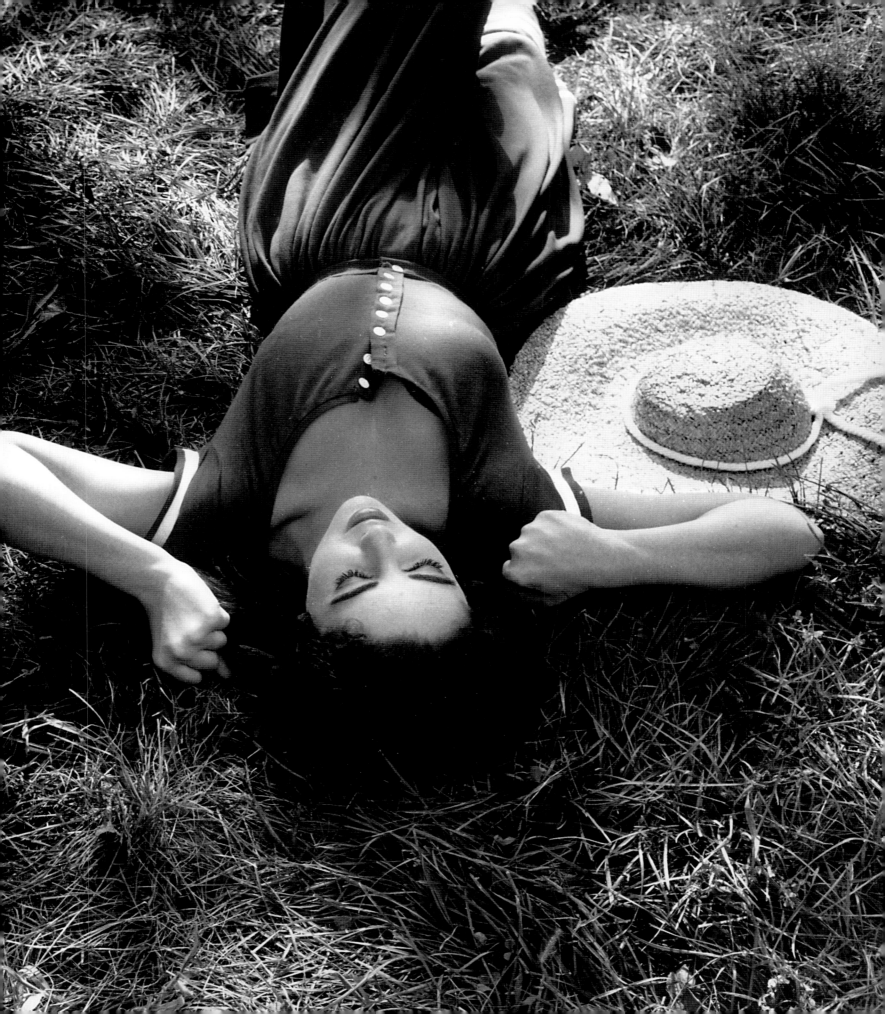

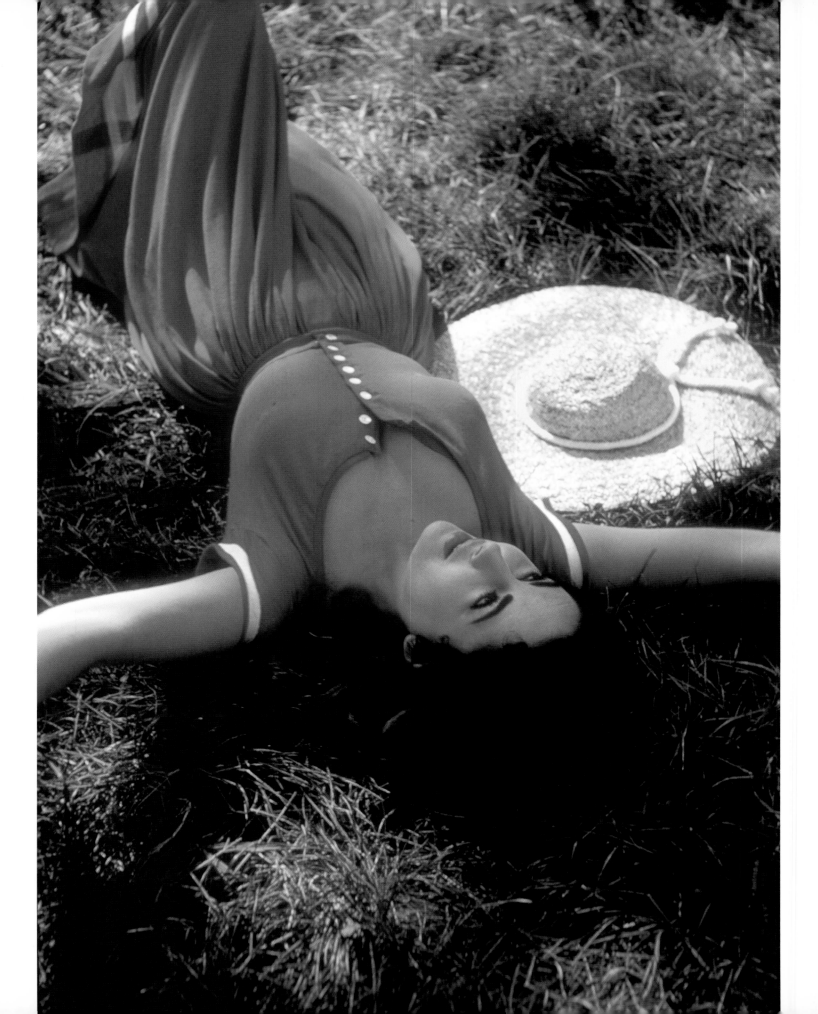

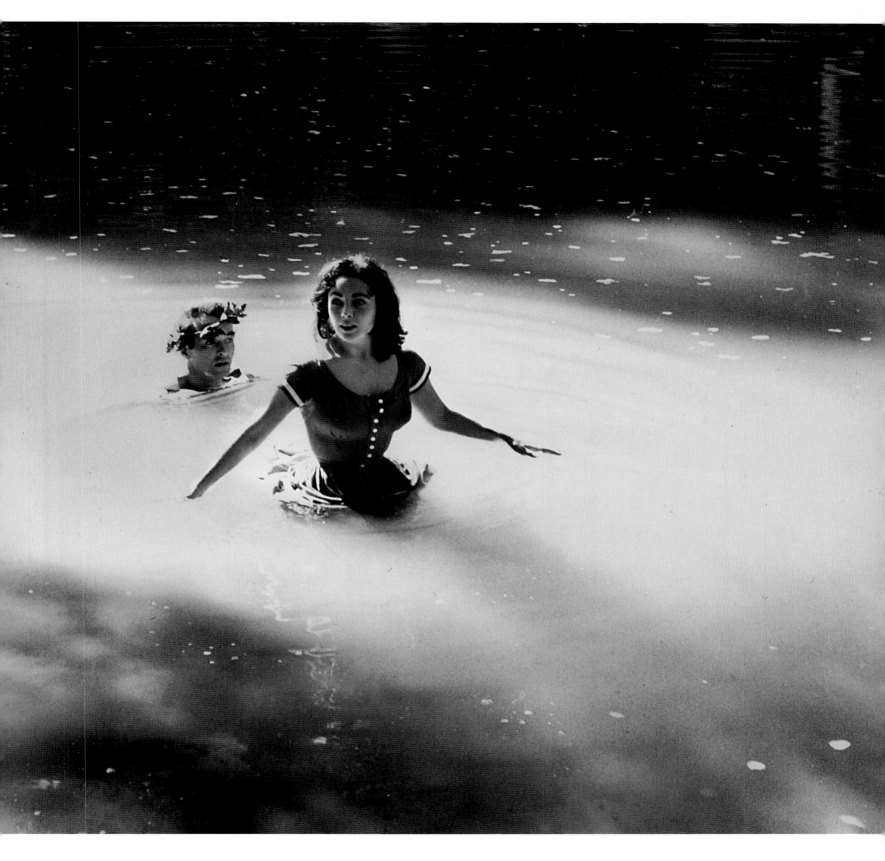

LEFT It was impossible not to photograph Elizabeth, so amazingly beautiful as she dried out in the shade.

ABOVE Even after filming ended, she and Monty tended to linger, enjoying the coolness of the water.

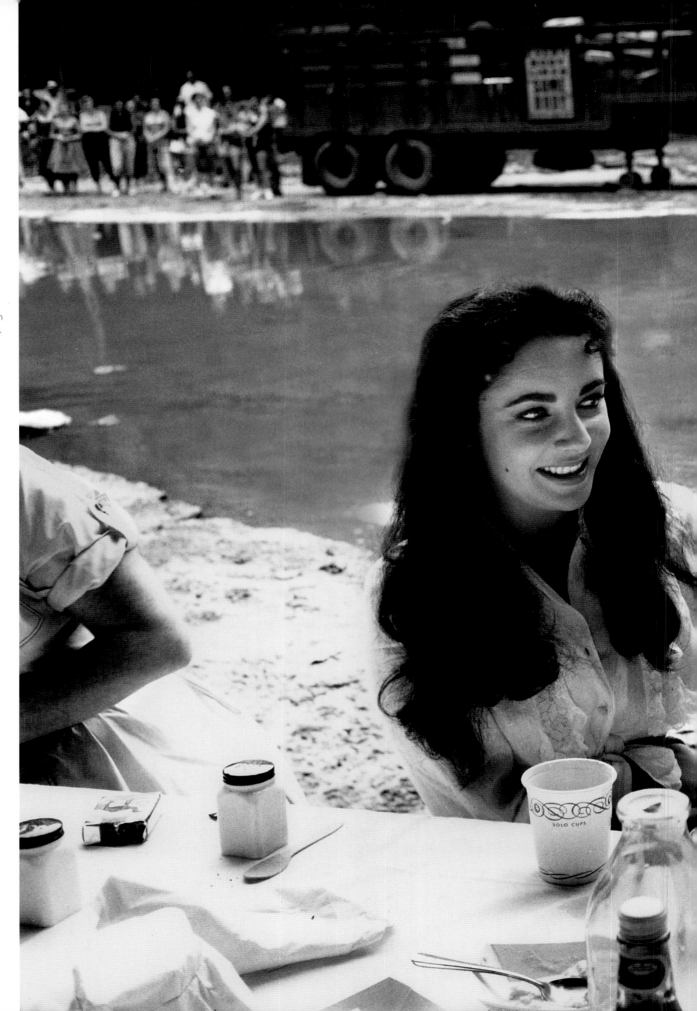

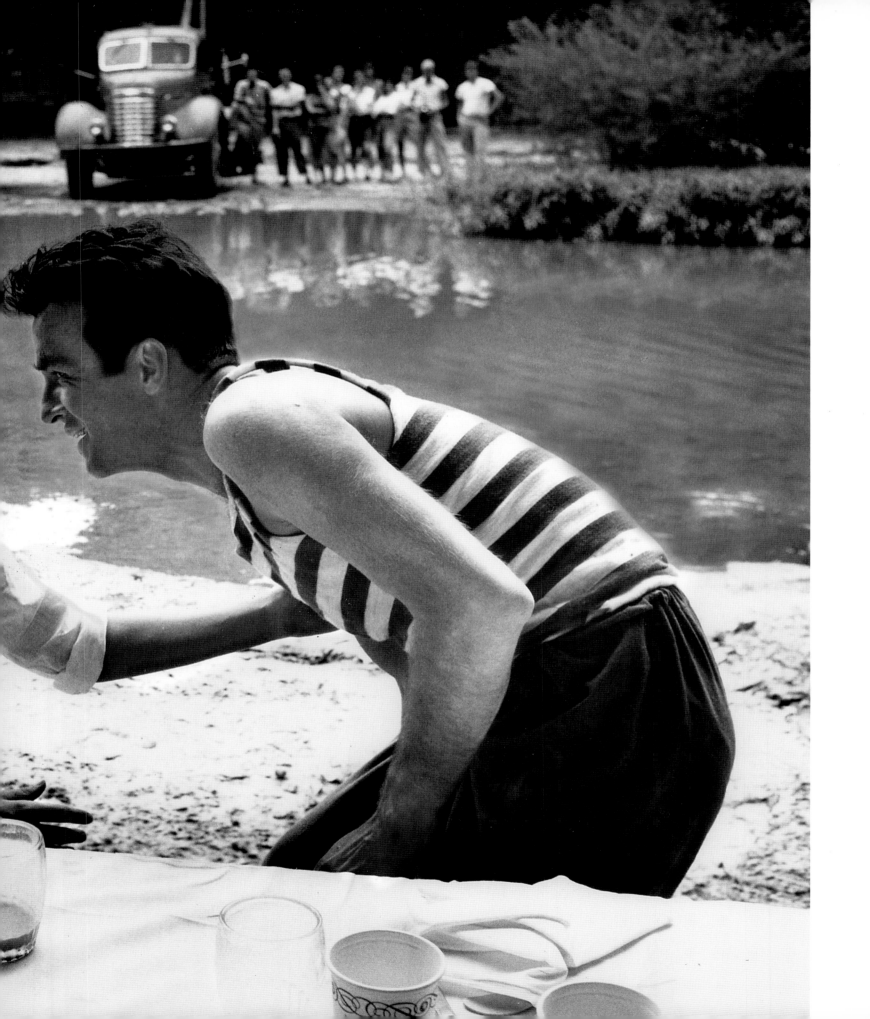

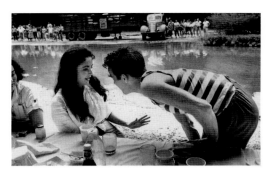

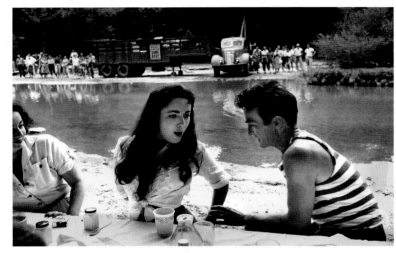

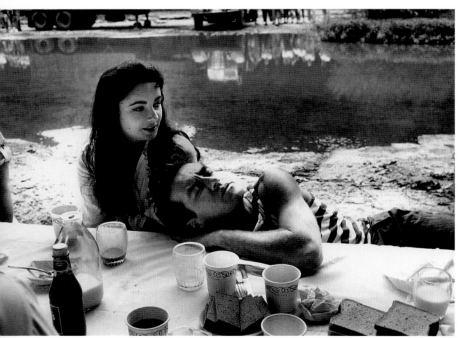

A luncheon break from the bathing scene, and Clift seems at first playful, then, like a moody child, tires of the game and dissolves on to Elizabeth's lap. There is no mistaking that Elizabeth mothered him in all of his mood swings and as you can see (*right*), her rather wistful expression says a lot about her concern for Clift.

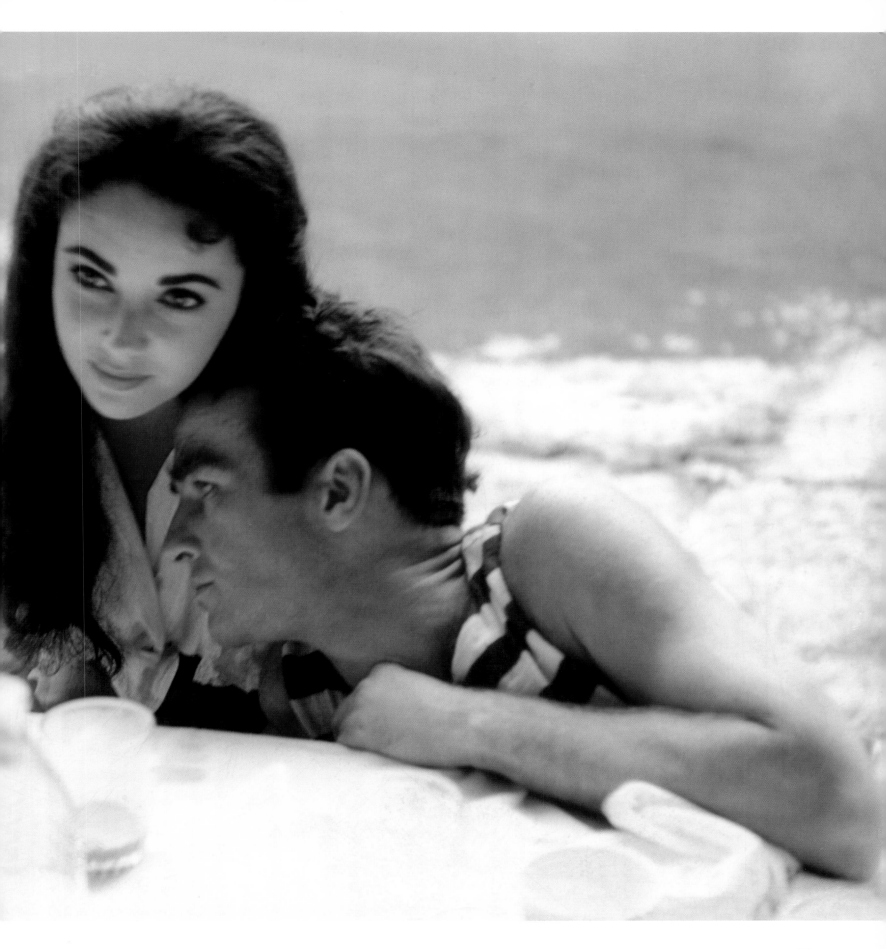

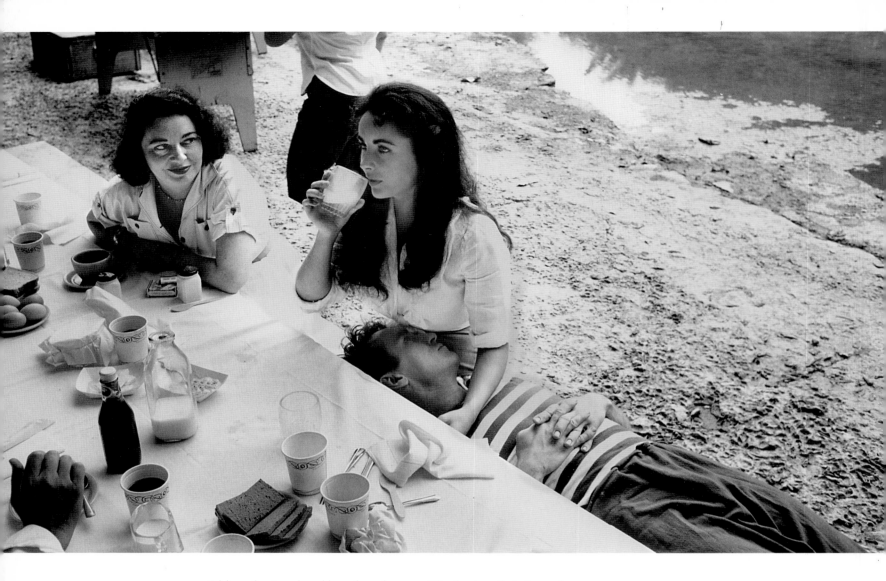

ABOVE Magazine writer Eleanor Harris watches Clift's shenanigans, and marvels at Elizabeth's composure through it all.

Old professional at films that she was, Elizabeth sailed through the entire location without any dramatics – except for the time when they called her back early from Chicago, where she was visiting her soon-to-be third husband, Mike Todd. Let us just say she was not happy to be called when she wasn't needed. She begrudged every hour she wasn't with Todd. Later, when the location was broken up, he sent his private airplane to bring her back to him.

Mike Todd and Elizabeth married in 1957 and had a little girl, Liza. In 1958, tragically, Todd was killed in a plane crash. A few months afterward, Robert Stein of *McCalls* magazine visited my wife Dorothy and me in California and played an interview tape he had made with Todd just before he died. Stein told us it seemed just as if Todd had known that something was going to happen to him. He was leaving instructions for Elizabeth along the lines of "you don't have to compete with the nursemaid" (I paraphrase). It was quite eerie at the time to hear it.

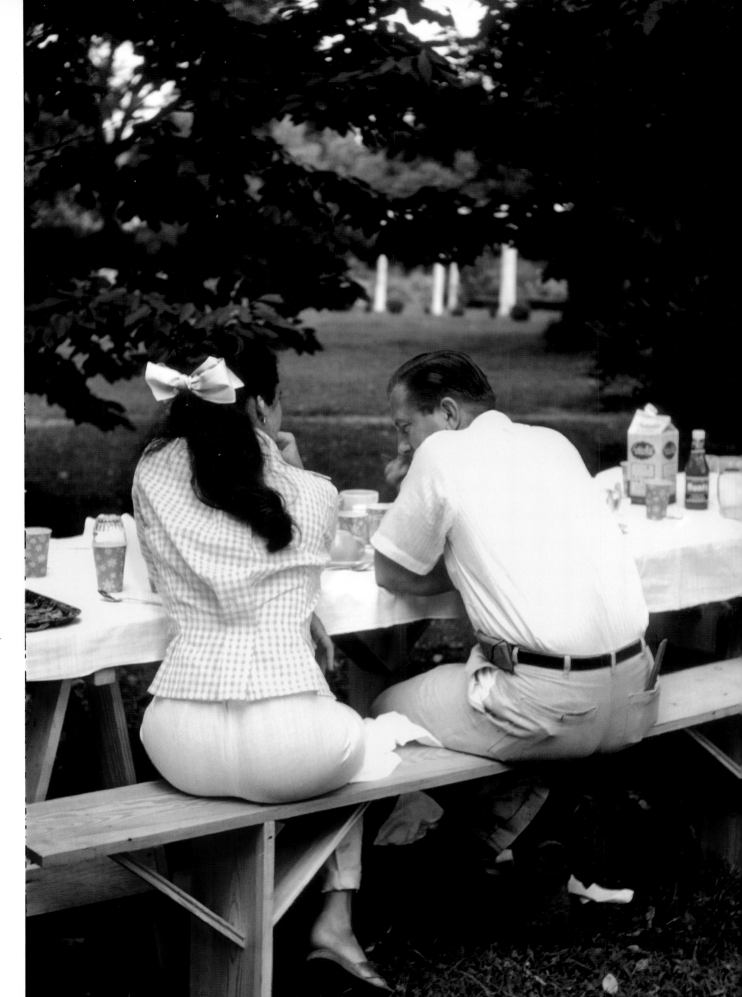

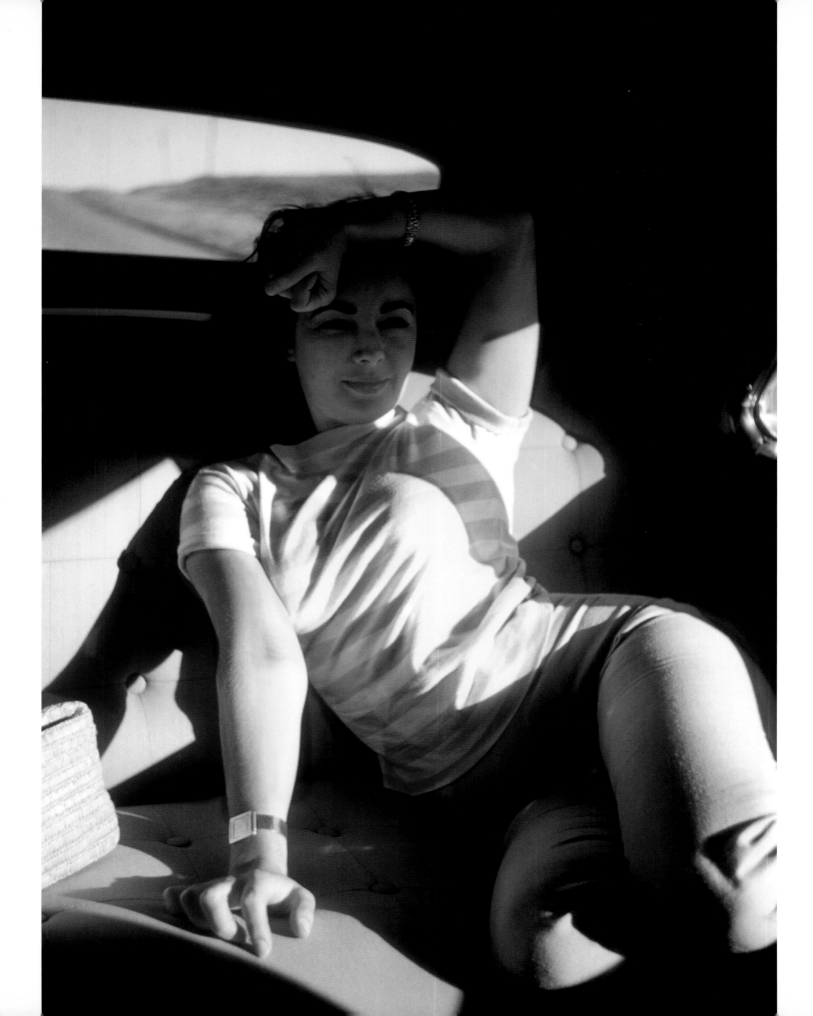

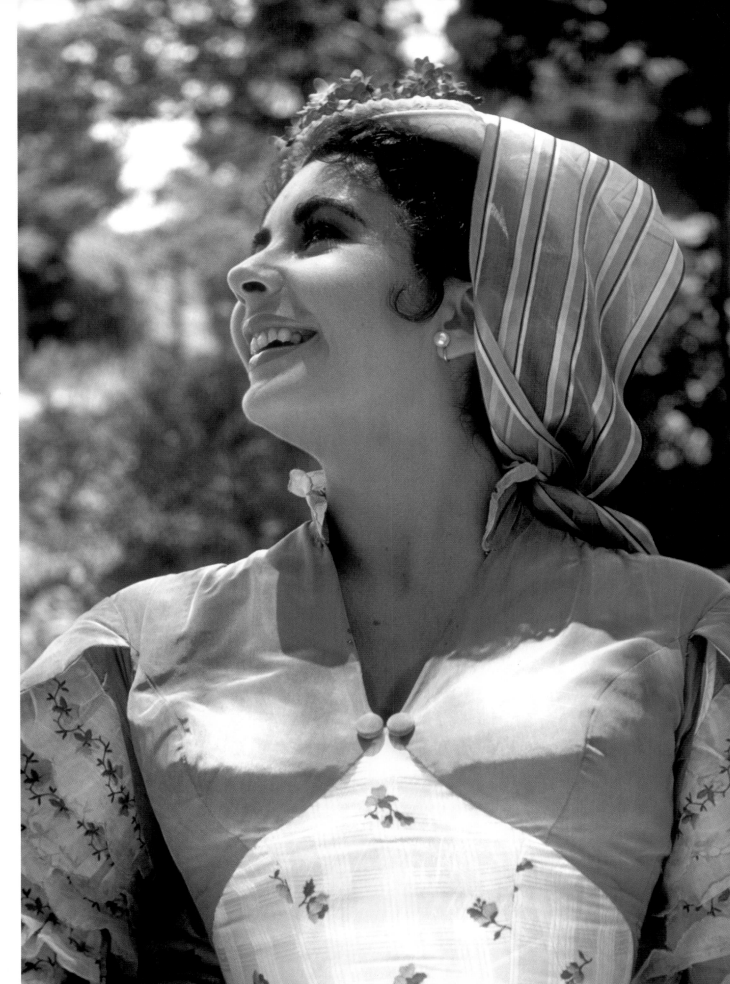

LEFT & RIGHT Riding into Danville from the location on one of those rare days when she wasn't filming, dressed in her "civvies," Elizabeth was maddeningly female – more so than when she was all laced into her costumes.

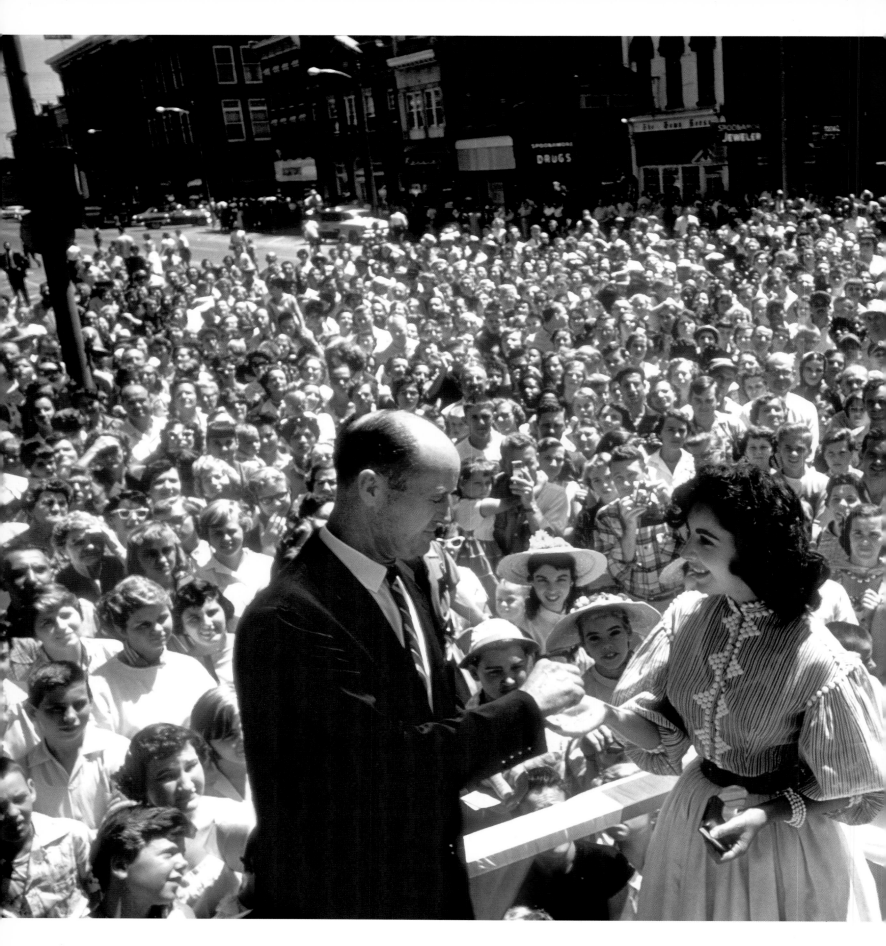

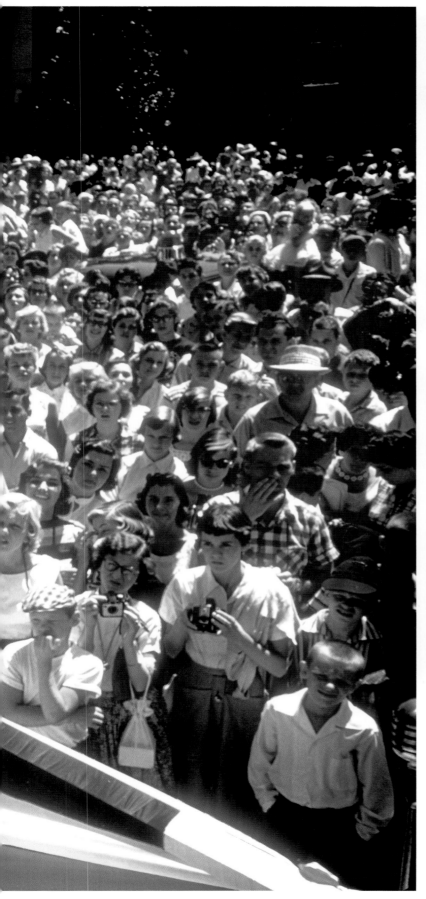

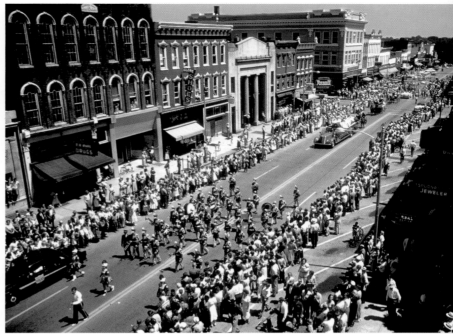

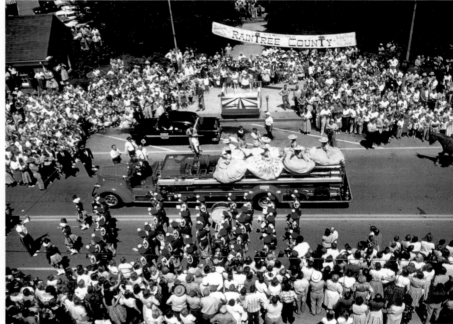

I had needed a capper for my *Collier's* story on the town, and conspired with Jack Atlas, who headed the MGM film trailer department. We talked the city officials into staging a parade and the MGM production department into lending the extra girls and costumes … and in the end everyone seemed quite pleased with their idea. Mayor Griffin presented Elizabeth with the keys to the city, the Danville fire truck was afloat with the local girls dressed in the MGM costumes, the high school band played "My Old Kentucky Home" again, and there were horse-drawn carriages, crowds, and banners. It was all terrific, and it was *my* parade.

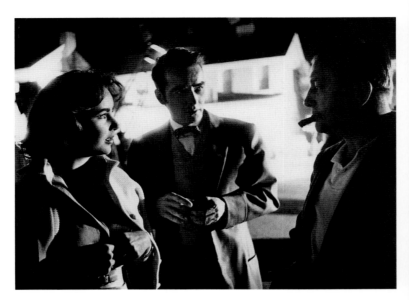

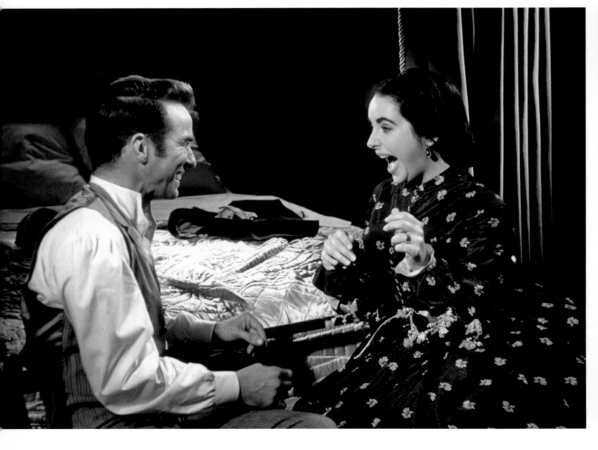

MGM returned home, literally being rained out of the location. There were a few more shots with Elizabeth and then Clift was basically on his own, for the scenes where he looks for his lost son and the 'raintree,' for the tag of the film.

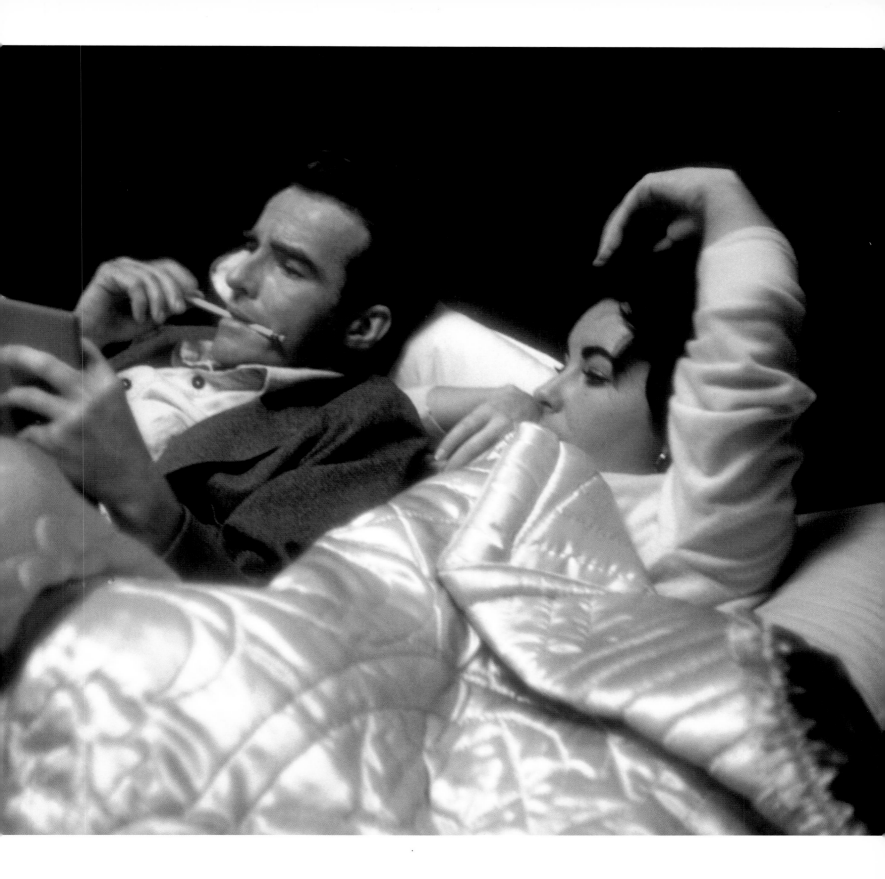

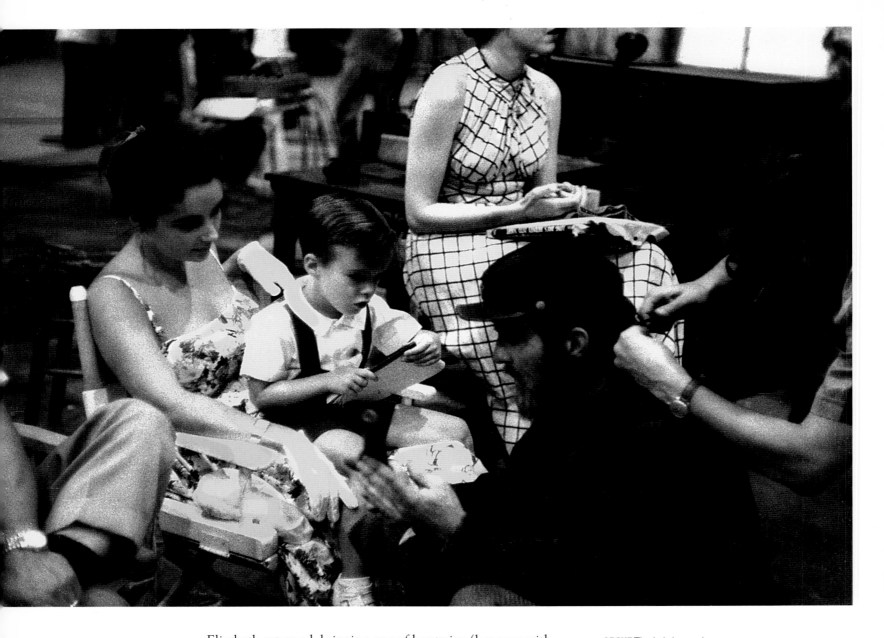

ABOVE The hairdresser has followed Clift as he comes to visit Elizabeth.

Elizabeth returned, bringing one of her twins (her sons with Michael Wilding), to see how Clift was doing. He had a hard time after his accident, and at times was very erratic. It wasn't for lack of trying; he just had his own demons to deal with, and he didn't cope very well at times. Elizabeth was always there for him, to encourage and help him in every way she could. I was told that when he couldn't get work as an actor, she posted the insurance bond (required by the studios) with her own money so that he could continue with his career.

Of all of the actors I've known, Elizabeth surely is one of the most loyal to all of her friends, a point that I've never seen in print. Think of her work for AMFAR (American Foundation for AIDS Research), which she continues to this day in memory of Rock Hudson. The list of those she supports is long, and I admire her for that; it's especially amazing in Hollywood.

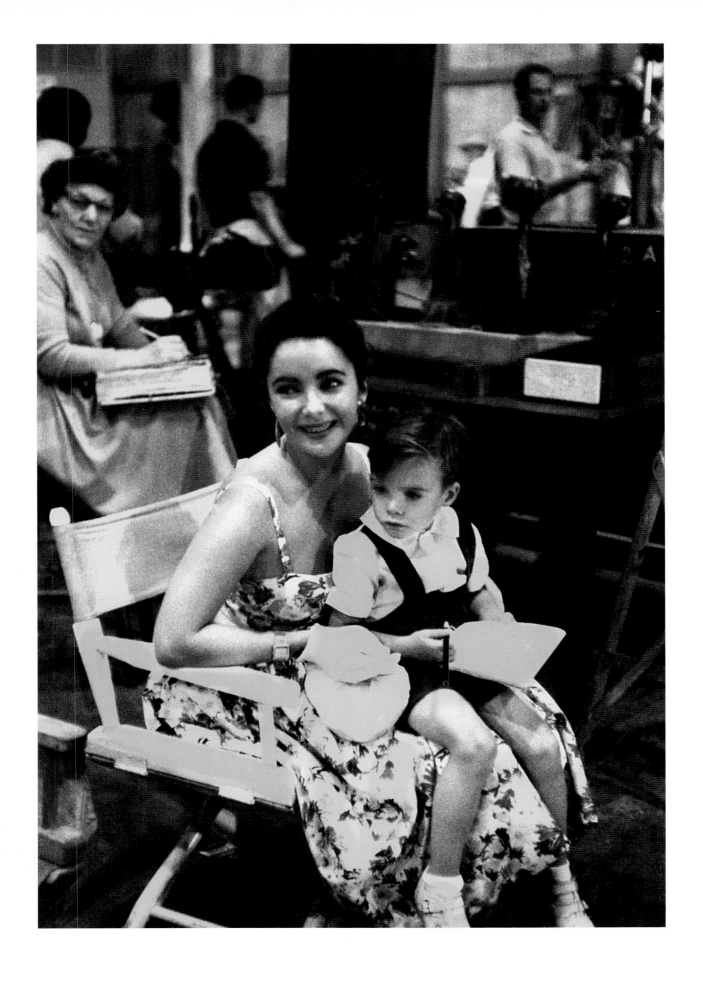

All the newspaper headlines announced it: Elizabeth Taylor Marries Eddie Fisher! It was May 12, 1959, in Las Vegas. Anything that Elizabeth did caused a commotion in the press, but this was of rather epic proportions.

Very sweetly, through her press agent, Elizabeth asked if I would take some photographs at their reception, and of course I was delighted. It was a fine compliment; and it also turned out to be very lucky for me that I went, as on the plane back, I would meet my wife-to-be, Dorothy.

The Las Vegas ceremony was awash with the press (*next page*). As might happen today, they even had a policeman guarding the door of the synagogue to make certain no one interrupted (*below left*).

RIGHT The newly married couple arrive at their reception to be welcomed by friends and family.

BELOW As the police escort Elizabeth and entourage into the synagogue, the enthusiastic crowds move as close as they possibly can, to be as much a part of this moment as possible.

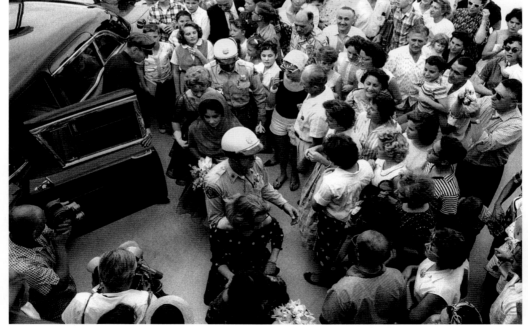

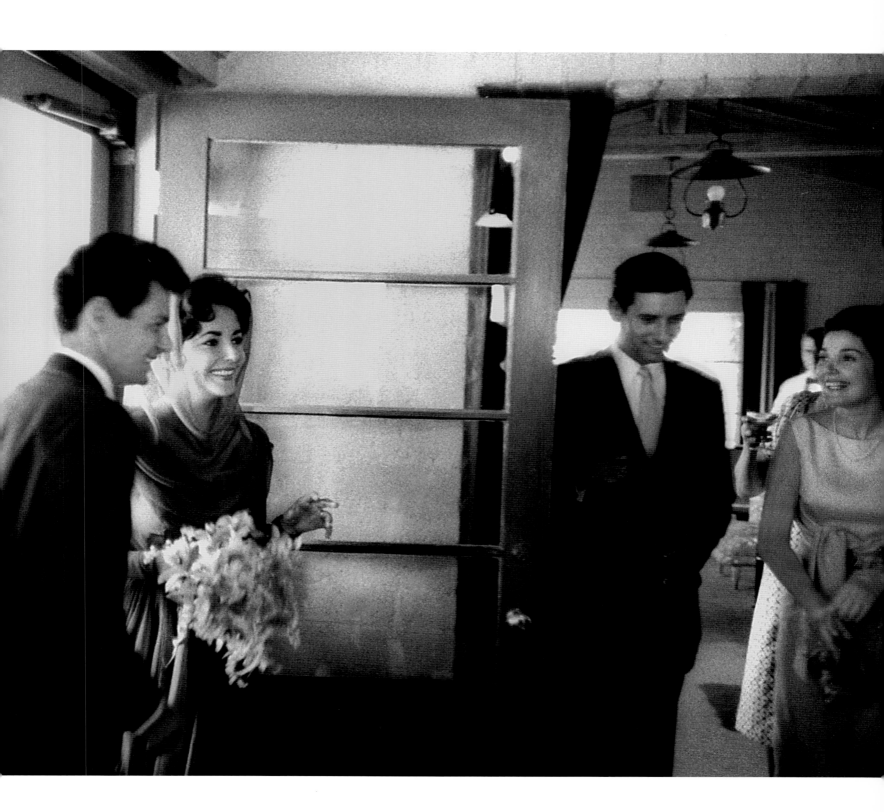

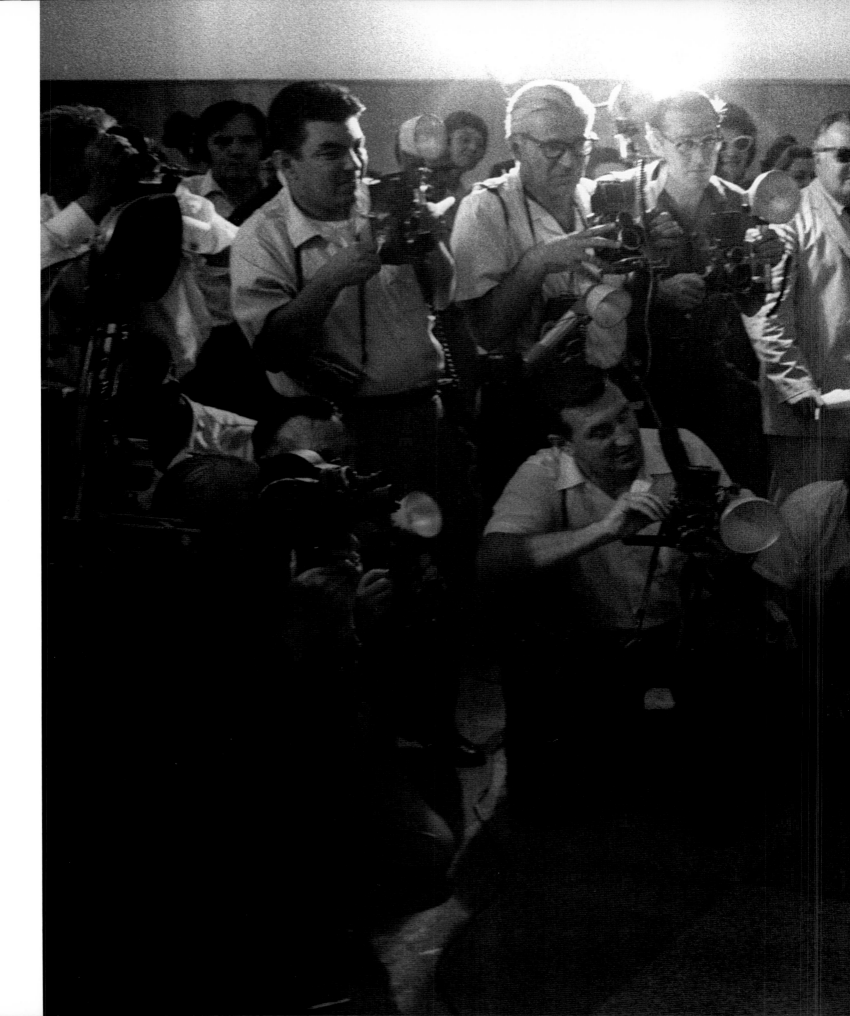

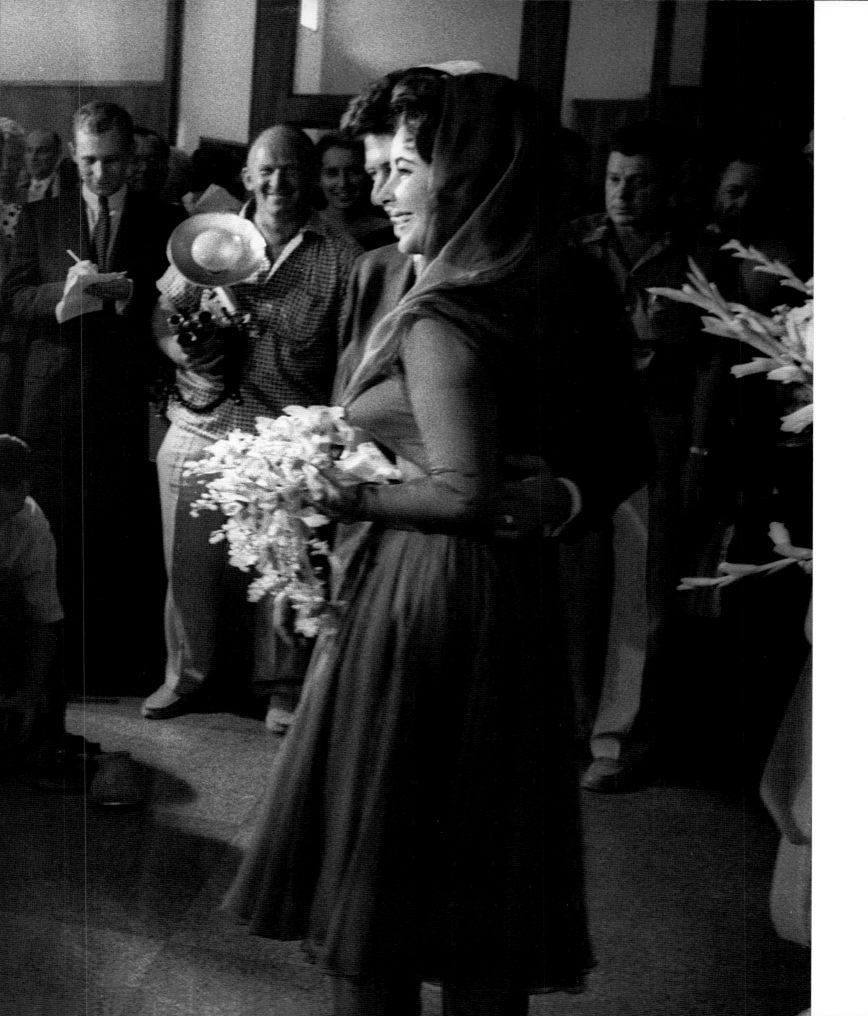

RIGHT The new Mr. and Mrs. Fisher pose for their wedding photograph.

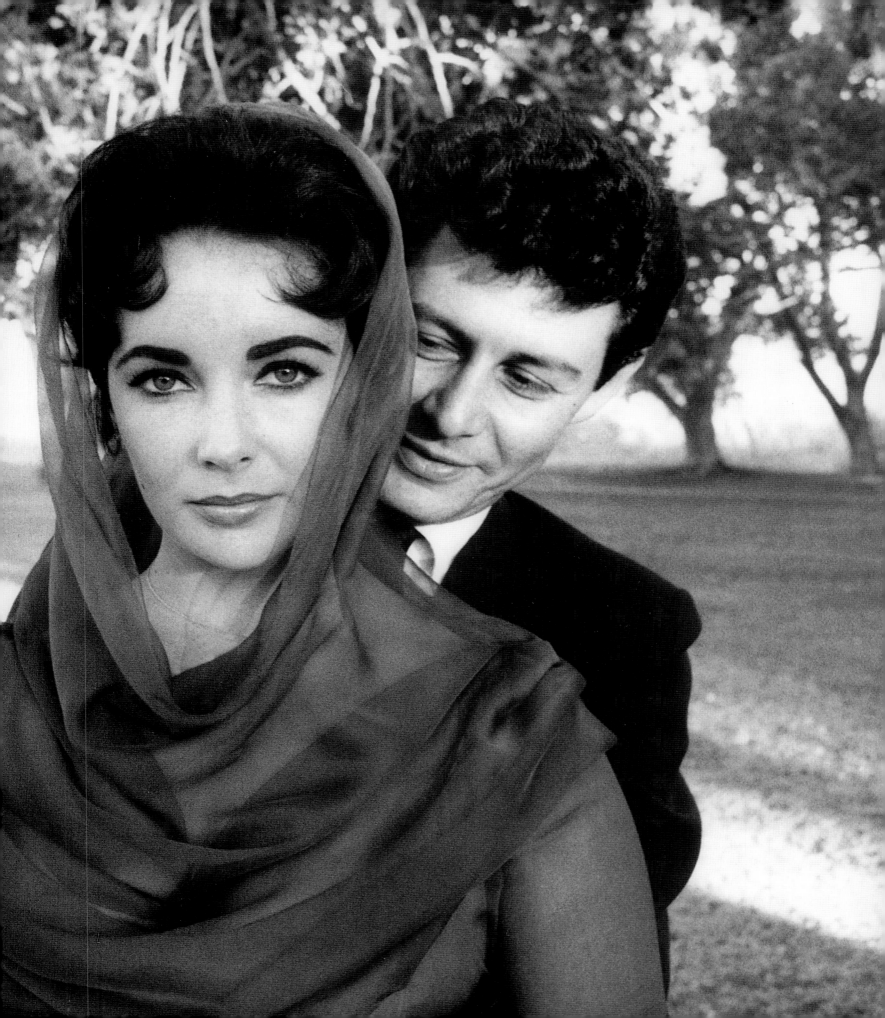

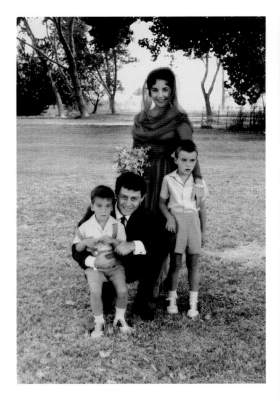

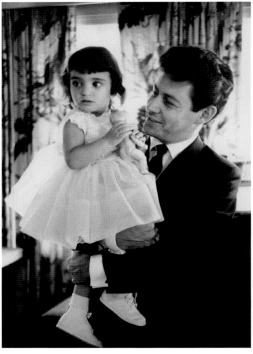

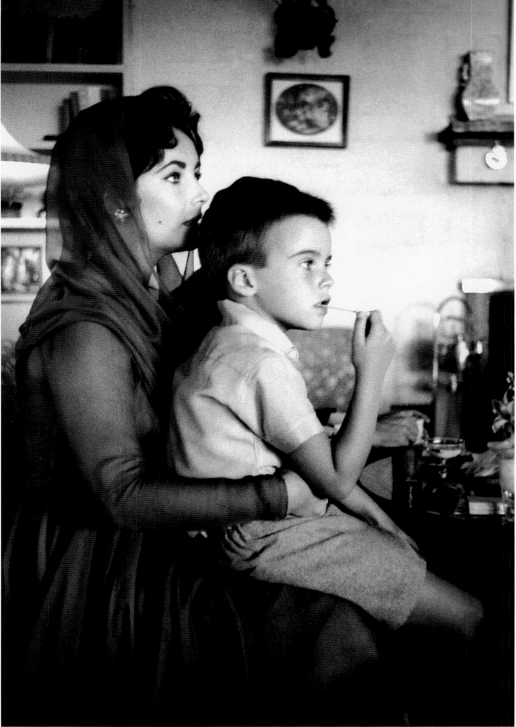

TOP Looking radiant, Eddie and Elizabeth in the garden with the Wilding twins.

ABOVE Eddie with Liza Todd.

ABOVE RIGHT Elizabeth with Christopher Wilding.

The future seemed so bright for them both. What changed Fisher, what made him become so bitter in his old age, I cannot guess; all I know is that Elizabeth survived the marriage (which would end in 1964) and went on and on, even as Eddie went down and down.

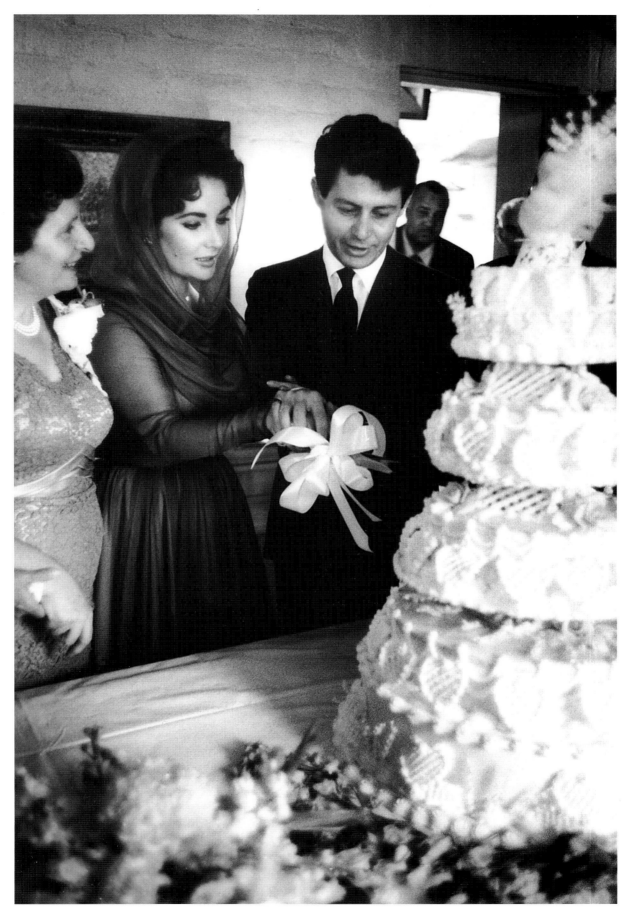

LEFT Eddie's mother smiles as Eddie and Elizabeth cut their cake.

RIGHT As I looked at
Elizabeth dressed for
the wedding ceremony,
I thought back to *Ivanhoe*
(1952) and the young
Jewish girl looking out from
the shadows who had
captured my heart so long
ago. And now here she was
for real, that beautiful girl:
life echoing film.

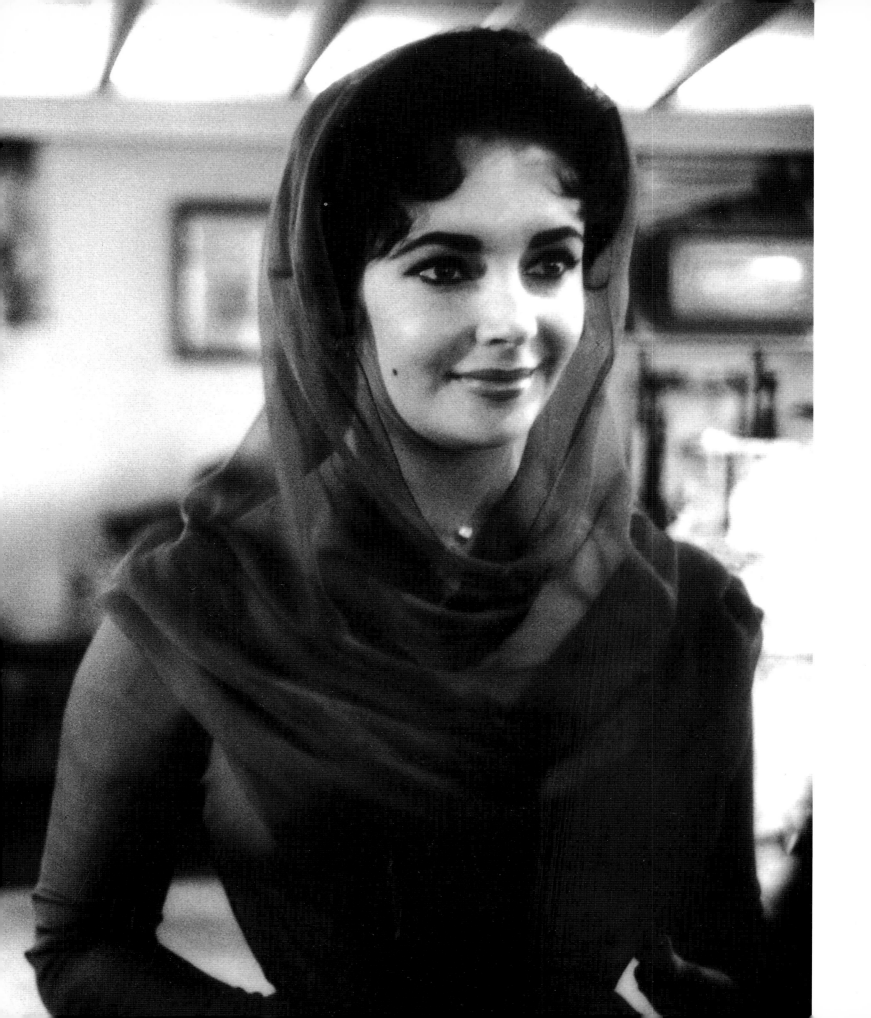

The next time I caught up with Elizabeth she had a new man on her arm, Richard Burton, and a new ring (*right*). It was 1965, and we all were at Warner Brothers Studios for the filming of *Who's Afraid of Virginia Woolf?*

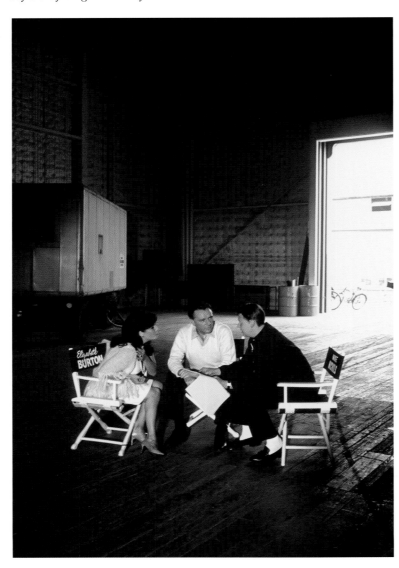

LEFT The Burtons get together with director Mike Nichols to discuss the months of filming ahead of them.

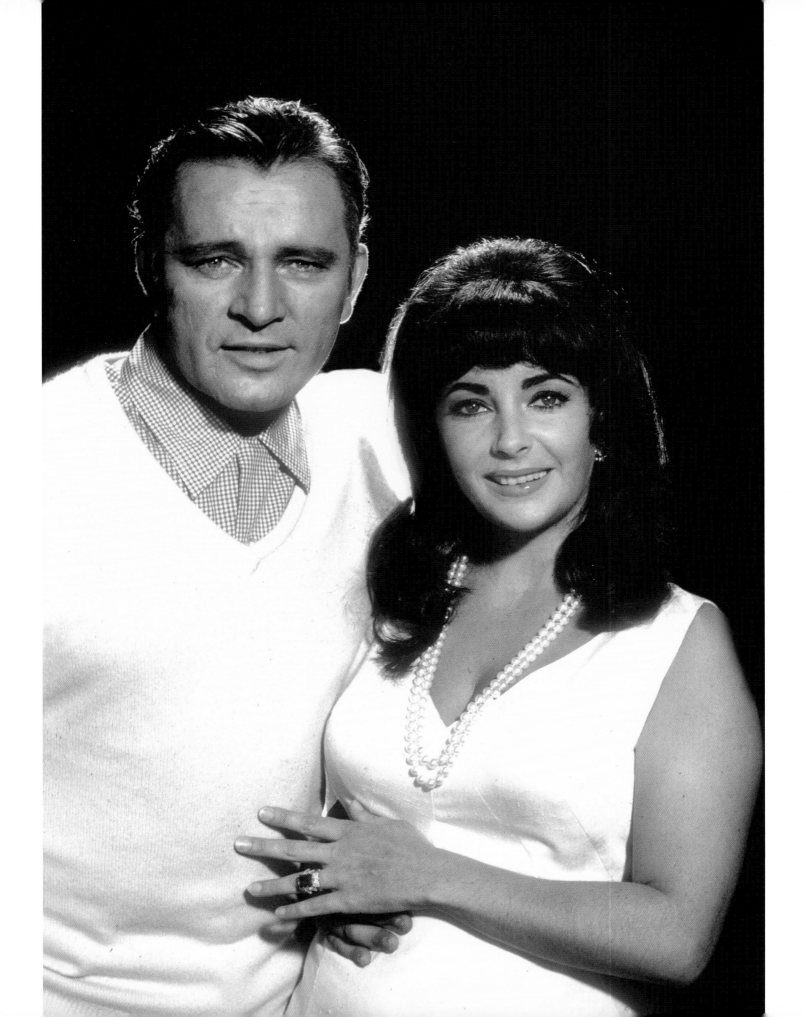

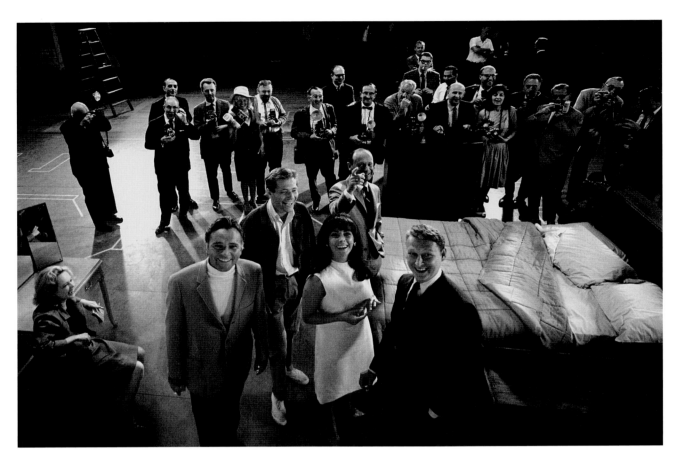

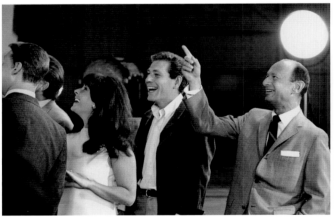

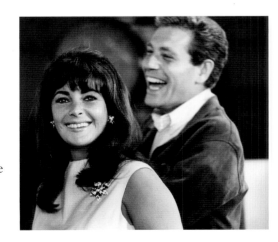

Before filming began at Warner Brothers, their publicity department gave a press call to introduce the actors to the reporters and photographers. The director, Mike Nichols, had stipulated that it would be a closed set from then on.

I was looking forward to seeing Elizabeth after all these years, and I wondered how I might get a different shot from the other photographers. Publicity had set up the interview on an empty stage that had a large flat behind the area where the actors would be standing. I had helped to develop a radio-controlled camera, which I had used to great advantage on a previous Warner Brothers film, *The Great Race*, and I thought, why not, for the fun of it, clamp one of these remote cameras to the flat behind the actors? Then when they were all there, I would get a shot of the entire scene.

My motorized camera started clicking and, as luck would have it, the actors all turned around to see what the noise was, and discovered my remote. Each time I shot my own camera, the remote would also go off – and I heard Elizabeth say, in that voice I remembered so well, "I'll bet you anything that's one of Bob Willoughby's tricks," and she looked around to find me (*right*).

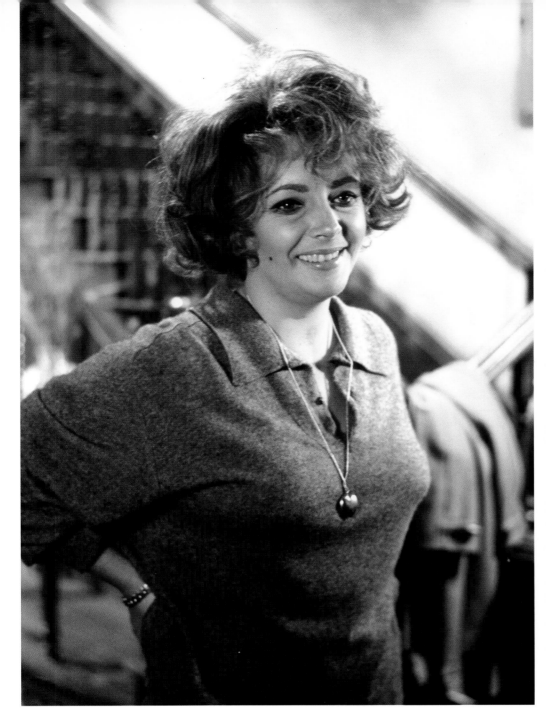

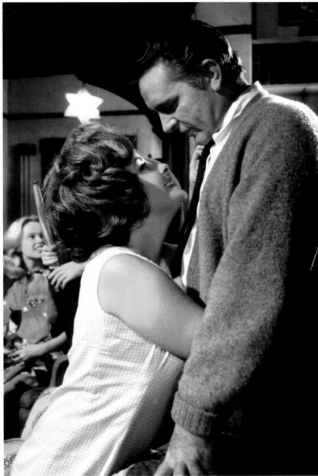

During the first rehearsals there was a really good feeling between Burton and Elizabeth. It made me happy to see her in such good form.

It was clear that Elizabeth had gained a fair amount of weight for the film. Nothing, however, prepared me for her coming on to the set for the first time, in dowdy clothes, a wig, and makeup to make her look dissipated. Wow!

I could not believe my eyes. Here was the girl so many of us had fallen in love with up there on the movie screen. What would her fans think? I was musing about this when the actual rehearsals began. They, too, would be another surprise.

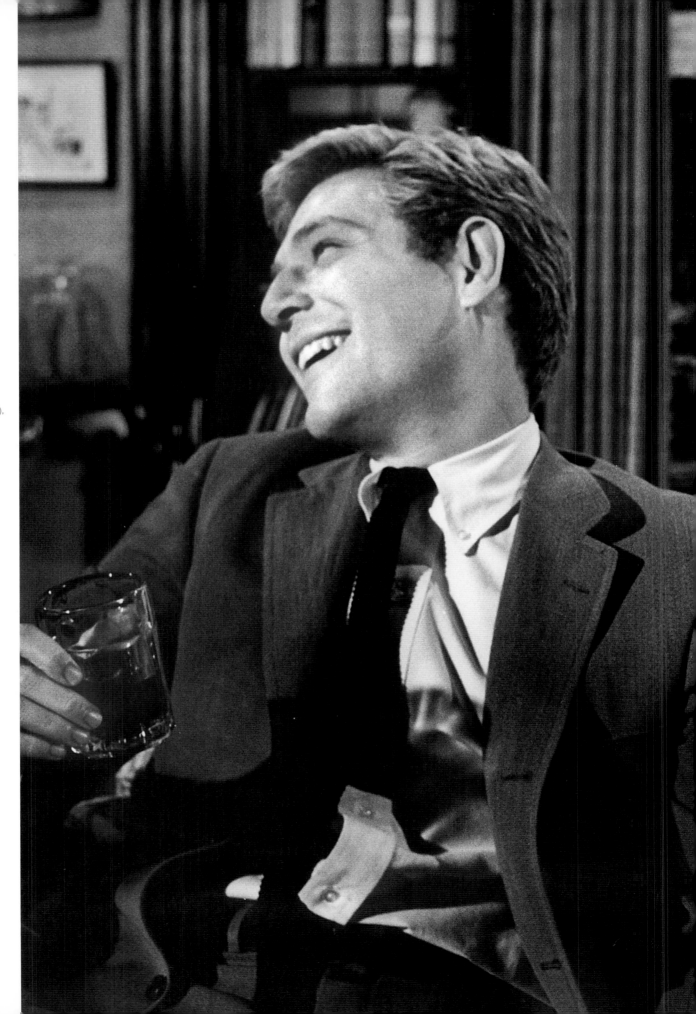

RIGHT Martha (played by Elizabeth) drinks too much, talks too much, and has an acid tongue, which is always directed toward her husband George (Burton). In this scene she is with Nick (George Segal), trying in every way to annoy George, and succeeding mightily.

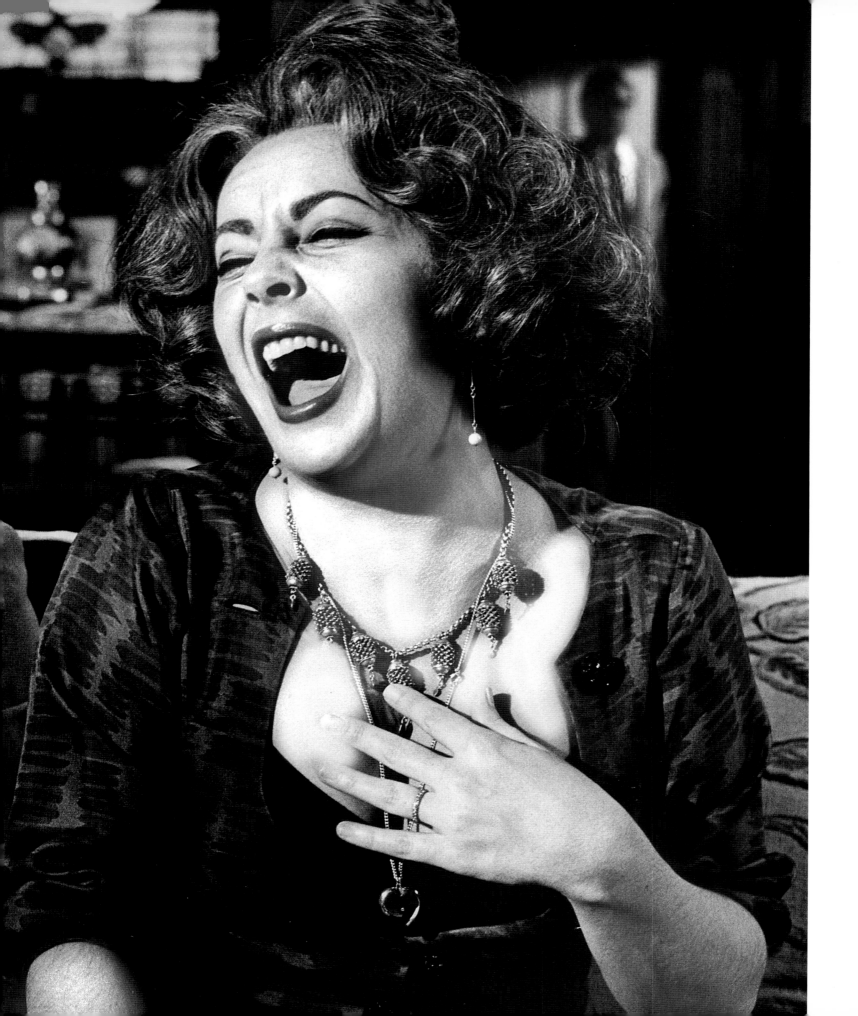

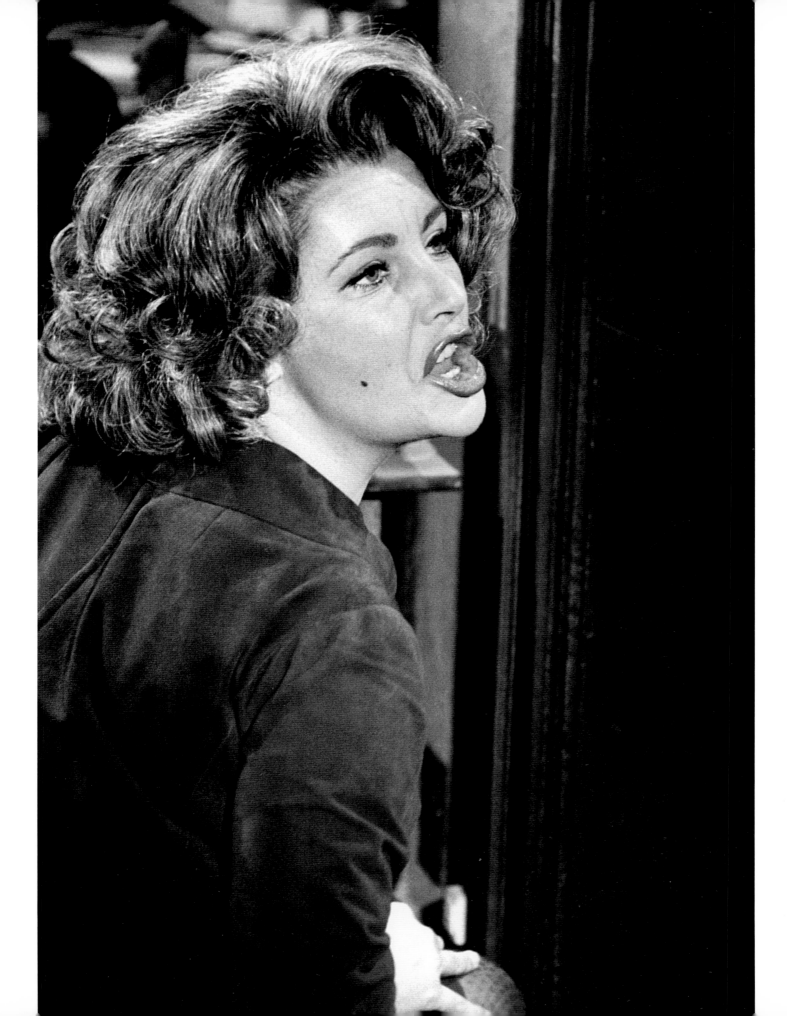

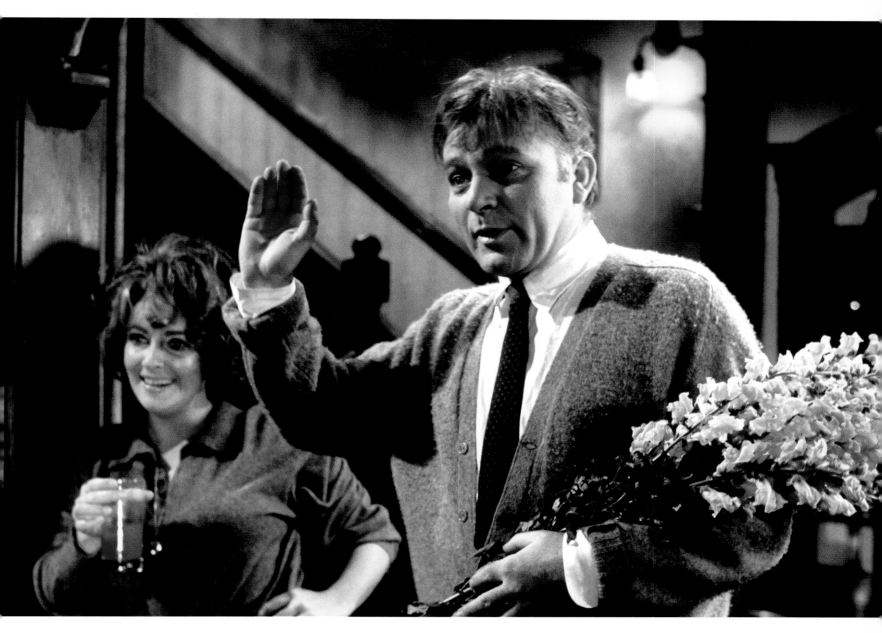

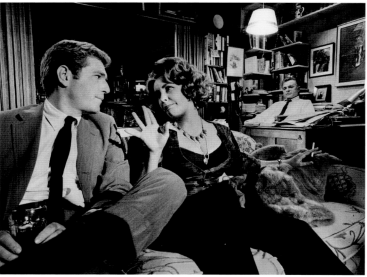

I had never read Edward Albee's play, so I didn't quite know what to expect. It was like a slap in the face when the ugly onslaught of the dialogue first hit me. To hear the acid, vitriolic words day after day was very difficult. After the first week, some of the crew just said "no thanks" and left – something I had never seen happen before and never saw again on any film. Talking with some of the crew, they told me that it was hard not to take some of it home with them. The Burtons were in full flower on this film, and because they were so good, it all became too real at times.

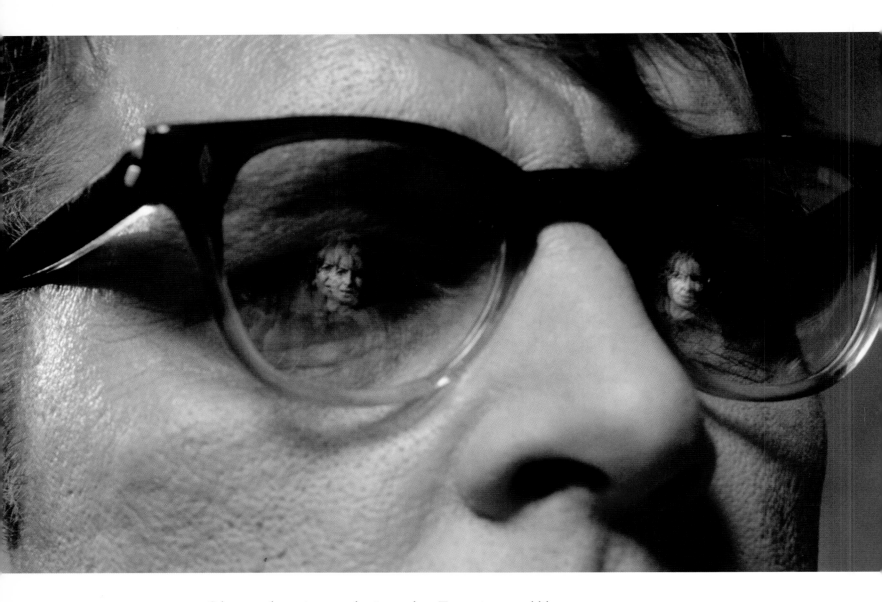

Of course the script was classic combat. To me it seemed like a duel of personalities both on and off the screen. It was marvelously intense, and as I said before, they were so good in these roles it was hard to believe that they were acting.

If you were a young actor, it would have been wonderful watching these two perform every day, as this combat took place. There is no doubt that Burton was a really superb actor, but he gnashed his teeth more than once as Elizabeth's presence took over scene after scene.

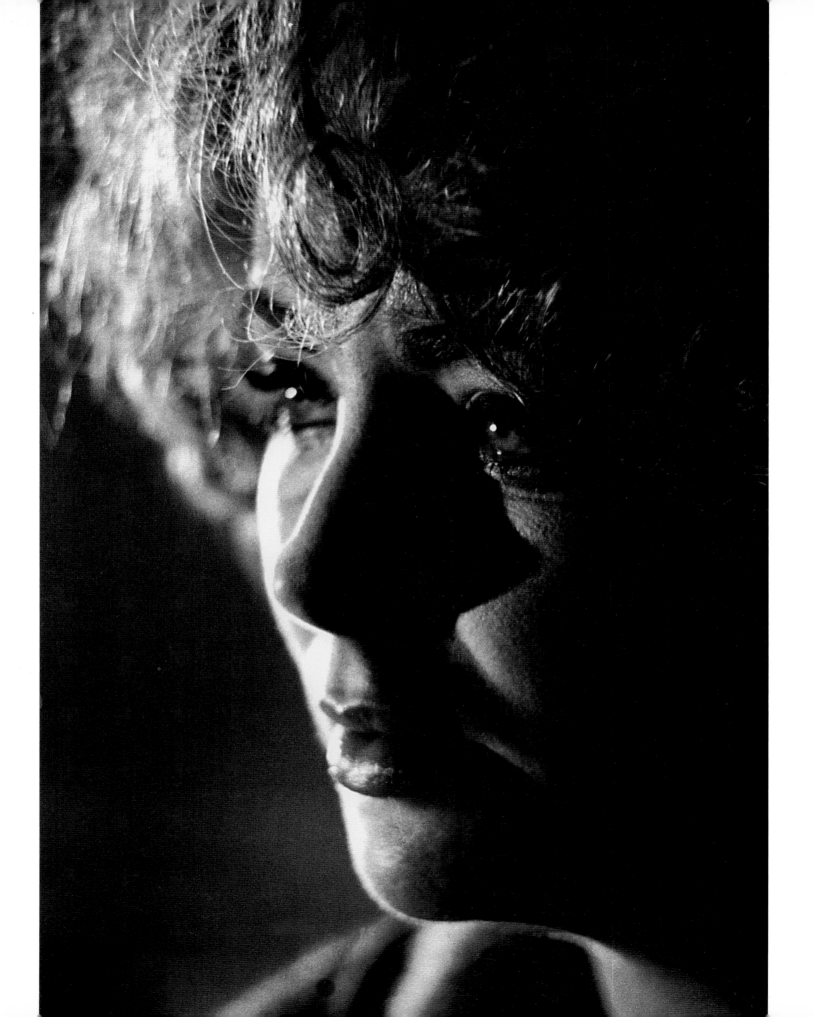

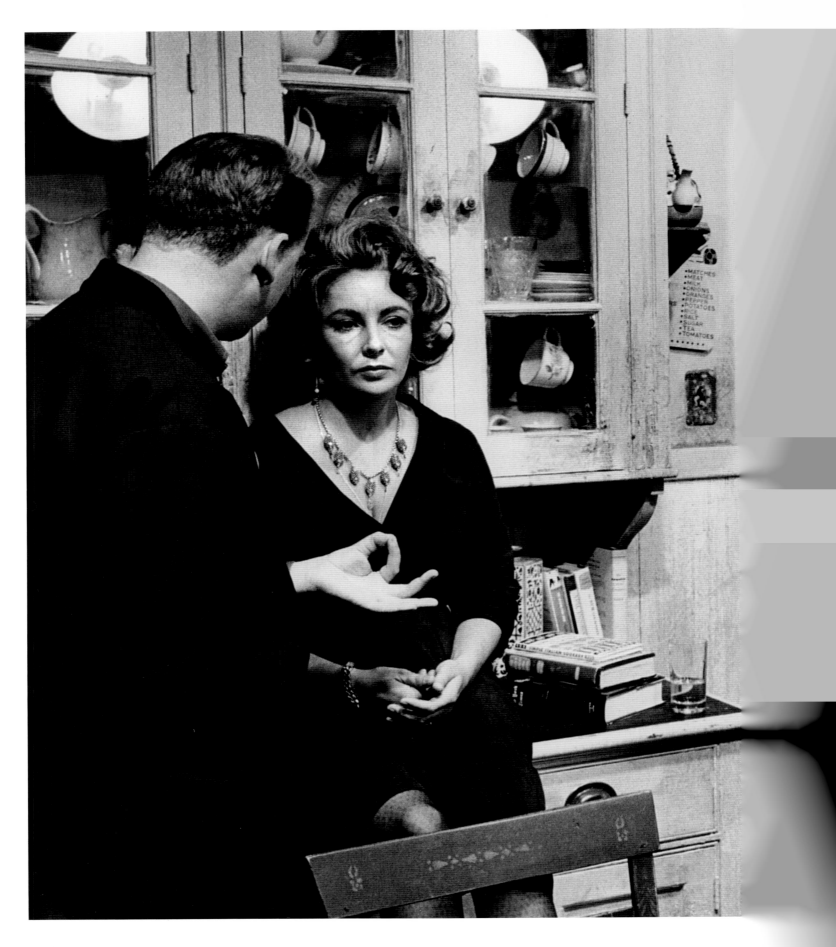

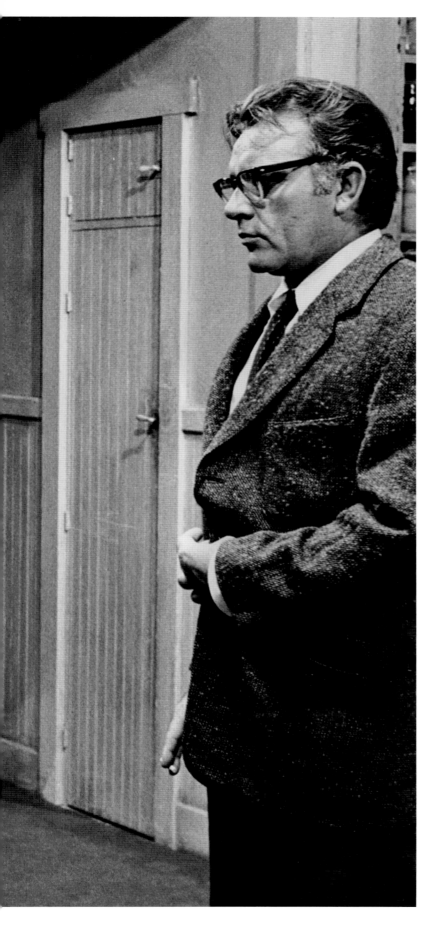

Another thing I noticed was that the direction that Mike Nichols gave the Burtons was not always accepted readily at first. Both of these actors had been in the film business a long time, and this was Nichols's first film. I think they both needed to know where he was coming from as he shaped their performances.

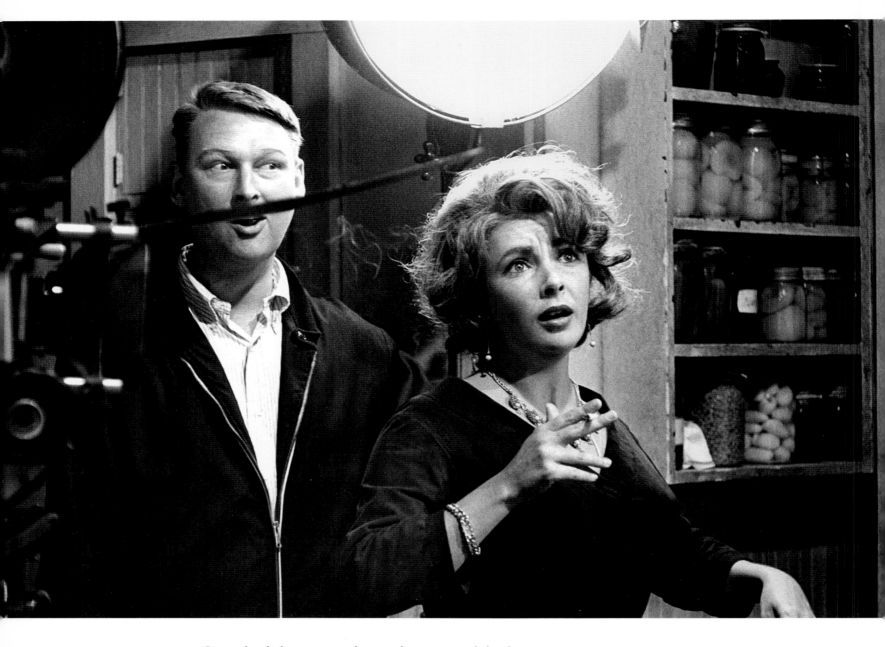

Since the dialogue was so heavy, the actors and the director
found it was necessary to bring a bit of whimsy to the set
whenever they could. Nichols, coming from a New York comedy
background, was particularly good at this (*above*), but Elizabeth
herself was also marvelous at breaking down the doom-ridden
atmosphere (*right*).

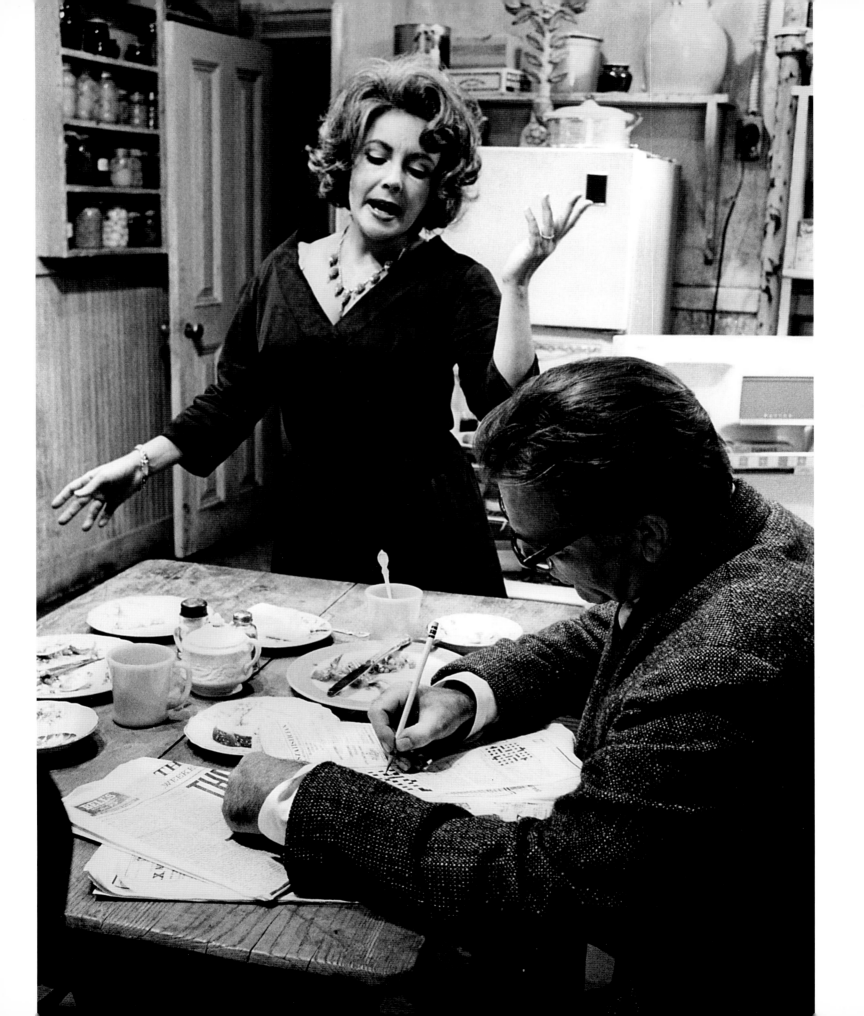

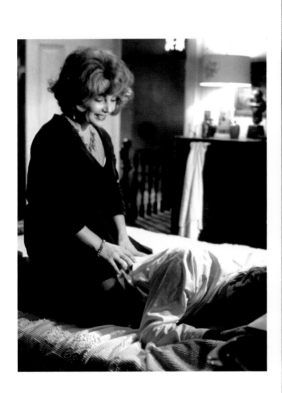

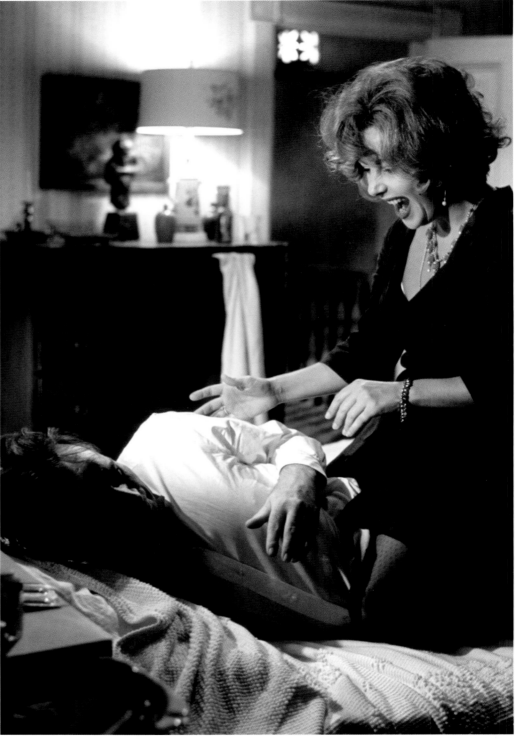

As Elizabeth and Burton start rehearsals for a scene in the bedroom, Elizabeth gets astride him as he pretends to sleep. But the temptation is too great for her, and she really starts to tickle him. He is not amused, but the fun has taken over, and the rehearsal just has to wait.

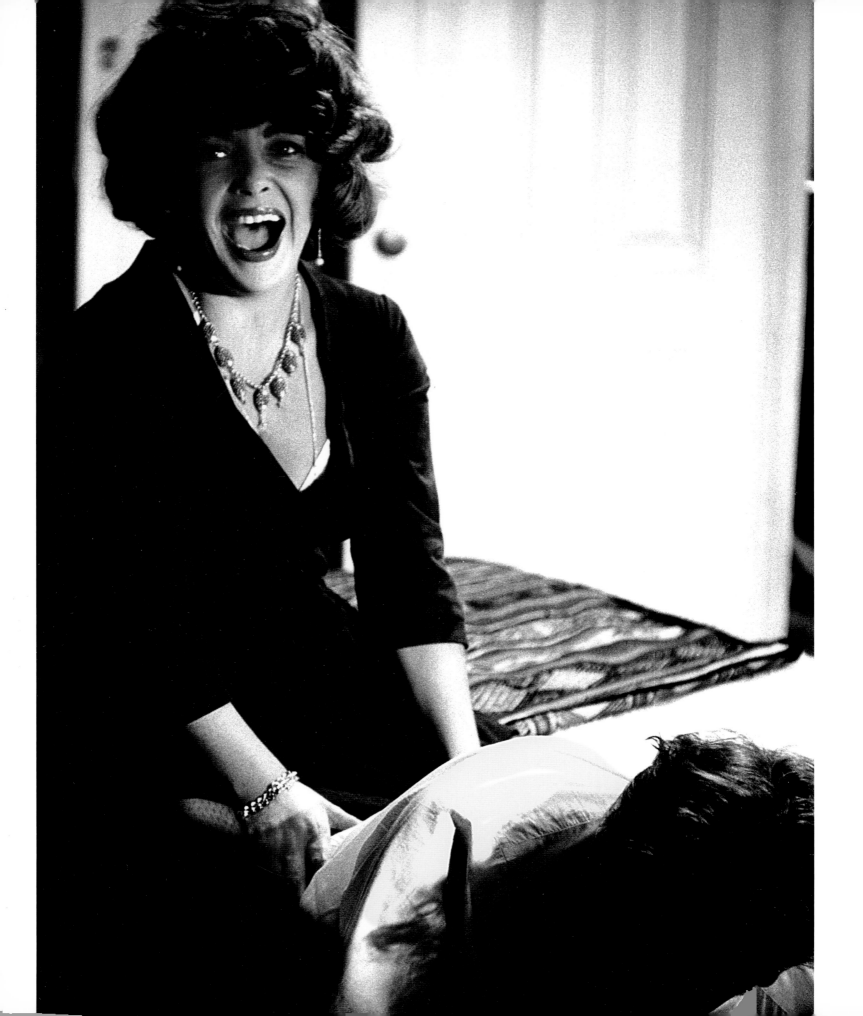

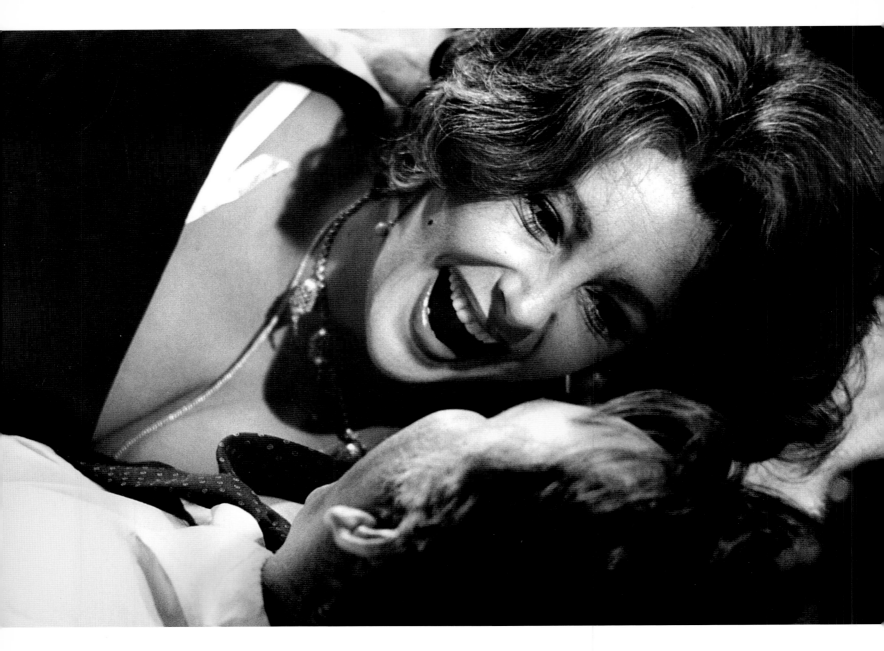

Elizabeth has broken the tension on the set with her laughter
(*above*) – which everyone needed – and then in flash she is
back in the role of Martha (*right*). She learned her lessons well
in the years before the camera. No prolonged emotional build-up
before the scene; reaching down into her psyche for something
to build the scene on.

She already knew, like Burton, how the scene would play, and
there was never any fuss or drama. They just rolled the cameras,
and away the pair of them went. Elizabeth won her second
Academy Award for this performance.

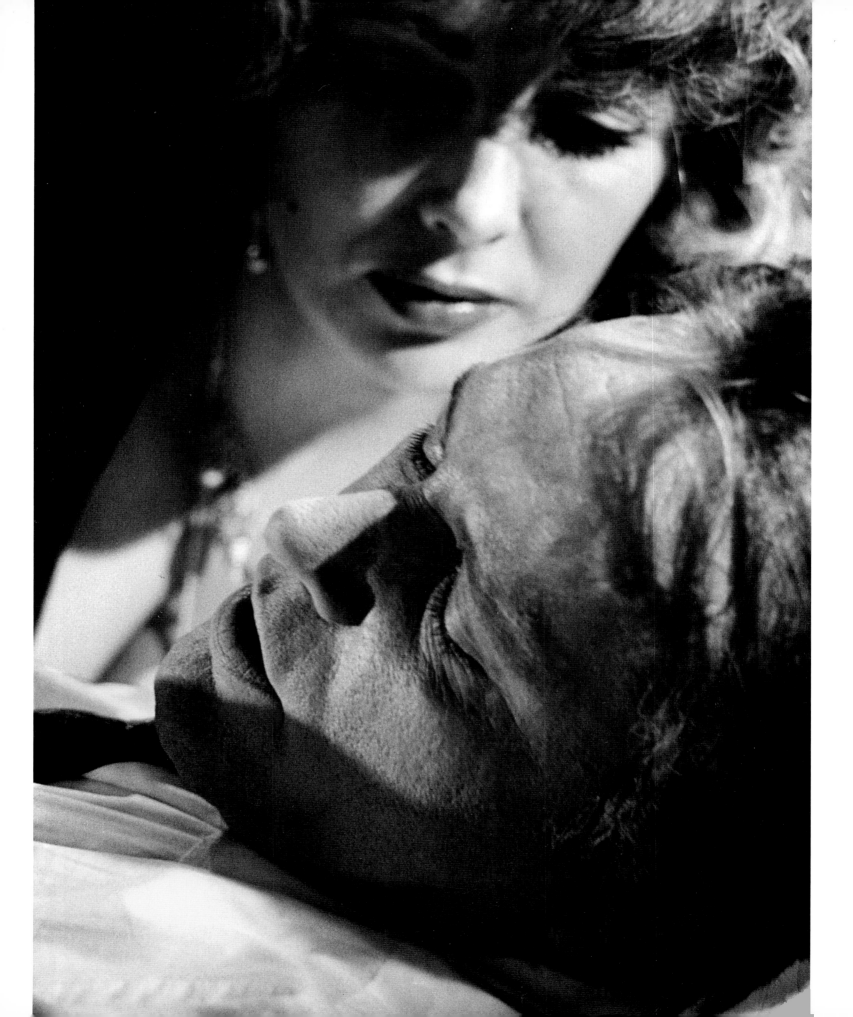

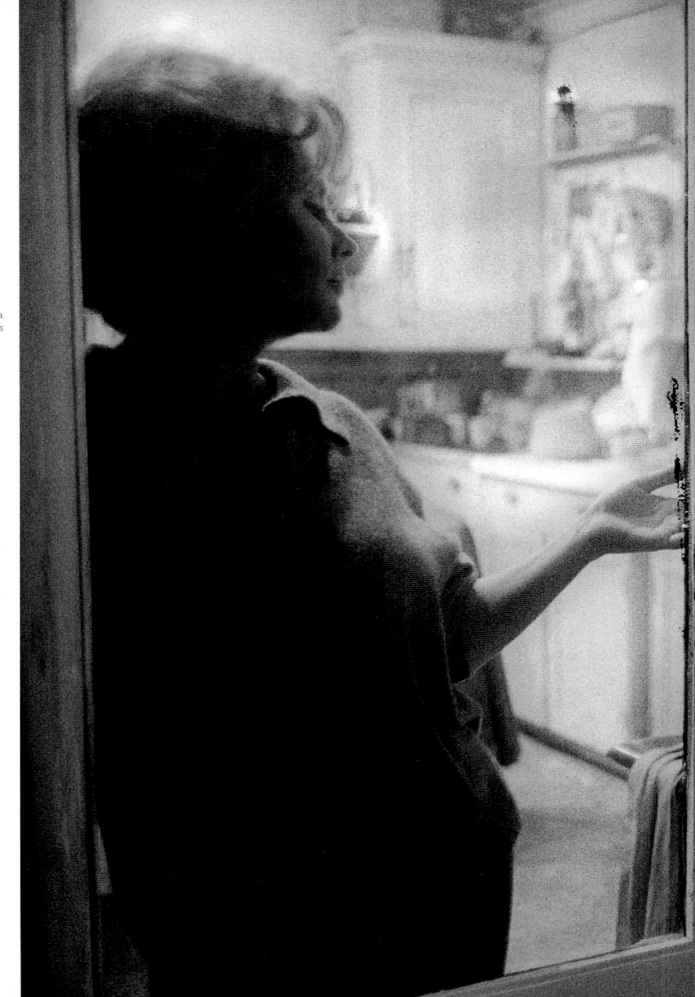

RIGHT Elizabeth caught in a moment of introspection as she prepares quietly for a forthcoming scene.

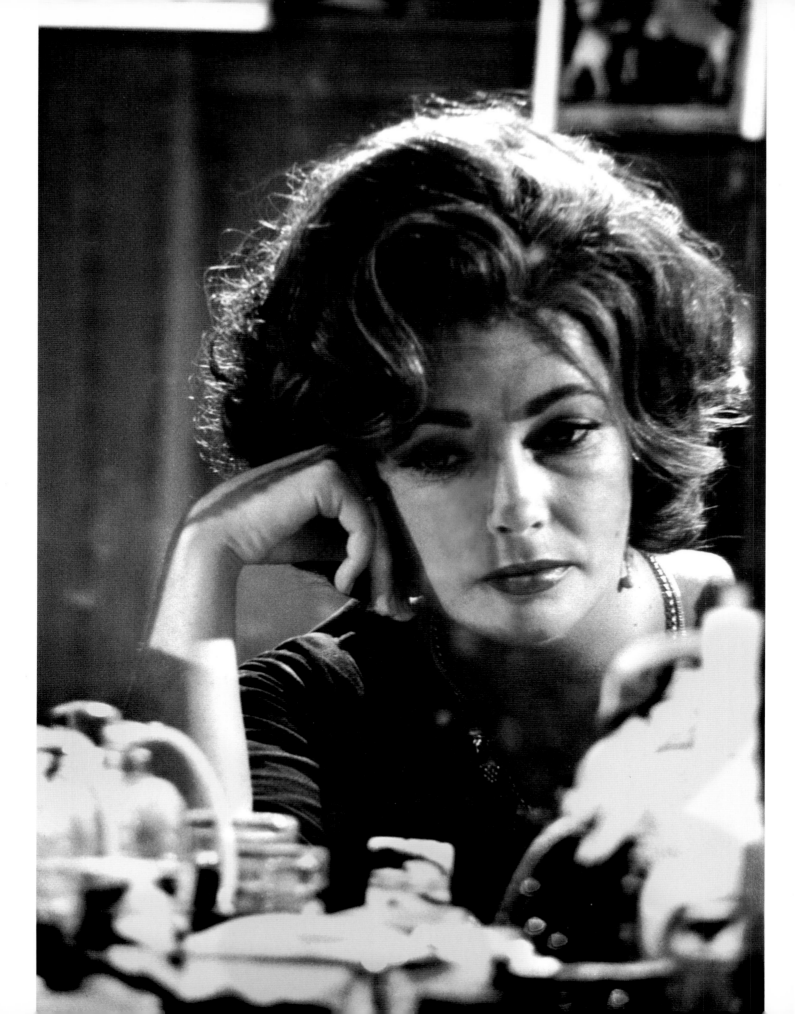

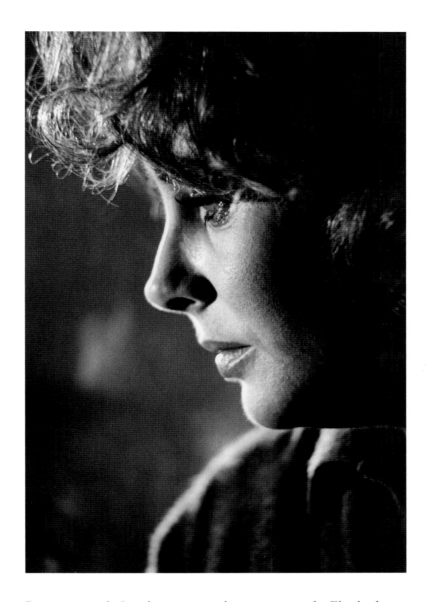

By no means do I wish to convey that it was easy for Elizabeth to play this part: rather, she just didn't have time for being the drama queen. And Richard Burton wouldn't have stood for that in any event.

She knew her job, and prepared for her coming scenes by quietly withdrawing into herself. For those that are working on the film set, this is a quality that makes everyone else's job that much more pleasant.

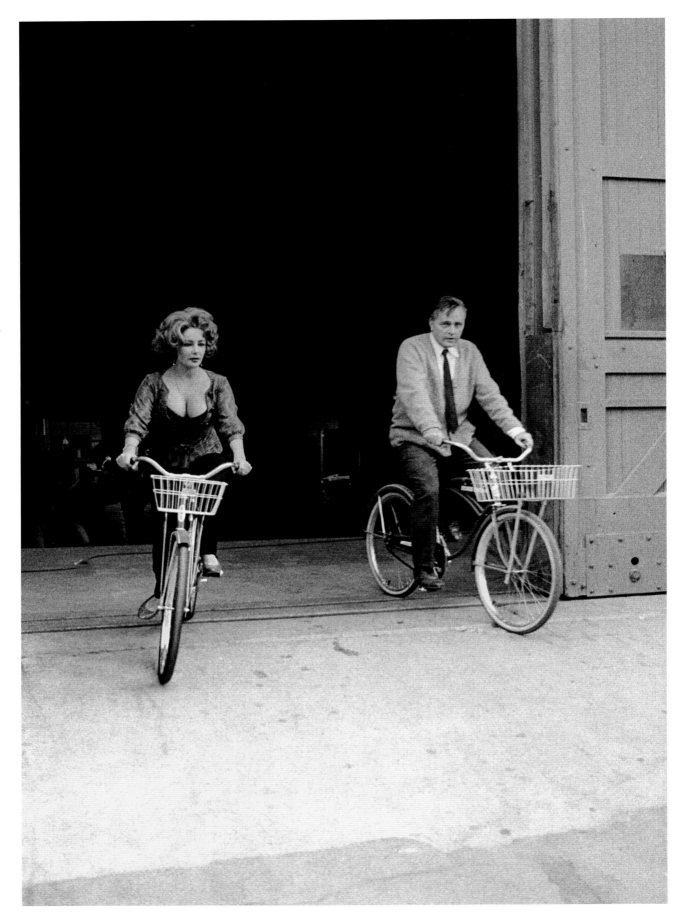

RIGHT The Burtons tool off on their bicycles at lunchtime, heading to their permanent dressing rooms on the Warner Brothers Studio lot.

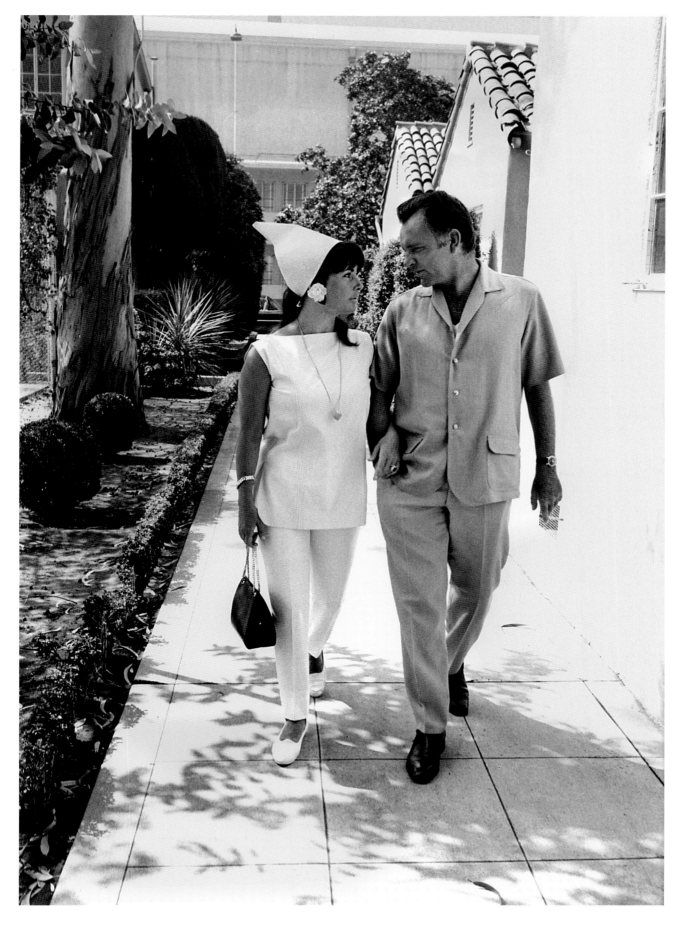

LEFT After working with the Burtons and seeing them in their makeup all day, it was good to see they still looked beautiful on their way home at night.

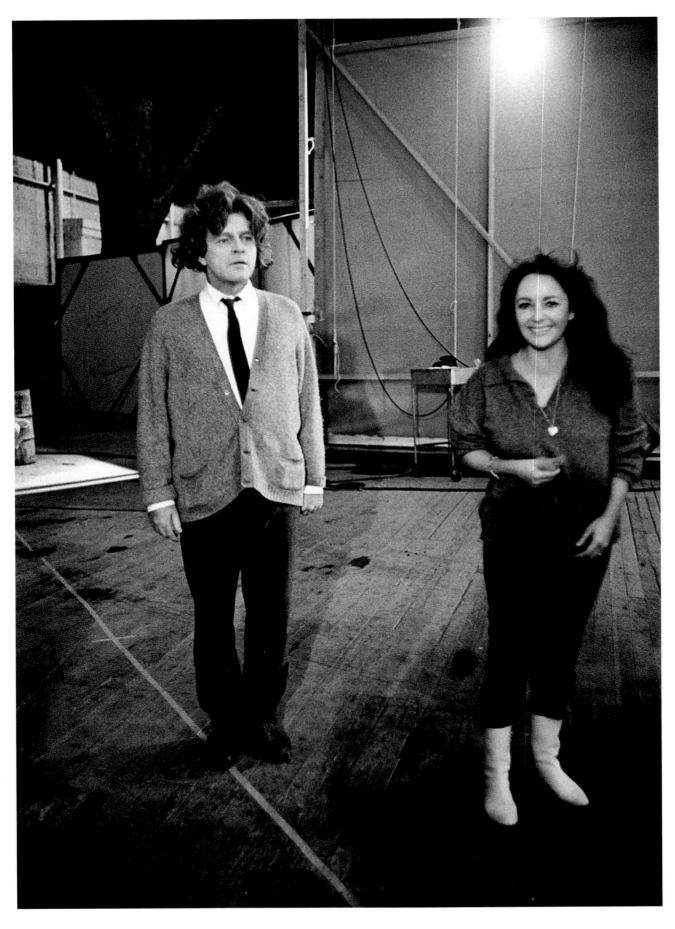

LEFT Elizabeth had a great influence on Burton's sense of humor; I felt he wasn't much prone to humor when she wasn't around. Here you see him wearing Elizabeth's wig after shooting is finished for the day.

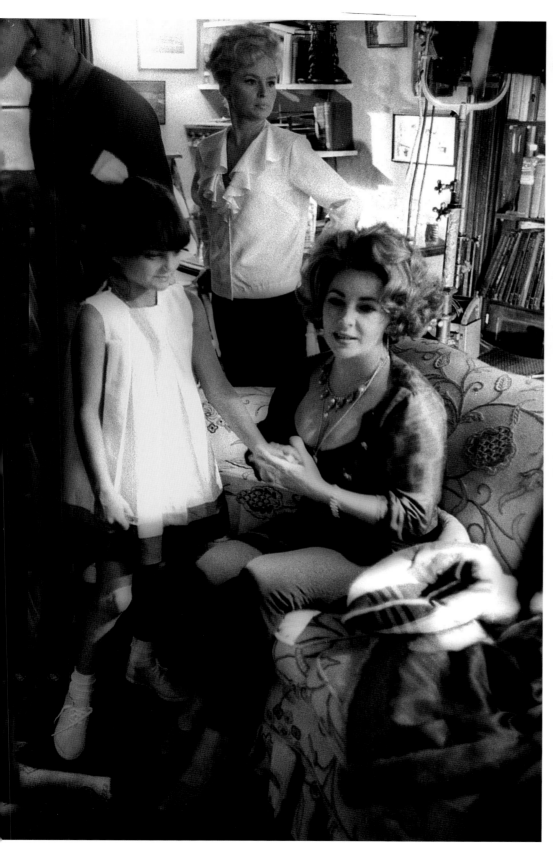

LEFT Elizabeth's daughter Liza Todd visits the set, and Elizabeth holds her hand while waiting for filming to begin.

ABOVE Burton pretends to give Liza an upper-cut to the chin. She seemed something of a lonely child, and when Burton paid attention to her she blossomed noticeably.

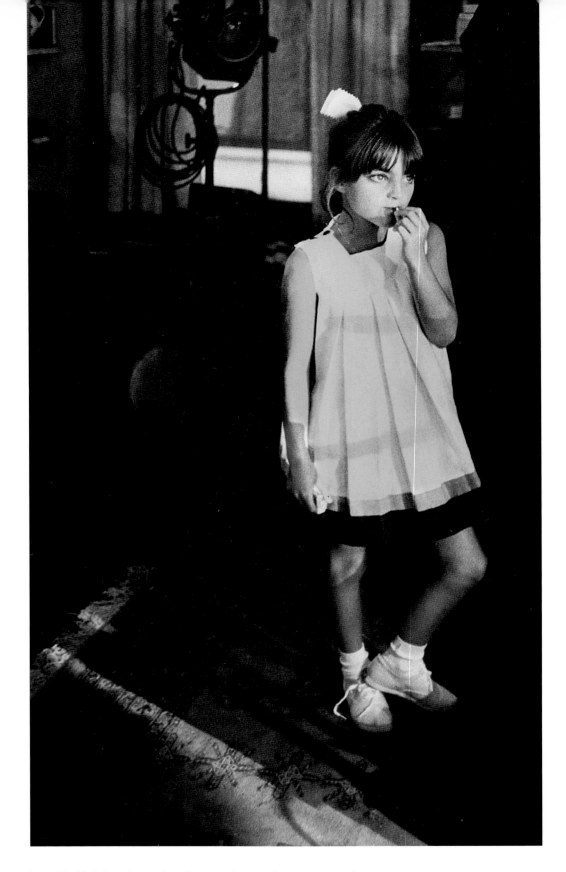

Liza Todd (*above*) watches her mother as she starts to rehearse the roadhouse sequence. I wondered what went through the little girl's mind as she saw her mother acting drunk and dancing wildly with George Segal (*opposite*).

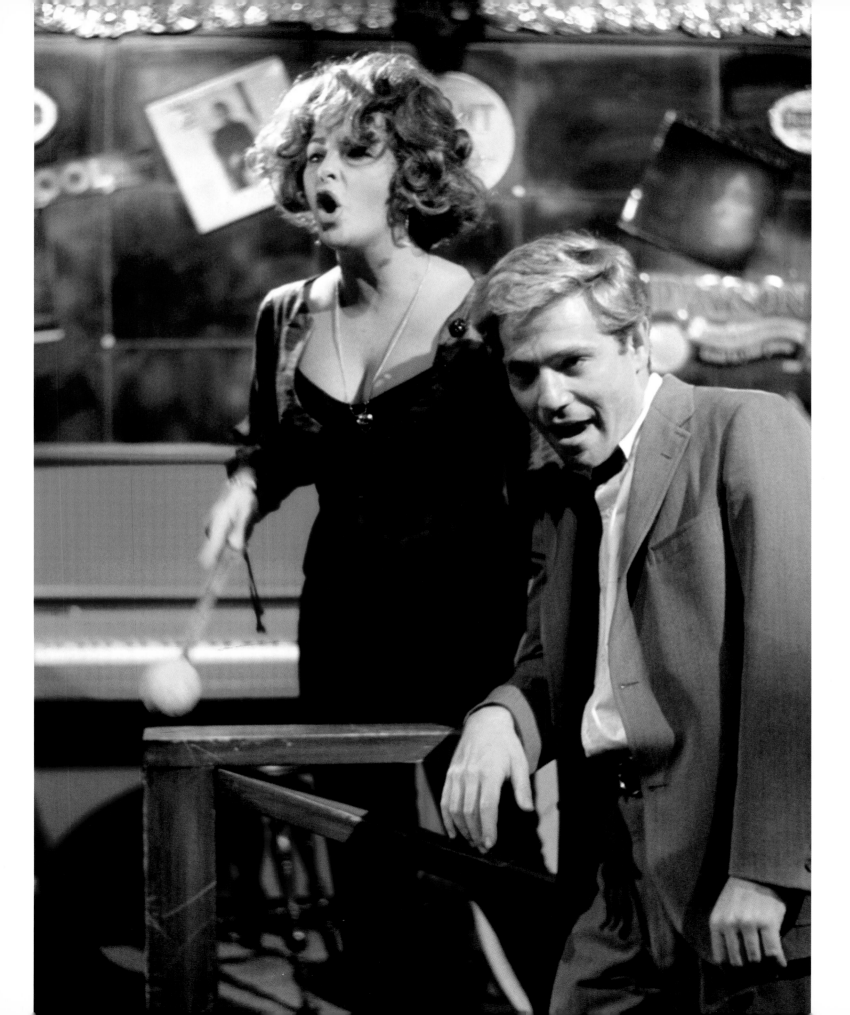

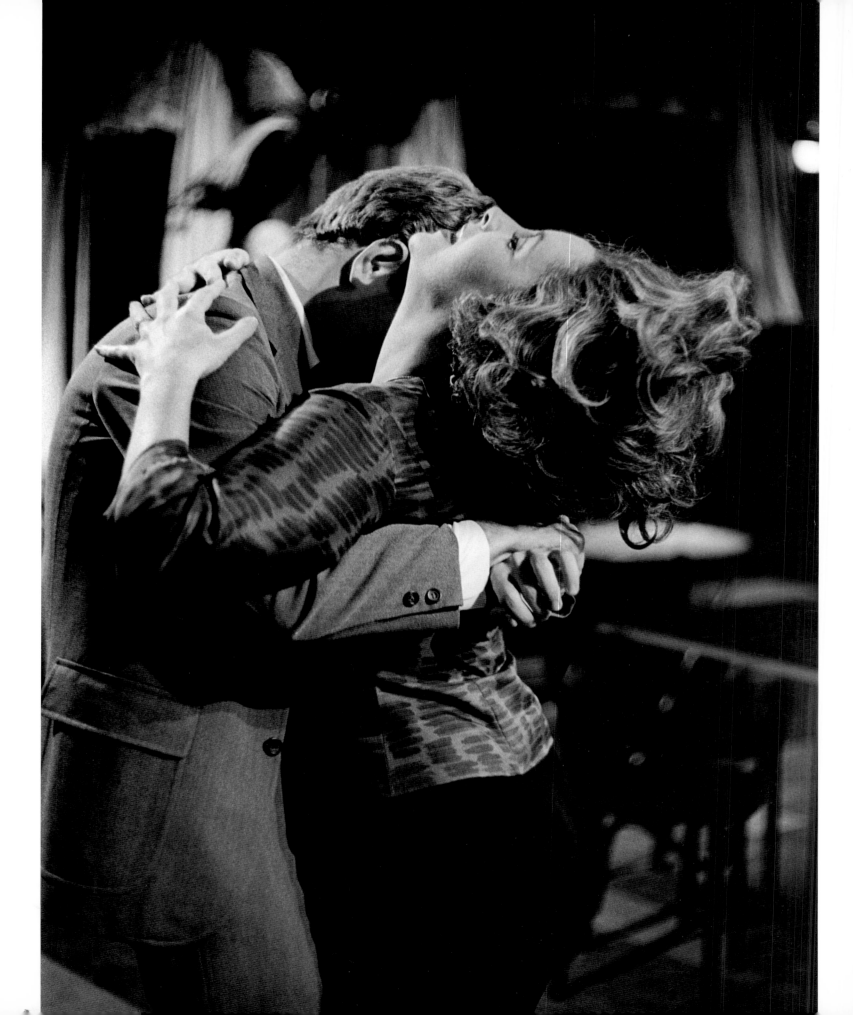

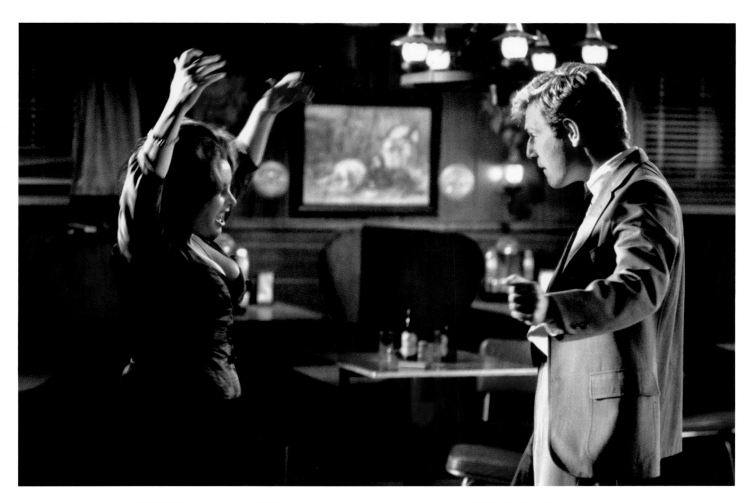

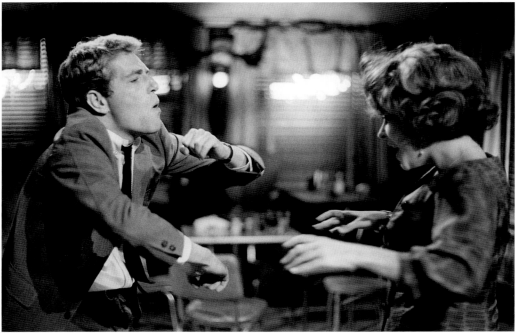

In the film, of course, Martha isn't really interested in Nick: she is dancing madly to infuriate her husband George, which she does with great success.

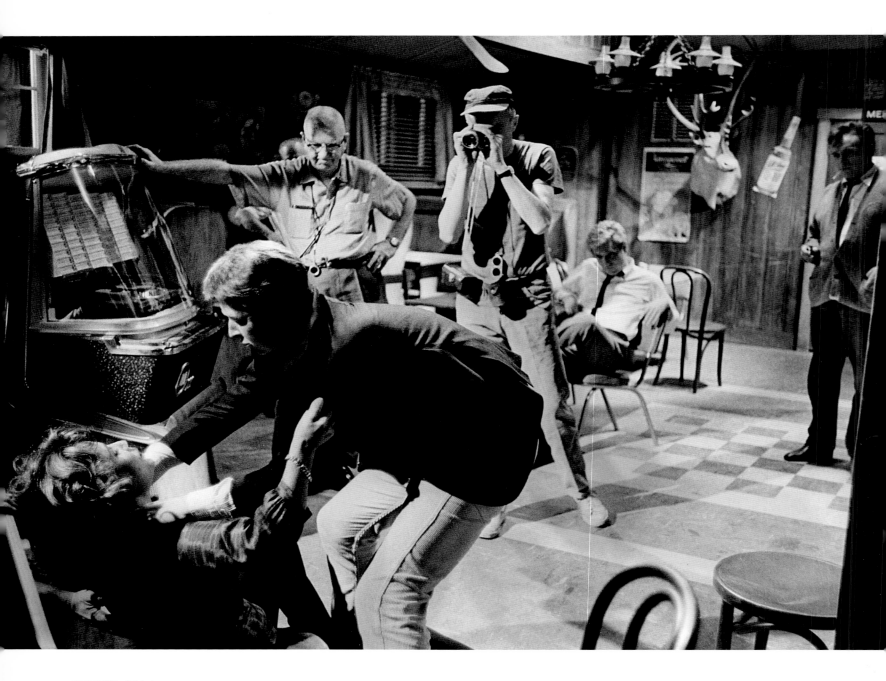

ABOVE Mike Nichols demonstrates how he wants Burton, as George, to try to strangle his wife (Burton watching at far right). Cinematographer Haskel Wexler watches the action through his viewfinder; gaffer Frank Flanagan decides how to light the scene.

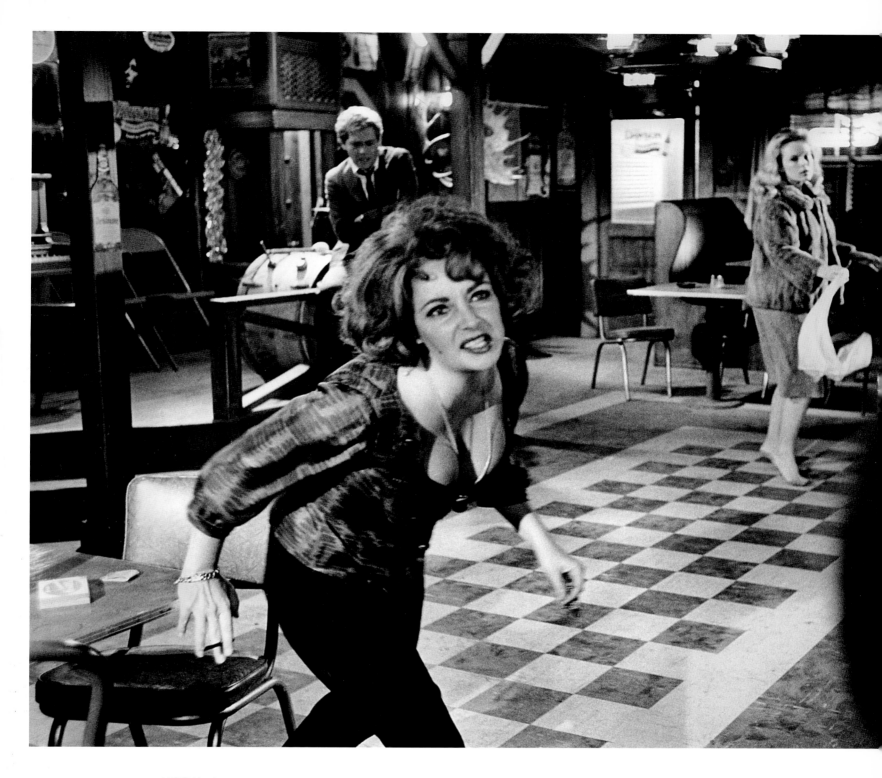

ABOVE Martha taunts George until he erupts from his alcoholic haze.

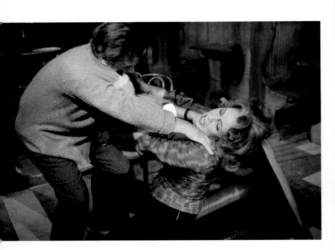

THESE PAGES George has been goaded beyond endurance, and all hell breaks loose.

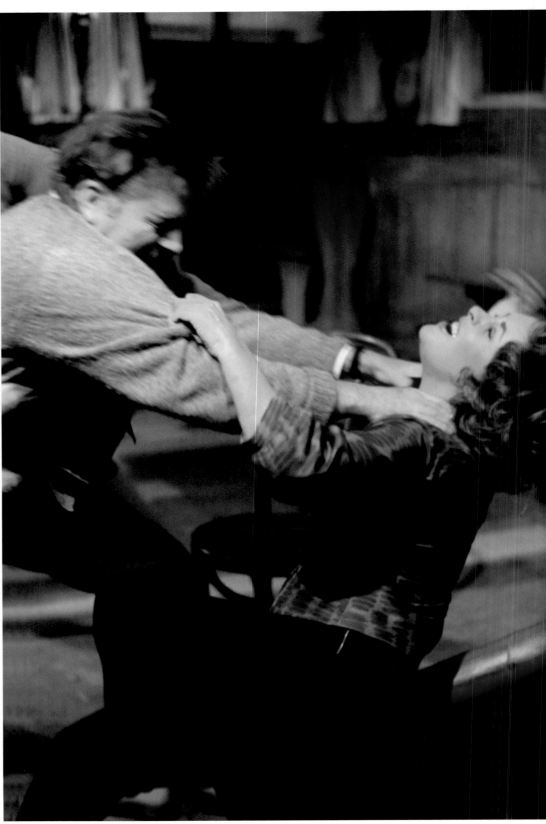

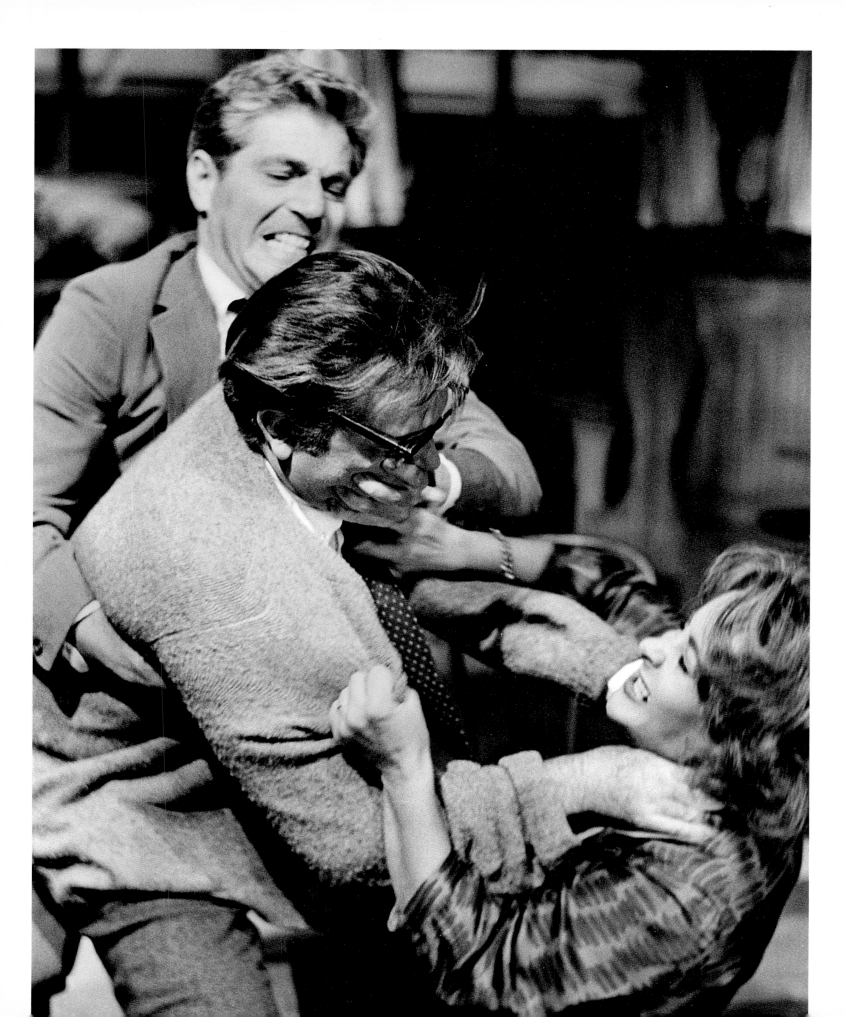

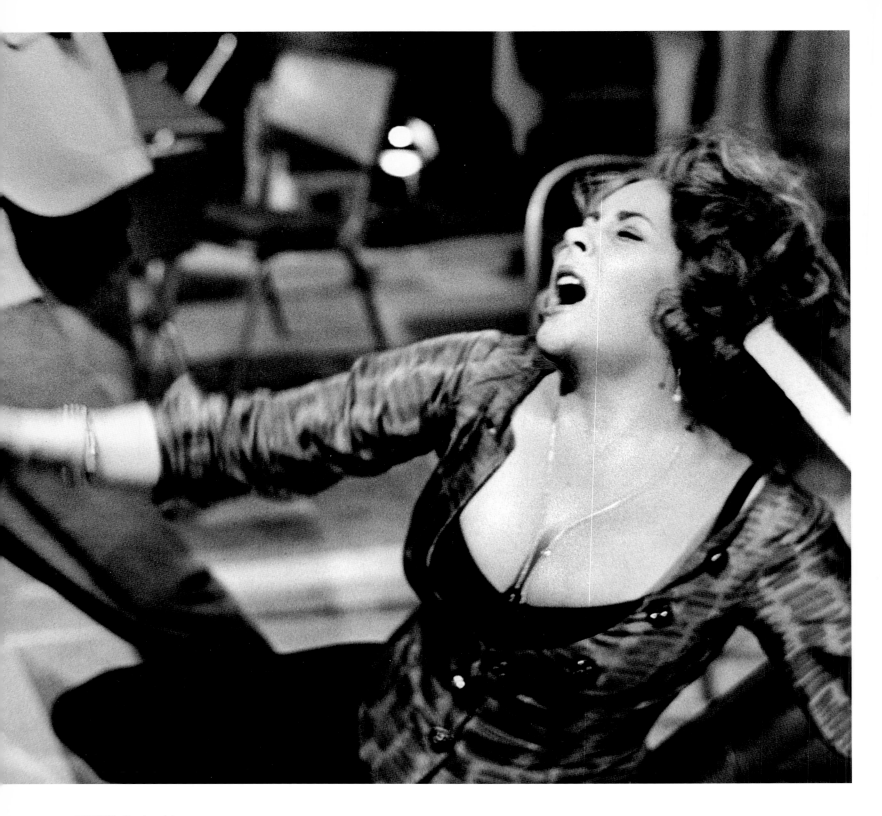

ABOVE Martha slams into the table and they both go crashing to the floor. The scene was more than a little realistic, and when it was over, Nichols came over immediately to see if any of his troops were hurt.

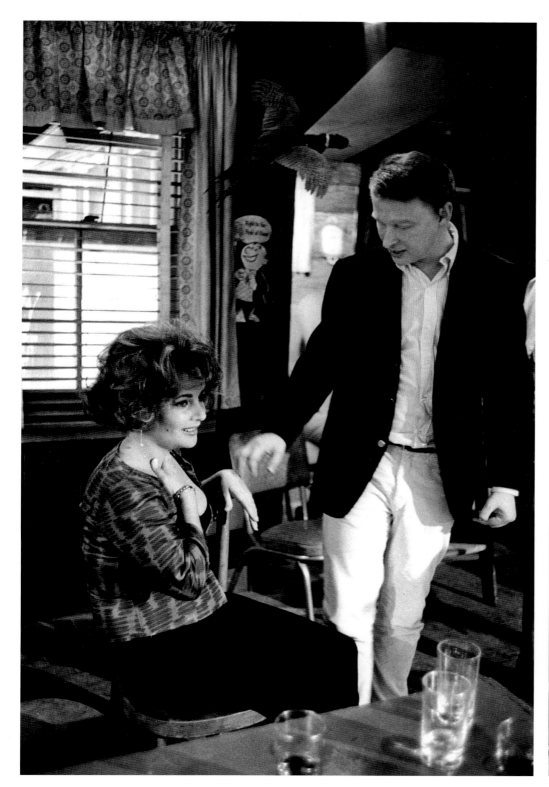

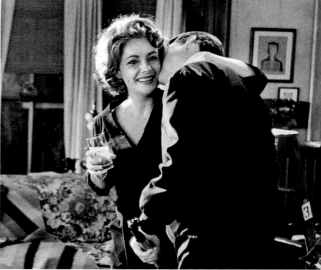

ABOVE LEFT & RIGHT
Elizabeth massages her
neck, and earns a kiss from
the director for such a
memorable performance.

141

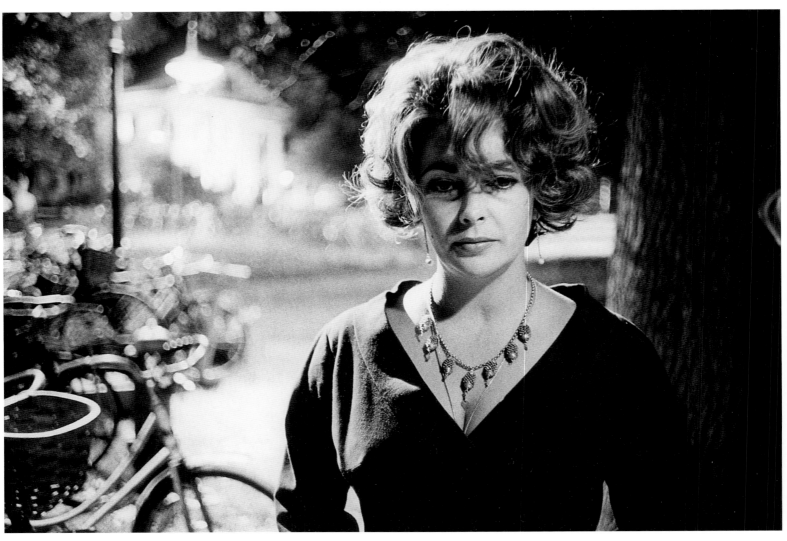

Then the company moved to Smith College, in Northampton, Massachusetts, for the exteriors. Filming went on all night long, it was cold, and it took an incredibly long time to light the campus grounds. All this, added to the continuing dialogue we had to listen to every day, wore most of us down.

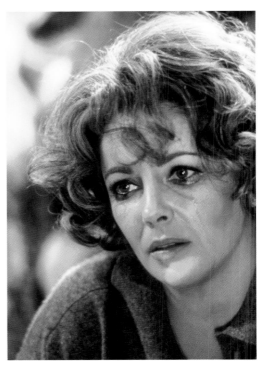

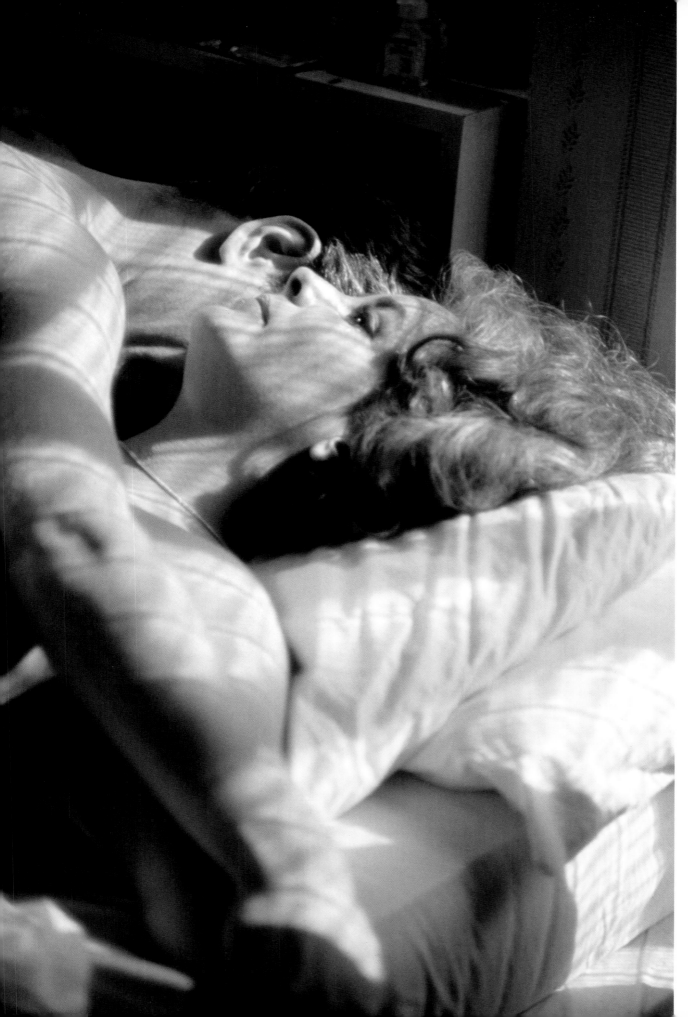

LEFT In a scene not
included in the final cut,
Martha, bitter, alcohol-
dazed, and wishing to
punish George for
whatever imagined wrongs,
goes to bed with Nick.

143

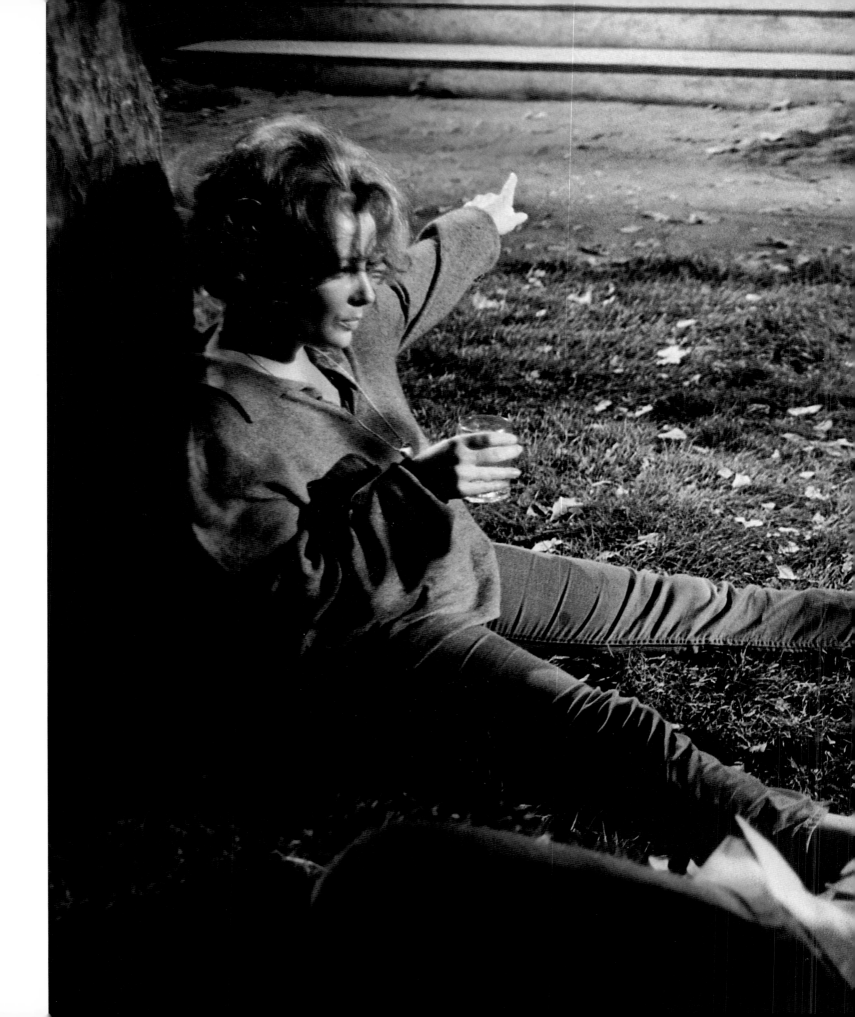

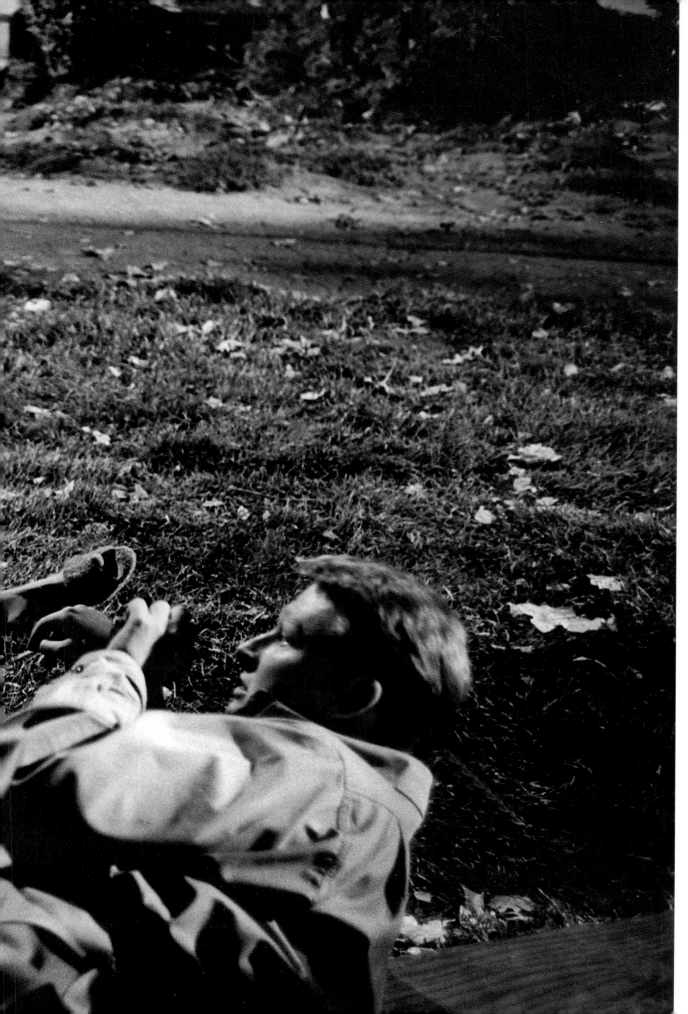

LEFT The night shooting on the Smith College grounds grinds on. Here, as Mike Nichols (holding his viewfinder) decides where to place his camera for the next shot, Elizabeth confirms her movements that will bring her to this spot.

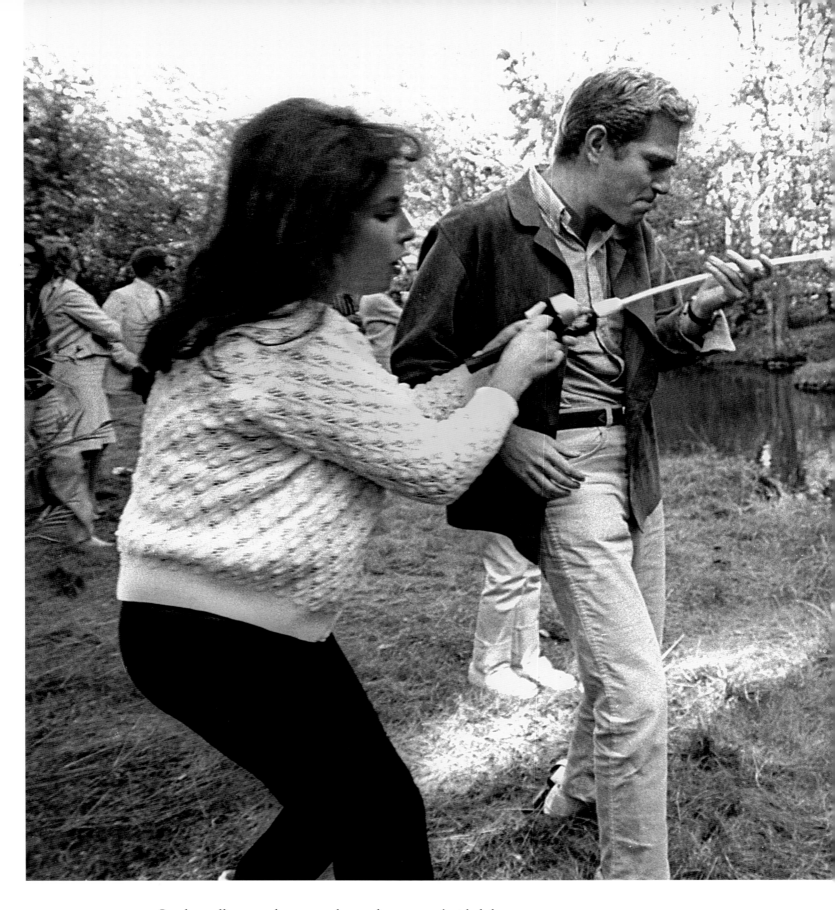

Sundays off were a chance to play, and someone decided that
fishing was called for.

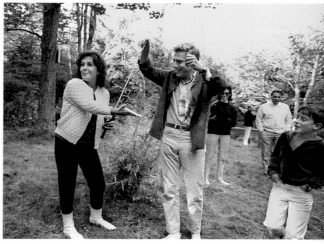

LEFT George Segal helps Elizabeth as she catches a fish, which really delights her.

ABOVE Hearing her squeals, Burton and one of the Wilding twins amble over to see what all the excitement is about.

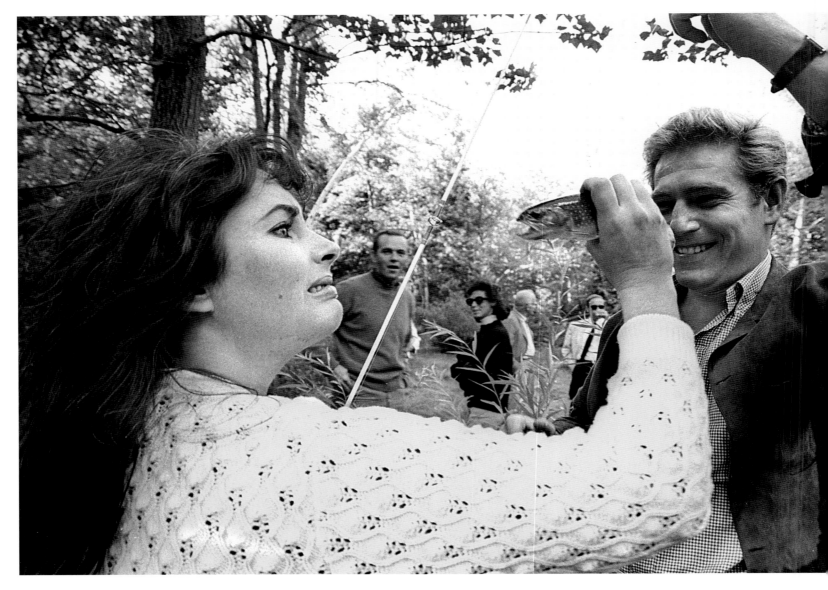

ABOVE Elizabeth looks the fish right in the eye, decides that's enough for the day, and gives the fishing rod to Segal. I noticed that Segal's wife was not too happy with all the attention he was paying to Elizabeth, and pointedly ignored her: see her hovering in the black sweater.

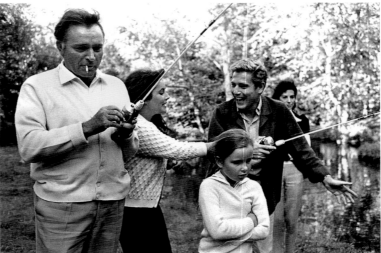

LEFT Burton, with his daughter Kate, decides to see what he can do.

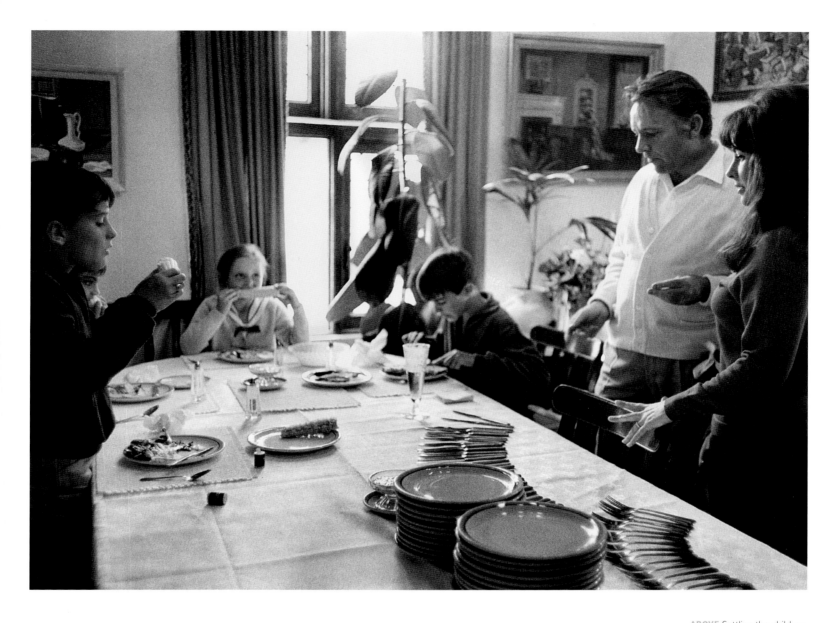

ABOVE Settling the children down for dinner: left to right, Christopher Wilding, Liza Todd (partly obscured), Kate Burton, and Michael Wilding Jr.

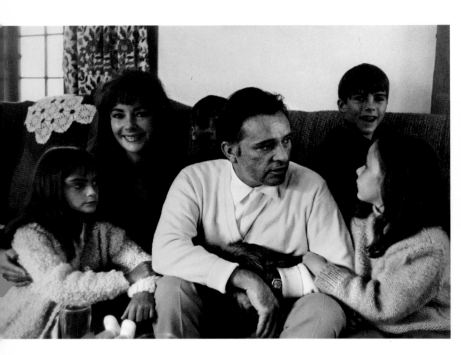

The children get together for a rare group photograph. Notice the look in Liza's eyes as she watches Kate holding on to Burton's arm (*above*), Liza's own arm pushing up against his leg; and the look on her face as she watches Kate enjoying being held in his arms (*right*). Telling images of a little girl who's lost her own father.

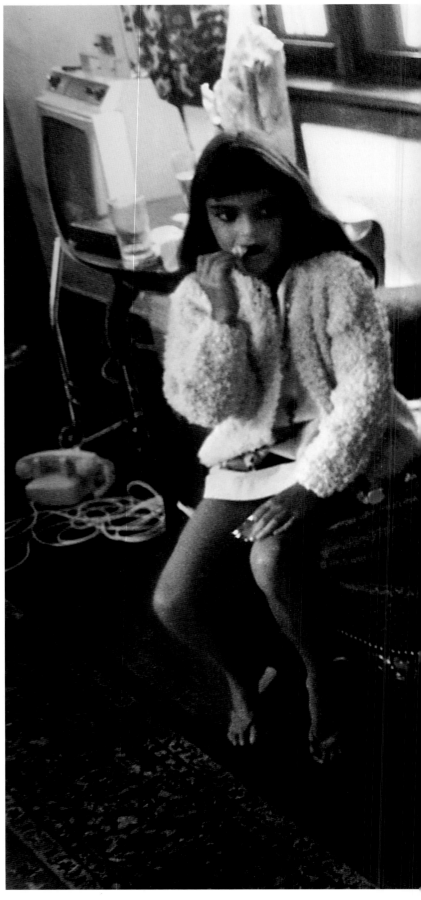

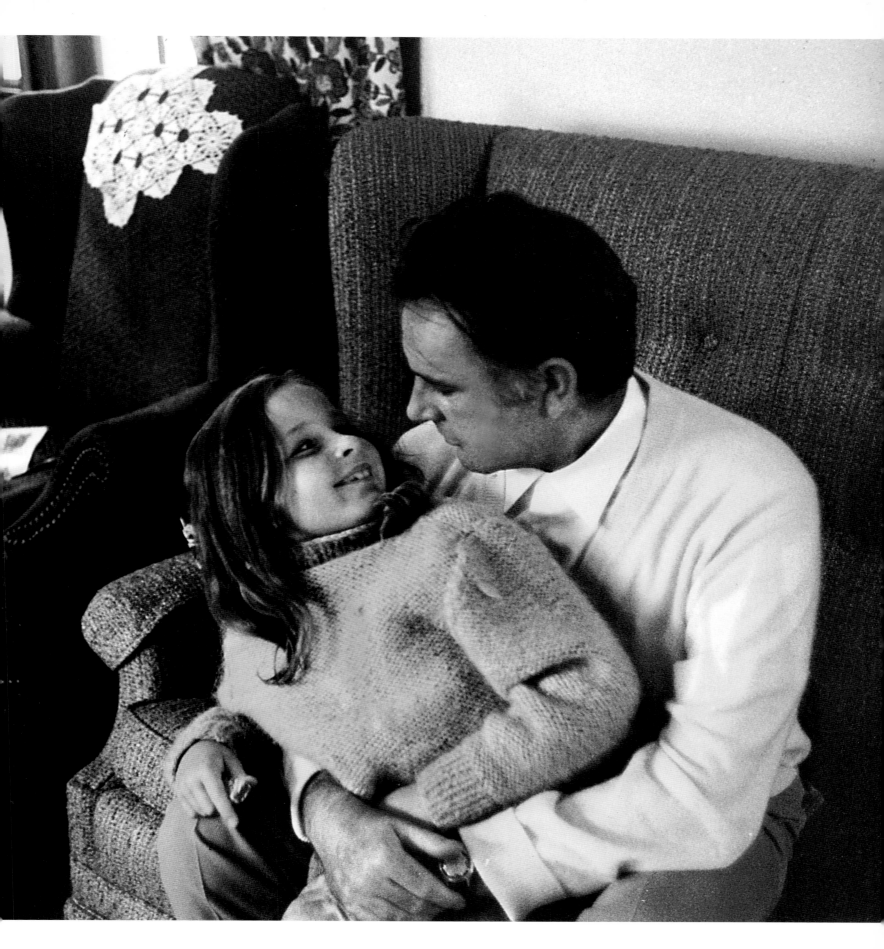

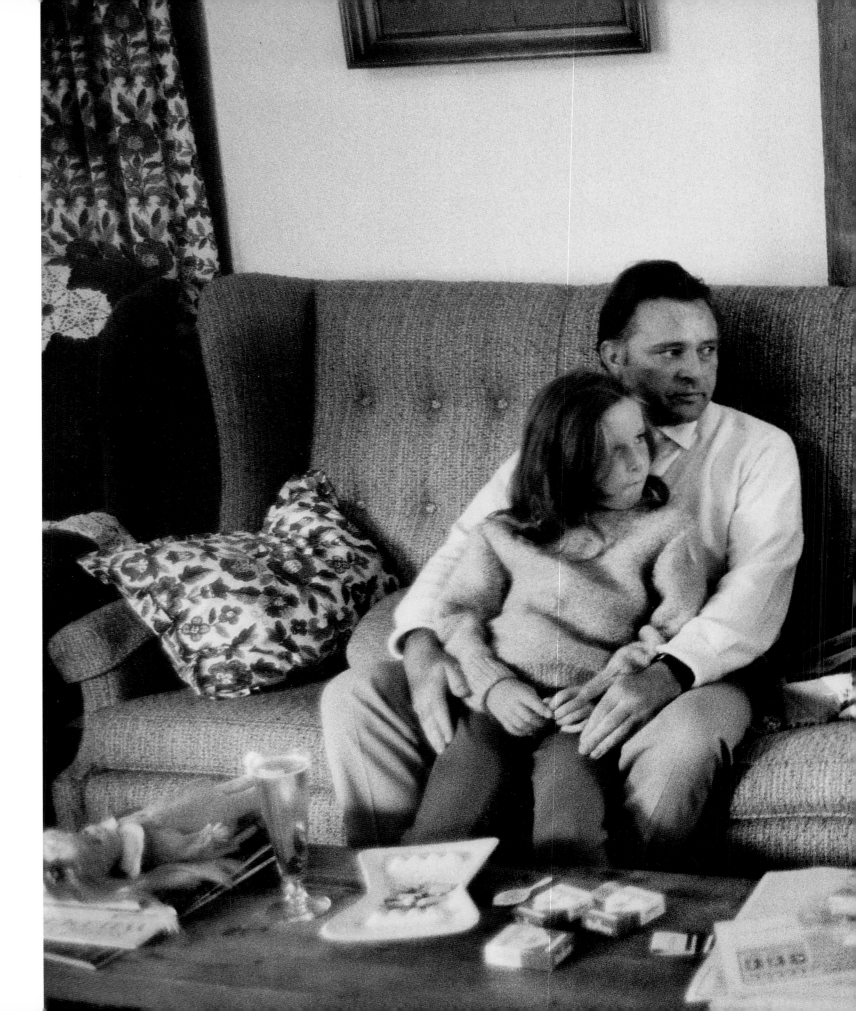

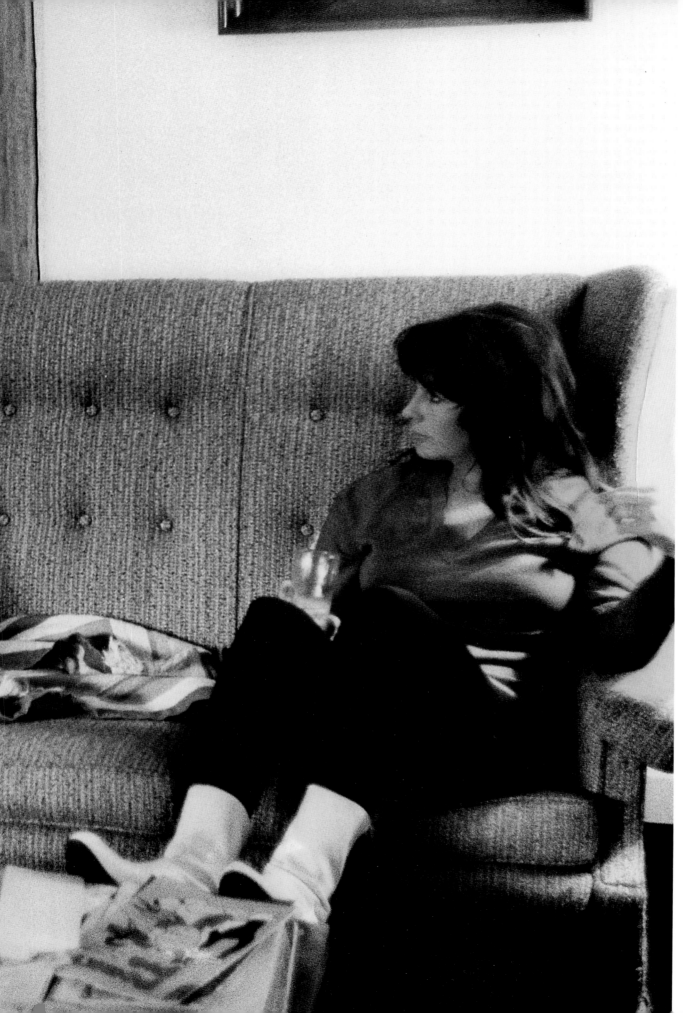

LEFT Every marriage has its moments of discord, and this seems to be one of them. The looks, the separation on the couch, the body language: it is all there. It was only a moment, and while I was working it was the only time I ever observed any negative vibrations between them.

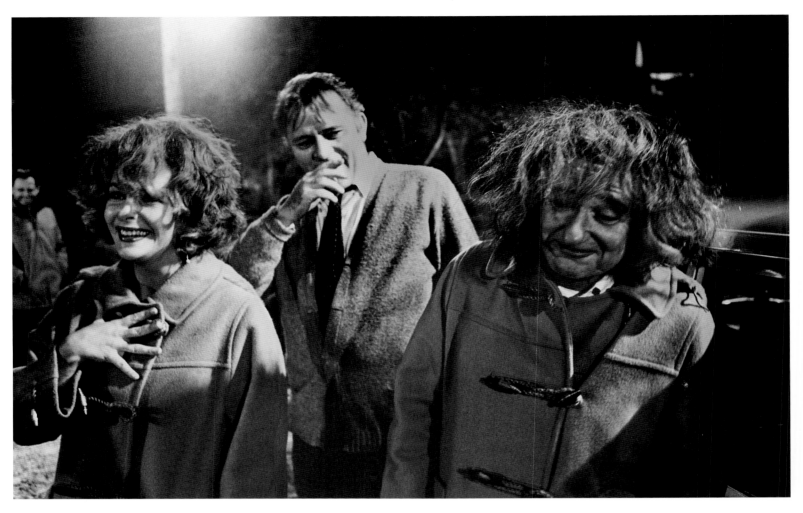

ABOVE The company had to get a stuntman to double Elizabeth one night. They dressed this poor guy in her costume and wig, and when he arrived on the location, everyone broke up.

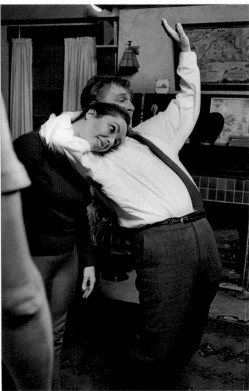

LEFT When we returned to Warner Brothers, the atmosphere on the set was very good. I think everyone was happy to be finished with the long cold nights. Here, Burton pretends to wrestle with Elizabeth, and she obviously loves it.

OPPOSITE Mike Nichols stops by Elizabeth's dressing room.

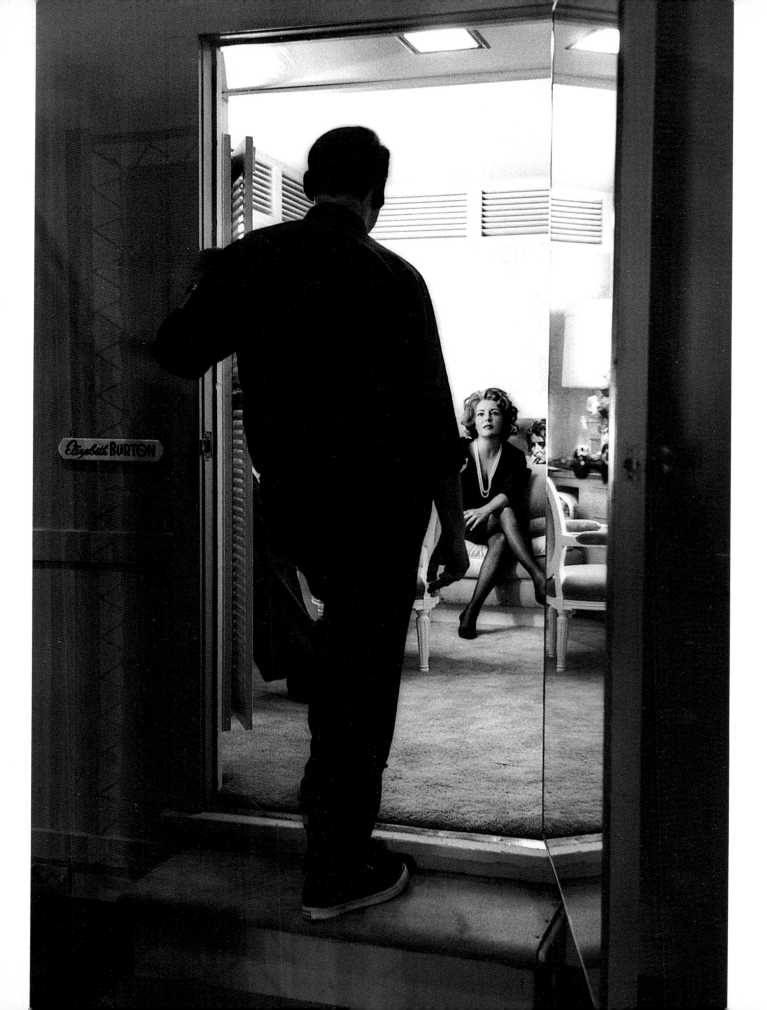

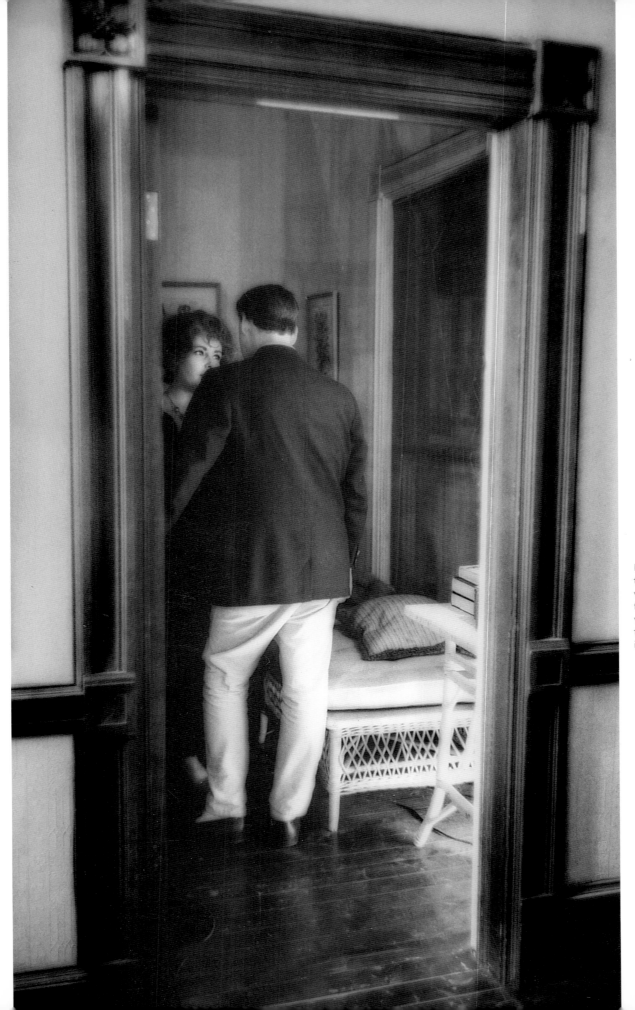

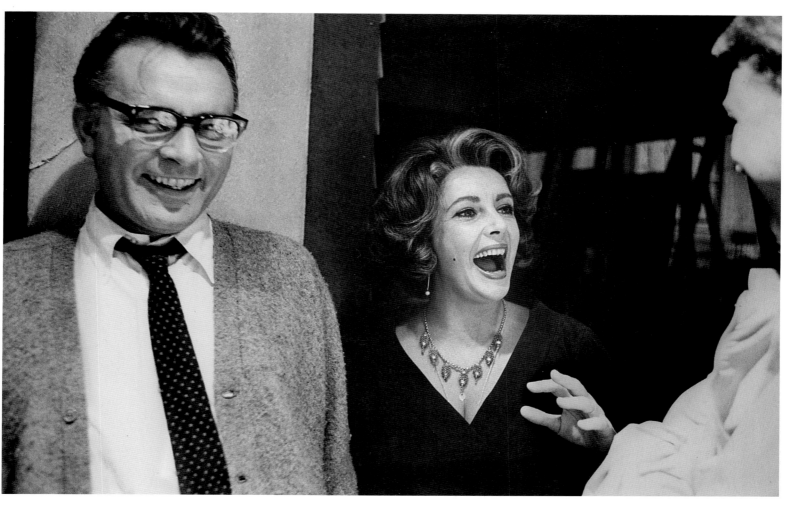

ABOVE & RIGHT Nichols could be very witty, and even Burton couldn't resist laughing at times. He kept the actors buoyant and their energy up, which was a great asset on this depressing film.

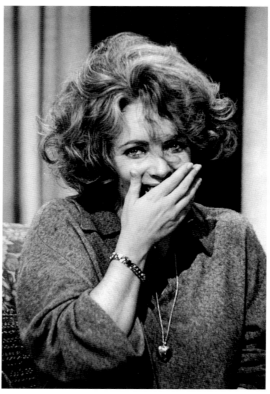

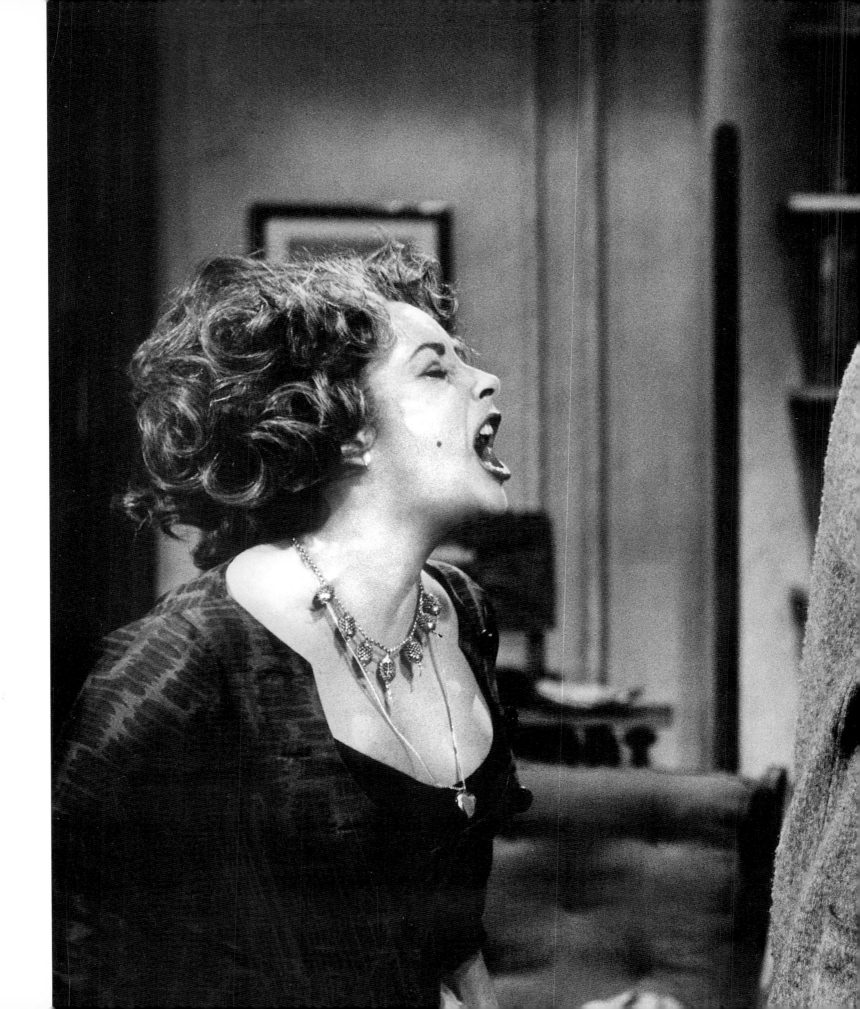

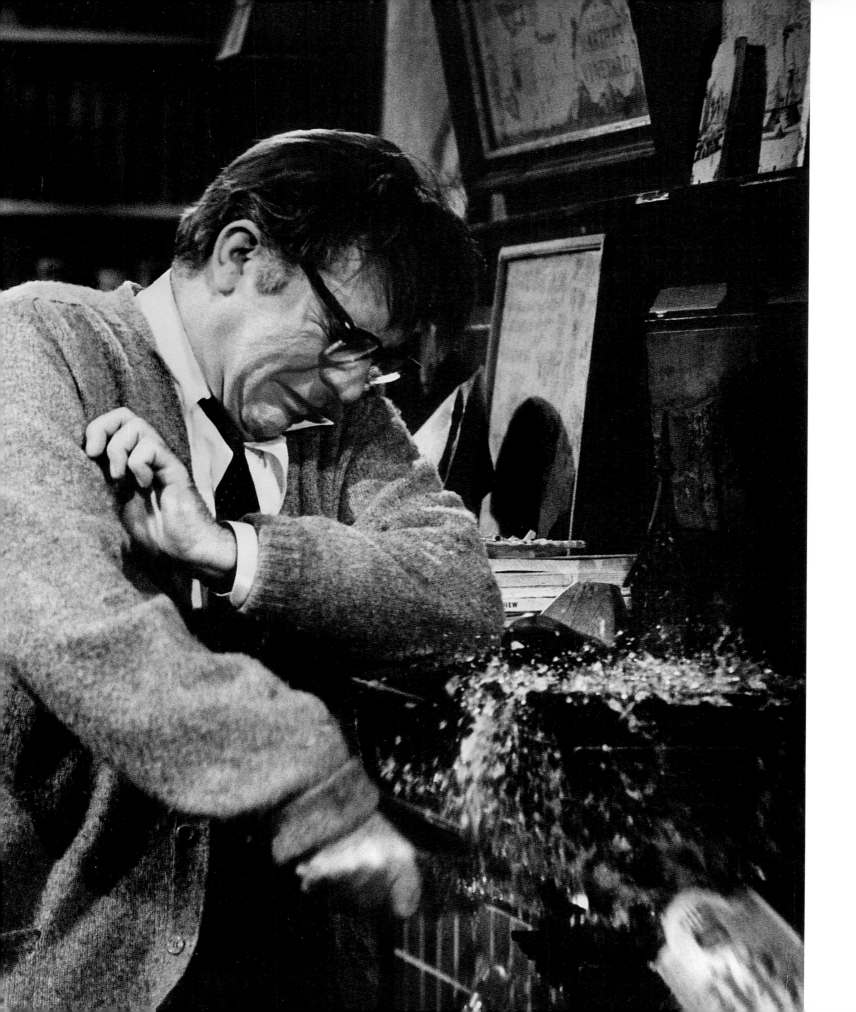

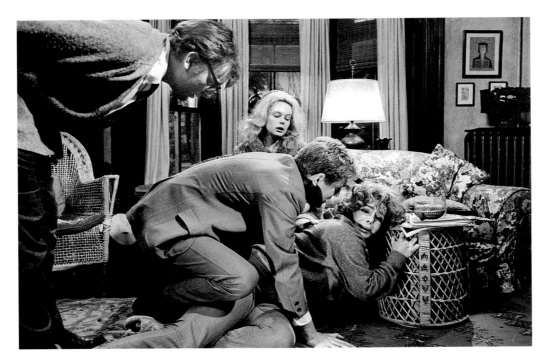

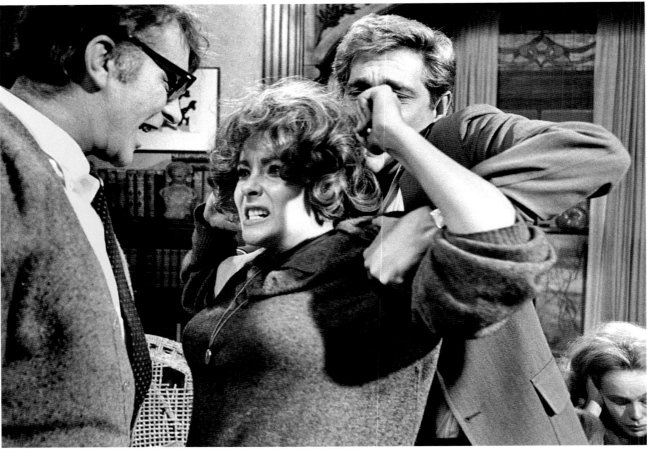

The emotional energy it took to sustain such dramatic scenes
must have been incredible (*see also previous page*). I could see it
had taken its toll on both the Burtons (*opposite*): they seemed
drained after one of the last violent scenes in the film.

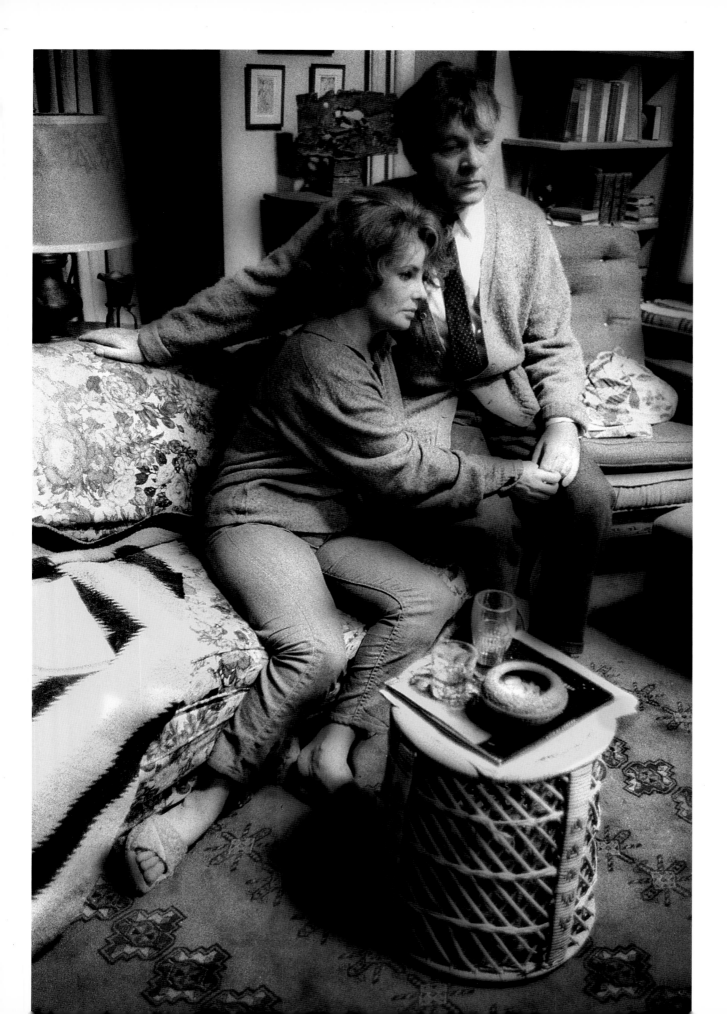

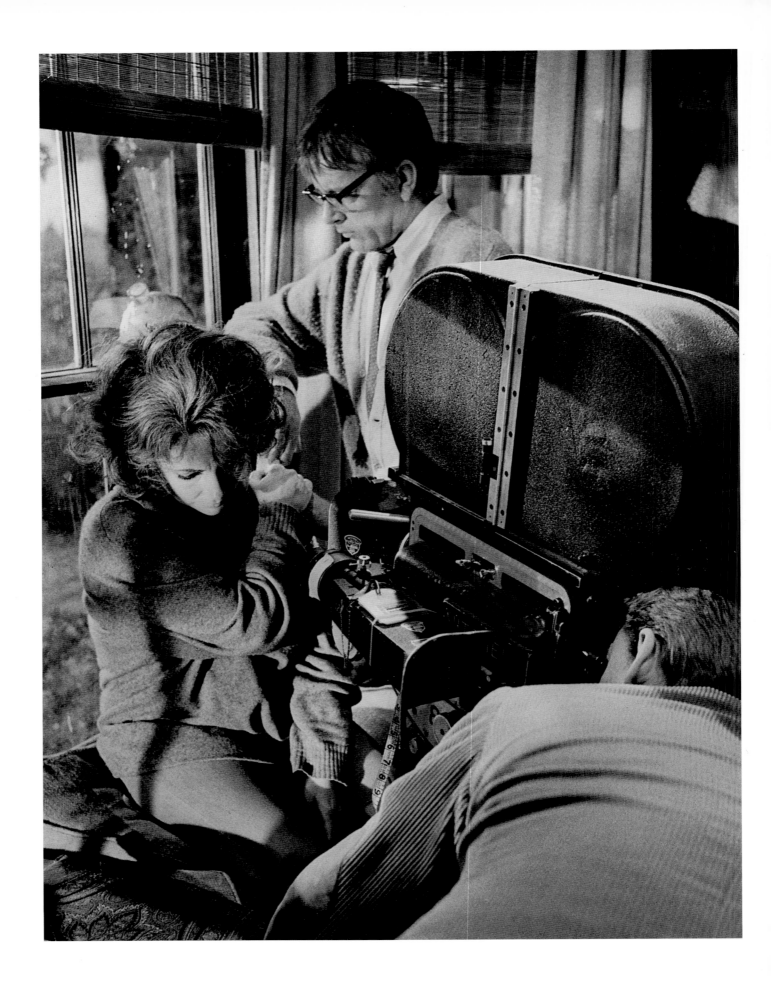

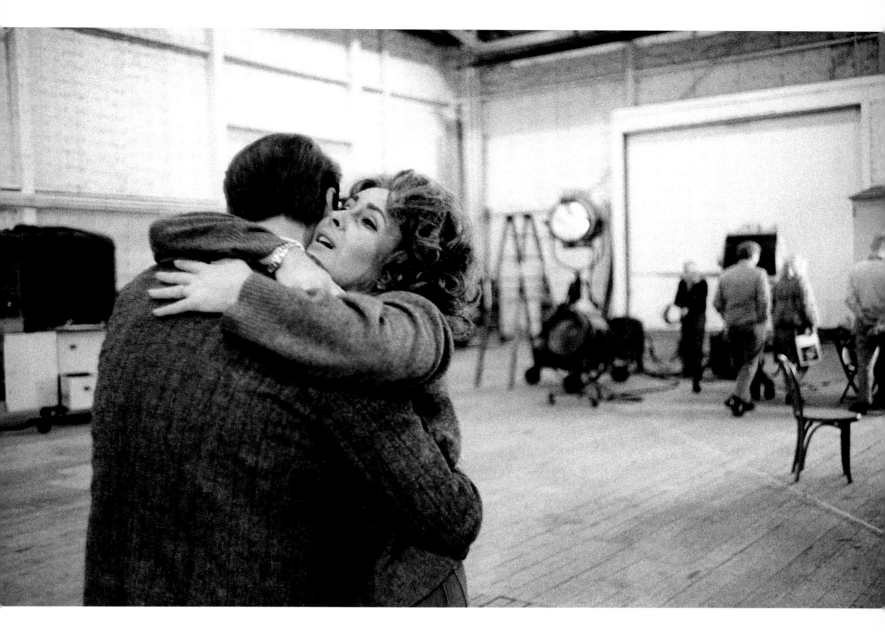

LEFT The last scene of the film. Nichols checks the Burtons' image through the camera.

Elizabeth's performance in the film would win her her second Academy Award; Sandy Dennis also won an Oscar, while Burton and Nichols were both nominated. It still seems inconceivable to me that Richard Burton never won an Oscar. This was just one of his many fine film performances that were passed over.

ABOVE The director gets a thank you from Elizabeth.

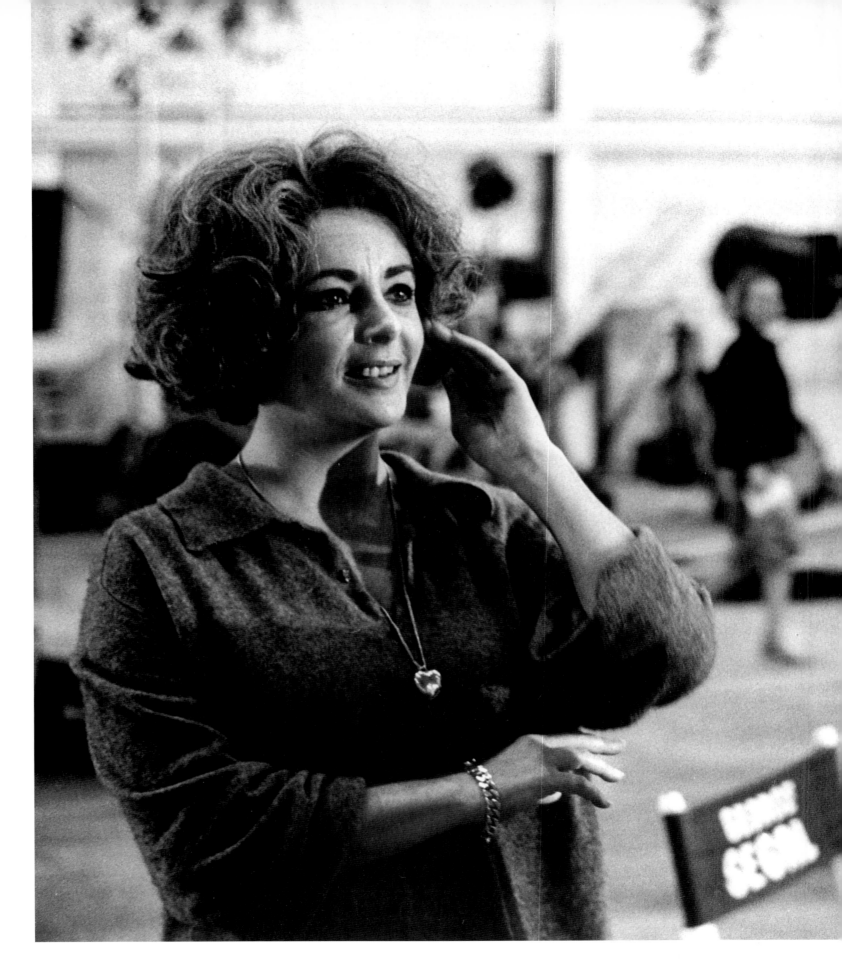

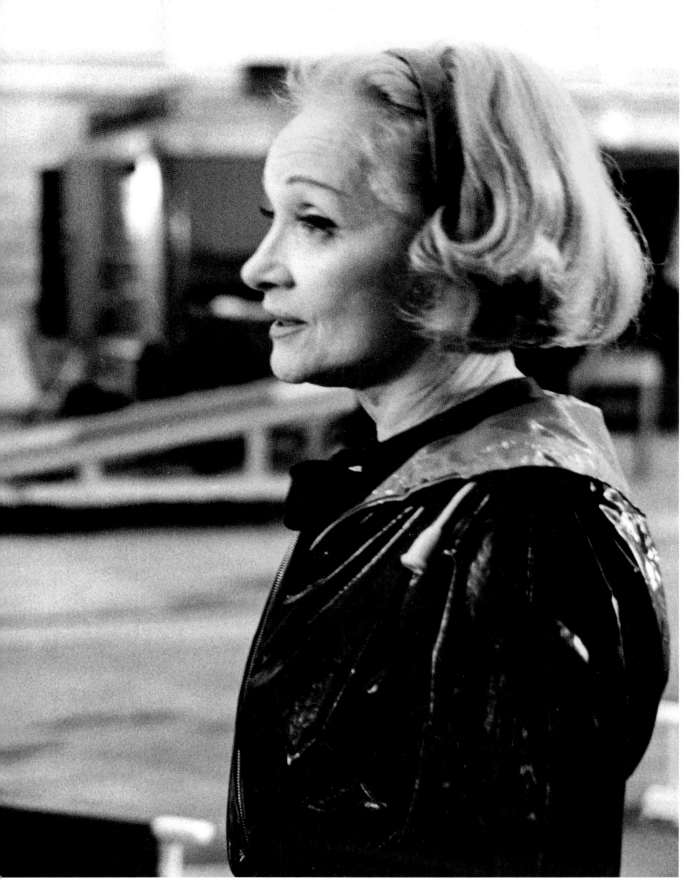

LEFT Marlene Dietrich attends the end-of-film party. Even though Elizabeth is the reigning female star at the time, she still touches her hair nervously as she meets this legendary actress.

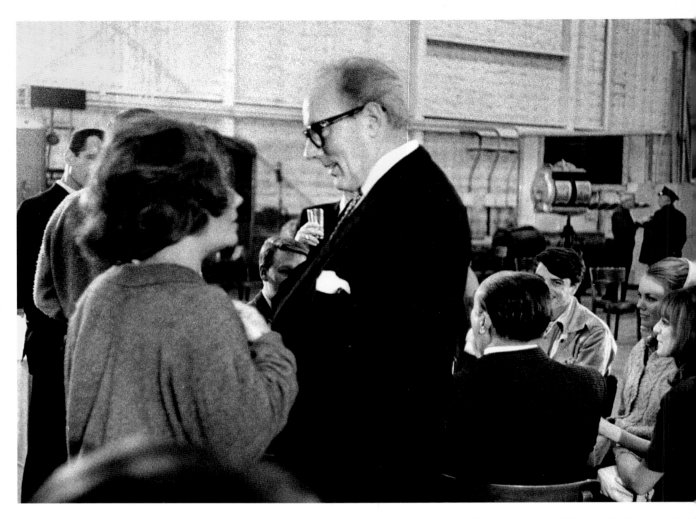

RIGHT Michael Wilding, Elizabeth's second husband, joined the cast and crew party, and the two of them seemed to have a lot to discuss.

BELOW Studio head Jack Warner joins in the fun, telling one of his terrible jokes.

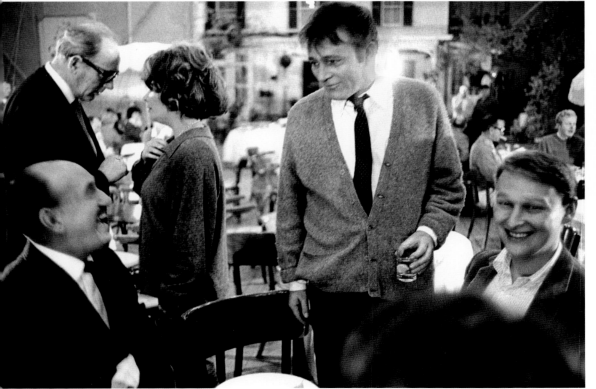

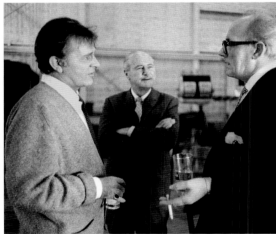

ABOVE Richard Burton, Patric Knowles, and Michael Wilding: three transplanted British actors in Hollywood.

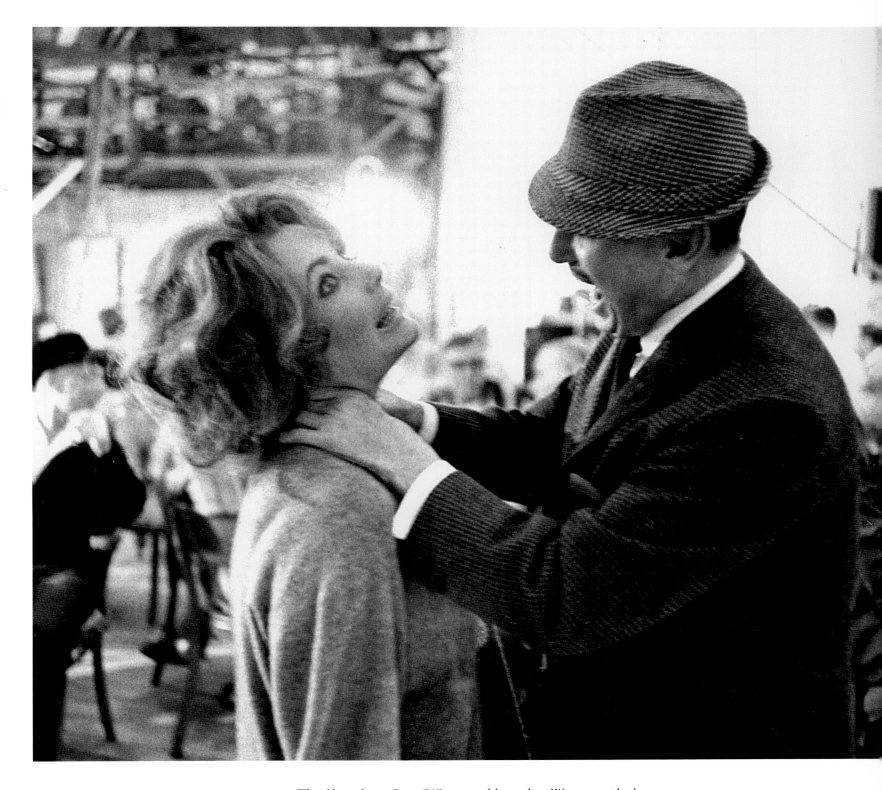

The film editor, Sam O'Steen, told me that Warner said when watching the first rushes, "I'm making a five million dollar dirty picture!" I'm sure that after the film was released, winning five Academy Awards and nominated for eight others, he was ready to make a few more "dirty" pictures.

ABOVE Warner pretends to strangle his famous star. I think by this time Elizabeth had had enough of being choked on this film!

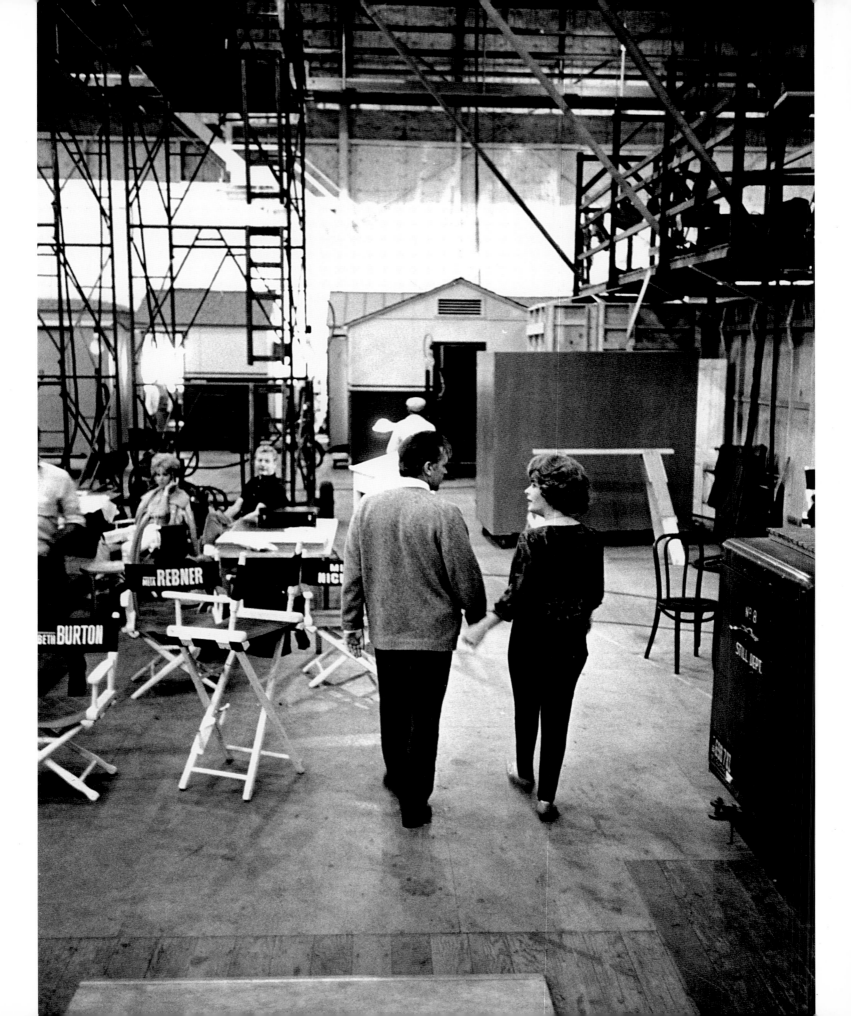

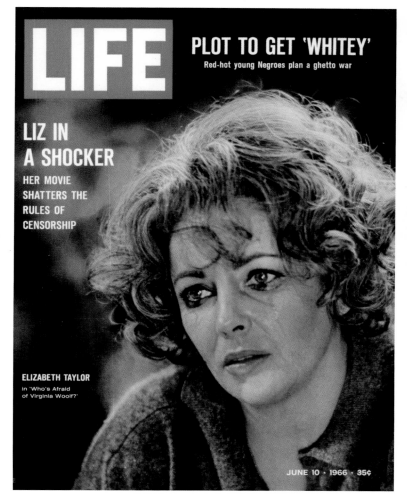

LIFE

PLOT TO GET 'WHITEY'
Red-hot young Negroes plan a ghetto war

LIZ IN A SHOCKER
HER MOVIE SHATTERS THE RULES OF CENSORSHIP

ELIZABETH TAYLOR
in 'Who's Afraid of Virginia Woolf?'

JUNE 10 · 1966 · 35¢

The Saturday Evening Post · October 9, 1965 · 25¢

POST

THE NEW YORK TIMES
INSIDE STORY OF A GREAT NEWSPAPER

FICTION BY FAULKNER

LIZ and RICHARD BURTON
team with Mike Nichols in new film 'Who's afraid of Virginia Woolf?'

OPPOSITE The Burtons, with the film now completed, walk back to their dressing rooms, hopefully leaving George and Martha behind.

THIS PAGE The world press of course responded to the way Elizabeth looked. *Life* magazine's cover thundered "LIZ IN A SHOCKER" but gave the film and all the performances critical acclaim.

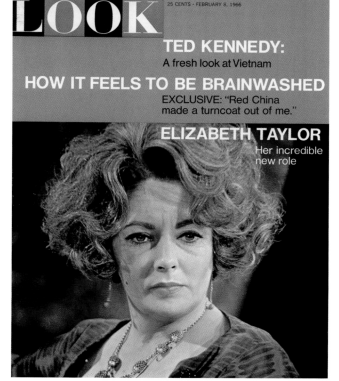

LOOK

25 CENTS · FEBRUARY 8, 1966

TED KENNEDY:
A fresh look at Vietnam

HOW IT FEELS TO BE BRAINWASHED
EXCLUSIVE: "Red China made a turncoat out of me."

ELIZABETH TAYLOR
Her incredible new role

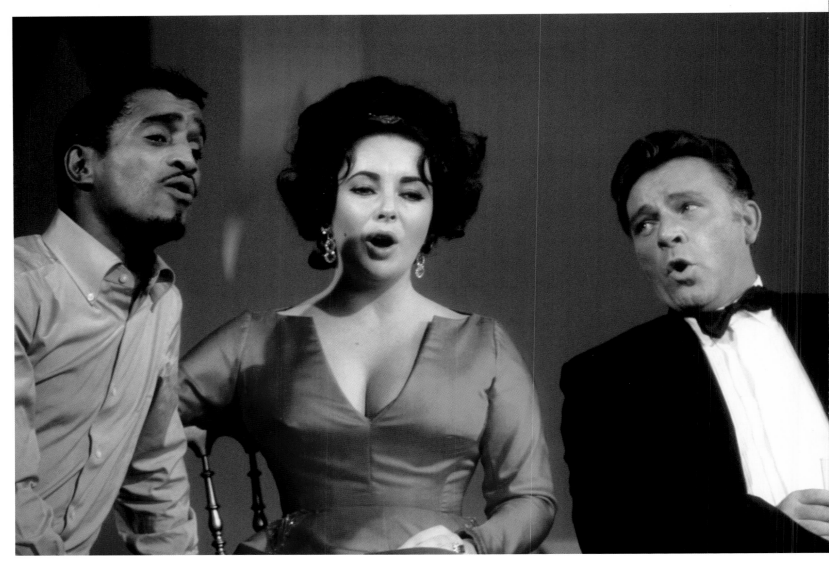

When I heard they were to appear on the Sammy Davis Jr. television show I jumped at the opportunity to photograph the Burtons in color. I knew the magazines would need something other than images of George and Martha – rather, a visual confirmation that they were still the glamorous couple that everyone knew. Elizabeth wore some of her famous jewelry. They seemed in great form that night, and besides harmonizing with Sammy, the two of them sang a song in Welsh that Burton had taught Elizabeth.

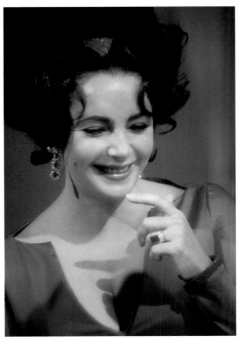

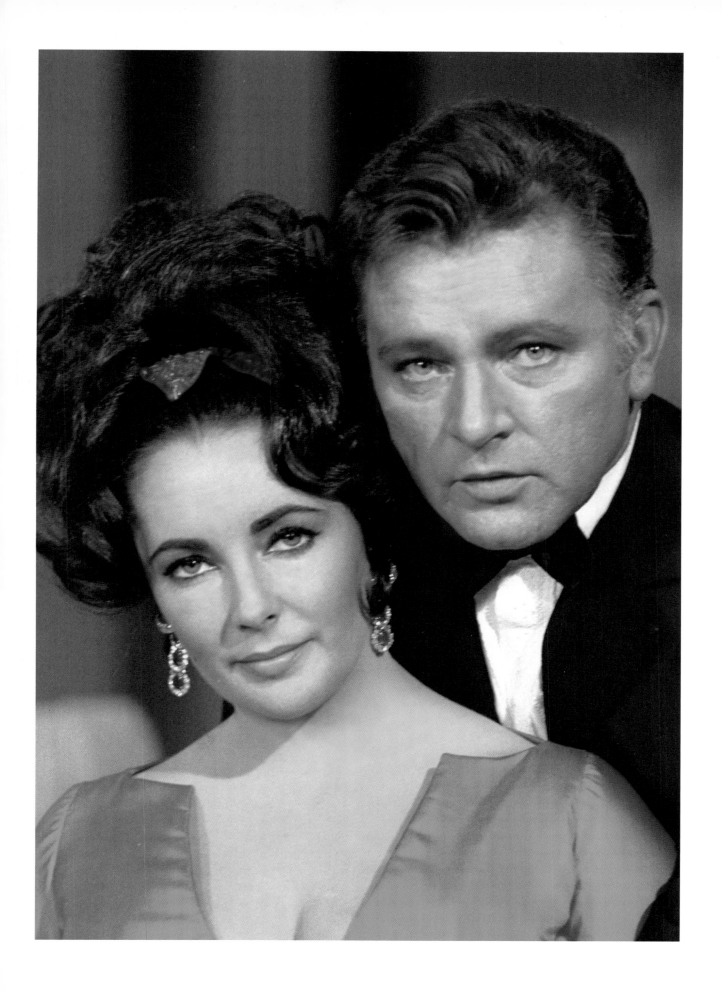

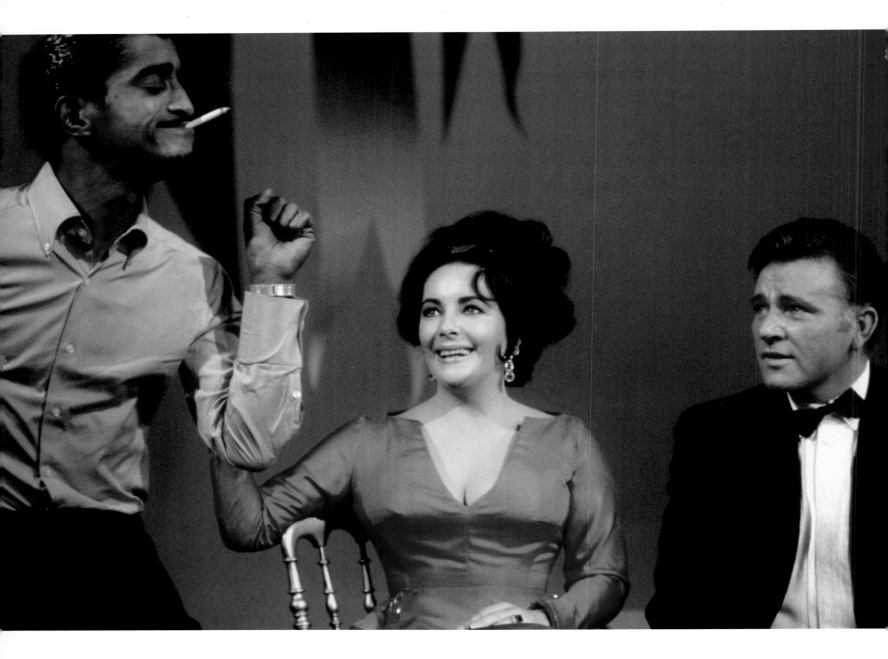

ABOVE & OPPOSITE
Elizabeth and Richard
Burton with Sammy
Davis Jr. in 1965.

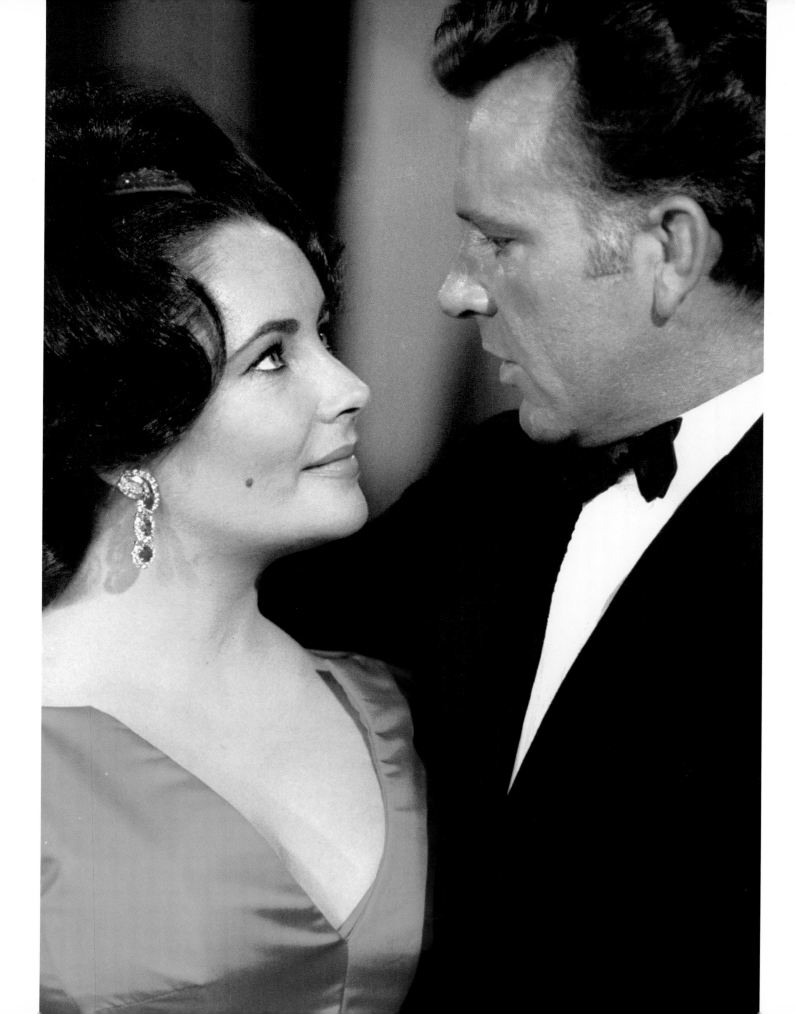

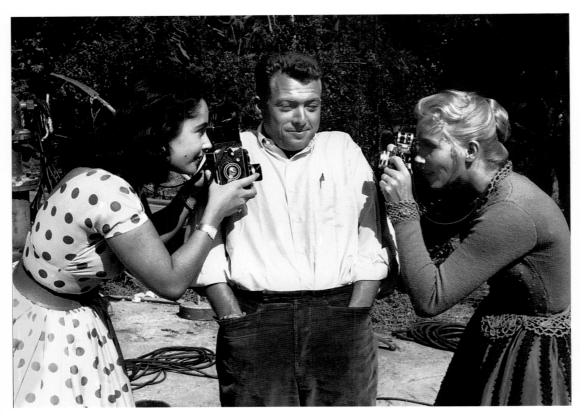

I saw the two of them – Elizabeth and Richard – in Paris one night, outside the Plaza Athénée, with my wife Dorothy. We said hello, exchanged a few words, and I never saw her again. I still have a soft spot in my heart for Elizabeth to this day, for what I observed of her character whenever we worked together.

Lovely memories for me, of dancing all night with her on the *Raintree County* location in Kentucky; picnicking with her and Margarite Lamkin (the Southern adviser on *Raintree*); just the three of us sitting on the floor in the back of Mike Todd's private plane, as we flew from Lexington to Chicago.

Sunny days, and a lot of beautiful photographs of a special lady.

Elizabeth Rosemond Taylor was born on February 27, 1932, in London, England, where her American parents ran an art gallery. Her father, Francis, was an art dealer and her mother, Sara (née Warmbrodt), a former stage actress. At the outbreak of the war, her parents, Elizabeth, and her older brother, Howard, moved back to the United States and settled in Los Angeles, California.

Her striking prettiness earned Elizabeth a screen test in Hollywood, and when she was ten her first film, a short called *There's One Born Every Minute* (1942), was released. In 1944 she made *National Velvet*, the children's film classic that would make her a star. After a brief flirtation with millionaire Howard Hughes, she married hotel heir Conrad Hilton Jr., known as Nicky, in 1950; but the marriage lasted less than a year. During this time she starred in *Father of the Bride* (1950) and its sequel, *Father's Little Dividend* (1951).

In 1952 Elizabeth married Michael Wilding, with whom she would have two sons, Christopher and Michael Jr. Her next big film was *Giant* (1956), in which she co-starred with the doomed James Dean, who would not live to see the release of the film. This was followed by *Raintree County* (1957), during which her marriage to Wilding ended and her romance with Mike Todd took off. With Todd she had a daugher, Liza, but the marriage ended in tragedy: Todd was killed when his private airplane crashed just one year after they had married. His death left Elizabeth a glamorous Hollywood widow – one who would soon, controversially, marry her late husband's friend the singer Eddie Fisher, having played her part in a scandalous love triangle with him and his wife, the actress Debbie Reynolds. More successful films followed, building on her sexy image, including *Cat on a Hot Tin Roof* (1958) and *Butterfield 8* (1960), for which she won her first Oscar, despite having starred in the film only grudgingly to fulfill her contract with MGM.

By now Elizabeth was a top-earning, full-fledged star, as famous for her private life as for her film roles. For her next film, the greatly anticipated *Cleopatra*, which began filming in 1960 and would eventually be released in 1963, she was reputedly paid one million dollars, becoming the first actress to command such a fee. During the filming she became dangerously ill with pneumonia and had to undergo a life-saving tracheotomy. The film's male lead was Richard Burton, and despite the fact that *Cleopatra* was a box-office disaster, Elizabeth's star status soared. She left Fisher for Burton in 1964 and ten years of a passionate, turbulent relationship ensued. The couple starred in several films together, the highlight being *Who's Afraid of Virginia Woolf?* (1965). Here Elizabeth won her second Oscar, for her visceral, unglamorous portrayal of Martha. But the resounding triumph of this film was not repeated and the movies that followed were far less successful and enduring. After its series of ups and downs, her marriage to Burton ended in 1974, and although the couple remarried in 1975 the relationship proved to be over and they divorced again in 1976.

During the 1970s Elizabeth undertook small film roles and television work, but her private life was increasingly difficult and she struggled with weight problems, drugs, alcohol, and illness, such elements being almost impossible to keep out of the press. From 1976 to 1982 she was married to politician John Warner. In the 1980s she continued to appear in a few films and TV movies, as well as on the stage, but her real interest switched to charity work. After the death of her friend Rock Hudson in 1985 she became active in AIDS charities and fund-raising. In 1991 she married Larry Fortensky, a construction worker whom she met at the Betty Ford Clinic, but this marriage, too, ended in divorce in 1996. She continued to suffer problems with her health, in 1997 being admitted to hospital to have a brain tumor removed.

In 1993 the American Film Academy honored Elizabeth with a Lifetime Achievement Award, and in 1999 she was made a Dame by Queen Elizabeth II in the New Year's Honours list in Great Britain. She has also received recognition and awards for her charity work. In 2001 she appeared in the TV movie *Those Old Broads* with, among others, her one-time rival Debbie Reynolds – all differences forgiven and forgotten.

Films

Selective listing of Elizabeth Taylor's feature films and shorts, not including television work.

The Flintstones 1994

Young Toscanini 1988

The Mirror Crack'd 1980

A Little Night Music 1977

The Blue Bird 1976

Identikit 1974

Ash Wednesday 1973

Night Watch 1973

Hammersmith Is Out 1972

Under Milk Wood 1972

Zee and Co. 1972

The Only Game in Town 1970

Secret Ceremony 1968

Boom! 1968

The Comedians 1967

Reflections in a Golden Eye 1967

Doctor Faustus 1967

The Taming of the Shrew 1967

Who's Afraid of Virginia Woolf? 1966
 (Academy Award winner: Best Leading Actress)

The Sandpiper 1965

The V.I.P.s 1963

Cleopatra 1963

Butterfield 8 1960
 (Academy Award winner: Best Leading Actress)

Suddenly, Last Summer 1959
 (Academy Award nomination: Best Leading Actress)

Cat on a Hot Tin Roof 1958
 (Academy Award nomination: Best Leading Actress)

Raintree County 1957
 (Academy Award nomination: Best Leading Actress)

Giant 1956

The Last Time I Saw Paris 1954

Beau Brummell 1954

Elephant Walk 1954

Rhapsody 1954

The Girl Who Had Everything 1953

Ivanhoe 1952

Love Is Better Than Ever 1952

A Place in the Sun 1951

Father's Little Dividend 1951

Father of the Bride 1950

The Big Hangover 1950

Conspirator 1949

Little Women 1949

Julia Misbehaves 1948

A Date with Judy 1948

Cynthia 1947

Life with Father 1947

Courage of Lassie 1946

National Velvet 1944

The White Cliffs of Dover 1944

Jane Eyre 1944

Lassie Come Home 1943

There's One Born Every Minute 1942